COLLAB

SNEAKERS X CULTURE
ELIZABETH SEMMELHACK
FOREWORD BY JACQUES SLADE

Rizzoli **Electa**

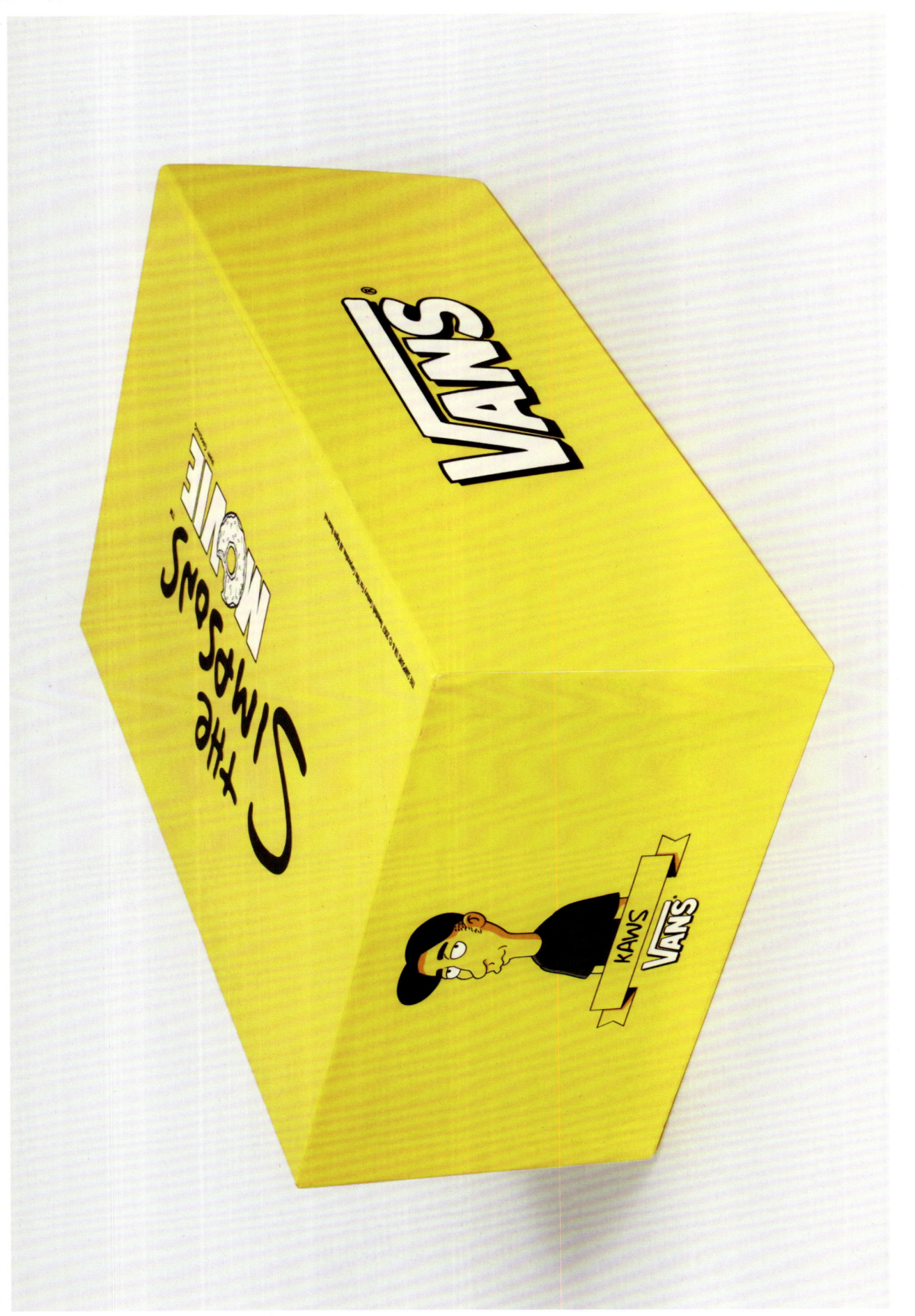

KAWS x Vans *The Simpsons Movie*, 2007. Collection of KAWS

CONTENTS

6	**FOREWORD: COLLABORATIONS** by Jacques Slade	144	**GARBSTORE**
		146	**MAISON MARTIN MARGIELA**
		148	**BUN B x CHRIS PAUL**
10	**A HISTORY OF COLLABORATIONS**	150	**RICK OWENS**
		152	**WU-TANG CLAN**
34	**COLLABORATION IN DETAIL:** **CHRIS HILL BREAKS IT DOWN**	154	**RAF SIMONS**
		156	**RIHANNA**
		158	**GE**
42	**JOSEF WAITZER**	160	**SNEAKERSNSTUFF**
44	**JACK PURCELL**	164	**OVO**
46	**CHUCK TAYLOR**	166	**PARLEY FOR THE OCEANS** **x ALEXANDER TAYLOR**
48	**WALT DISNEY**		
50	**PETER MAX**	168	**TAKASHI MURAKAMI**
52	**TONY ALVA x STACY PERALTA**	170	**FUTURA**
54	**JOHN WOODEN**	172	**PHARRELL WILLIAMS**
56	**KATE KNUDSEN**	174	**SOCIAL STATUS and A MA MANIÉRE**
58	**ALLEN IVERSON**	178	**WTAPS**
60	**CHANEL**	180	**SHANTELL MARTIN**
62	**YOHJI YAMAMOTO**	184	**VIRGIL ABLOH**
64	**HTM**	188	**UNDEFEATED**
66	**JEREMY SCOTT**	190	**ALEXANDER WANG**
68	**STELLA McCARTNEY**	192	**DANIEL ARSHAM**
70	**ATMOS**	196	**RICCARDO TISCI**
72	**JAY-Z**	198	**TREVOR "TROUBLE" ANDREW**
74	**HAZE**	200	**KAWS**
76	**50 CENT**	202	**VETEMENTS**
78	**DAVE'S QUALITY MEATS**	204	**COMME DES GARÇONS PLAY**
80	**EMINEM**	206	**ALEALI MAY**
82	**JEFF STAPLE**	210	**MAYA MOORE**
90	**MISSY ELLIOTT**	212	**UNION**
92	**KENZO MINAMI**	216	**SALEHE BEMBURY**
		220	**JW ANDERSON**
96	**COLLABORATION VANGUARDS:** **NIC GALWAY ON WORKING WITH LEGENDS**	222	**DR. WOO**
		224	**NIGEL SYLVESTER**
		228	**CÉSAR PÉREZ**
102	**ALEXANDER McQUEEN**	230	**MISTER CARTOON**
104	**ALIFE**	232	**SHOE SURGEON**
106	**BOBBITO GARCIA**	234	**PYER MOSS**
112	**CEY ADAMS**	236	**MACHE**
114	**KANYE WEST**	238	**TRAVIS SCOTT**
118	**CLARK KENT**	240	**RUSS BENGTSON**
120	**DAMIEN HIRST**	242	**DON C**
122	**VASHTIE KOLA**	244	**FEAR OF GOD**
126	**SWIZZ BEATZ**	246	**HARLEM'S FASHION ROW**
128	**CONCEPTS**	248	**LES BENJAMINS**
132	**HUSSEIN CHALAYAN**		
134	**DAVE WHITE**		
136	**TOM SACHS**	252	Endnotes
138	**MISSONI**	254	Photo Credits
140	**MELODY EHSANI**	252	Acknowledgments

FOREWORD
by Jacques Slade

COLLABORATIONS

In sneakers, as I am sure is the case in most areas of pop culture, the word *collaboration* (or *collab*) carries a broad set of expectations. For the sneaker historian, the curator of the culture, in a sense, the word implies that a story must be told. But not just any tale will do. The story must connect to the product and the collaborator in a way that is undeniable and meaningful. Looking across the spectrum of sneaker culture, you also have the profiteer and the opportunist. For them, too, the word *collaboration* needs to tell a story, one that will allow the quick sale of the sneaker and a meaningful return on an investment. While each navigates the culture in his or her own way, both play crucial roles in developing and expanding the reach of the story created through collaboration.

Step back and look at collaborations in sneaker culture, and a large swath of colors, styles, and finishing touches is revealed. Some collaborations are as simple as attaching a name. Others are as complicated as redefining a silhouette and changing the way the intended use and perception of the sneaker are communicated. Neither is right or wrong. They are simply different ways of tapping into the extraordinary power that sneakers have come to wield in the world of finance and the psychology of the self.

With so many variables, capturing the essence of a collaboration is an extremely tough challenge. Some would ask that a line be drawn in the sand and a set of criteria be established that determines whether a pair of shoes is to be considered viable. Others, myself included, see the

path to sneaker enlightenment through a very different lens. A lens that sees the beauty, the flaws, and the stories that are told by a meeting of the minds. A lens that beautifully blurs the past and at the same time brings the future into the conversation in a way that is clear and concise.

With *Collab: Sneakers x Culture*, Elizabeth Semmelhack dives deep in the sneaker world to not only provide an origin story for this niche market of collaboration, but also to take us on a journey that veers from marketing, to refinement, to destruction, to profit. This book takes into account the culture of sneakers and how its dynamics have changed over the last ninety years, as well as the political implications inherent to the communities where sneakers are often marketed.

Finally, this journey explores the most complicated aspect of the creative process—the art. Divorced from the intended purpose of the sneaker, the art of design has managed to fight its way into the conversation. From the rudimentary designs of the early 1900s to the technically informed designs of the current generation, the art of the collaboration has given rise to new stimuli that bridge the gap between culture and commerce. Since the utility of sneakers was mastered years ago, the element that makes a difference for the consumer is no longer form or function, but fashion. We now live in a world where a collaborator can add a new shade of red, or deconstruct a classic design, and create a frenzy that shuts down stores and cripples servers.

Explored through the eyes of the doers, the makers, the consumers, and the watchers, this look at sneakers through the lens of the collaboration brings us closer to understanding America's fascination with what was once just rubber, canvas, and glue. It's a look at the rise of sneaker culture, which is now out of the box and in the hands of the artists, designers, entertainers, and athletes who are often the emotional and moral conduits through which we tell our stories.

Wall of sneakers at Stadium Goods in New York City, 2019

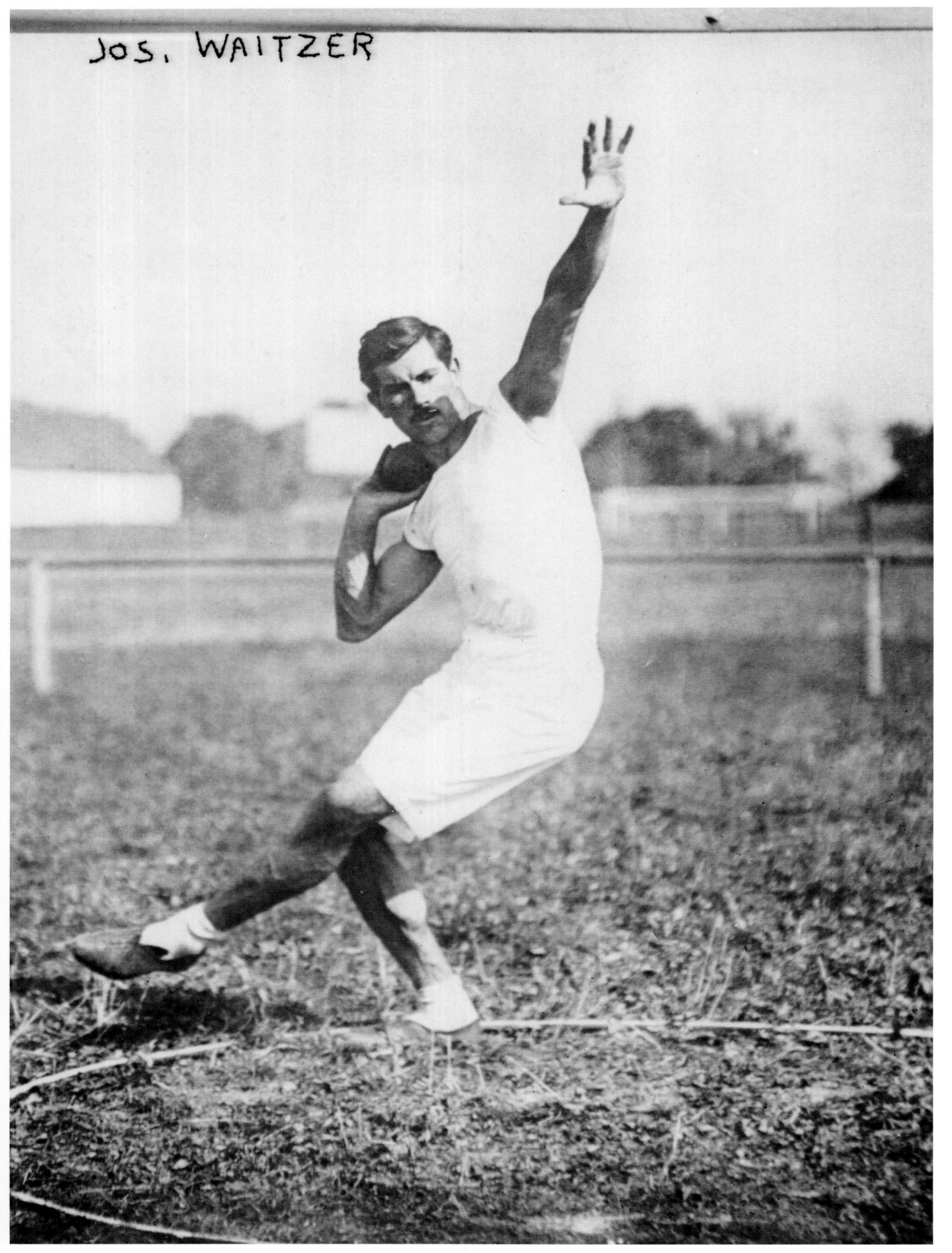

A HISTORY OF SNEAKER COLLABORATIONS

Collaboration—working together and being acknowledged for that work—is everywhere. The music, gaming, tech, and fashion worlds have all seen a surge in collaborations. For sneakers, collaborations have provided a means of crossing boundaries in ways that both add to their cultural complexity and expand their market. Some of these collaborations have pushed the design envelope by offering radically reimagined sneaker architecture. Others have been a conduit for reinvigorating interest in heritage sneakers, while still more have deepened the narratives that sneakers have to tell. It must also be acknowledged that some collaborations are inspired by little more than profit. But what is behind the desire to collaborate? What is behind the desire to consume collaborations? Do collaborations reflect larger cultural shifts? Sneakers have always been the result of the work and insights of many people, so how did we arrive at this moment?

It Begins

One of the earliest athletic footwear collaborations was between German track star and coach Josef Waitzer and German sports shoemakers Adi and Rudi Dassler. The Dassler brothers established the Gebrüder Dassler Sportschuhfabrik in 1923 with the goal of creating elite-level athletic footwear. In order to achieve this, Adi Dassler sought the insight and advice of Waitzer, an Olympian and the track and field coach for the German national team. Waitzer was committed to helping create the best performance running shoes, and he agreed to have his team members wear Dassler models during practice. He then sent reports back to Adi Dassler on which features worked and where improvements could be made. By 1928 the Gebrüder Dassler Sportschuhfabrik was ready to introduce its newest running shoe, which was named the Modell Waitzer in honor of the collaboration. ▸

Josef Waitzer, c. 1910–1915.
Bain News Service. Library of
Congress Prints and Photographs
Division, Washington, D.C. 20540

Two Leaders

THE LEADER IN CANVAS

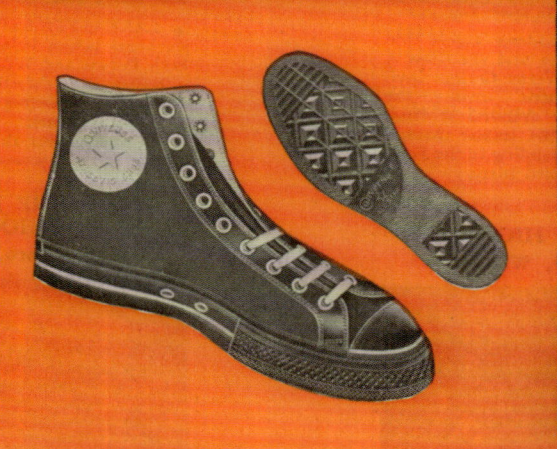

IS THE LEADER IN LEATHER

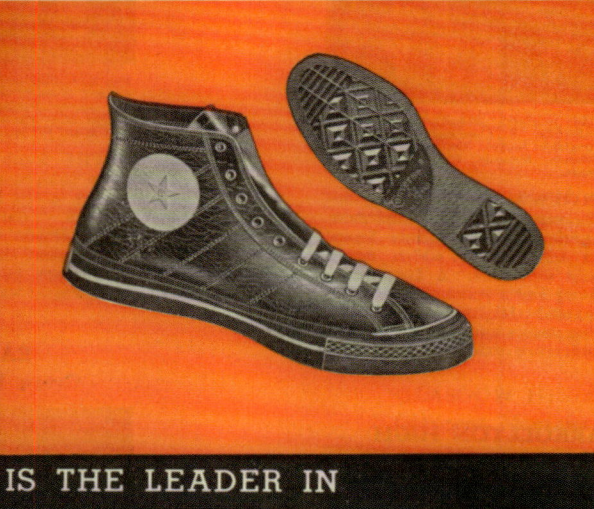

Improved AIR-FLO Insole
"Breathes" with every step you take. Means cool feet for hot contests.

Both **"Chuck" Taylor** **ALL STARS** feature the AIR-FLO Insole

CONVERSE ALL STARS Bring Exclusive Extra Features

CANVAS ALL STAR

The leader 20 years ago—the leader today. Features the MOLDED OUTSOLE for smooth, effortless stopping on every type of floor. ● FLEXIBLE COUNTER prevents chafed and blistered heels. ● DUCK BACKSTAY—flexes with every motion of the foot. ● CUSHION HEEL AND ARCH SUPPORT—greater comfort and extra support at these vital points.

LEATHER ALL STAR

All the desirable features of the canvas ALL STAR but with uppers of soft, flexible leather ● PADDED TONGUE prevents chafing or binding.

● YOU expect leadership from Converse. The molded traction sole, the peg-top, the cushion heel and arch support—these and many other improvements that added to playing comfort and longer wear of ALL STAR basketball shoes were first pioneered by Converse.

Again Converse demonstrates its leadership—this time with the leather ALL STAR. Long famous for their light weight, ALL STARS in leather now weigh a full three ounces less. Non-stretching top assures permanently snug fit, no matter how often you play. As comfortable to play in as they are good to look at—as long-wearing as they are comfortable.

So now you may have your choice—canvas ALL STARS or leather ALL STARS. Either style the best possible buy in foot-comfort, smart appearance and durability.

CONVERSE RUBBER CO., MALDEN, MASS.

Inviting a well-known figure to endorse a product was not a new idea. For centuries, purveyors of a vast array of products had sought to distinguish their goods from those of others through endorsements and testimonials from renowned individuals. Such endorsements boosted the trustworthiness of a marketer's claims in consumers' eyes. However, the majority of these partnerships were nothing more than endorsements, and there was no claim that the celebrity was instrumental in the creation or refinement of the product. The Modell Waitzer was different. Adi Dassler altered the construction of the shoes based specifically on Waitzer's input, and, more significantly, Gebrüder Dassler Sportschuhfabrik acknowledged this when naming the shoes. This strategy would become an important tactic for sneaker manufacturers as the competition for customers grew during the economic crisis of the 1930s.

Competition and Collaboration

On October 29, 1929, the New York Stock Exchange crashed, sinking the world into the Great Depression. Most people were hard-pressed financially, and many became particularly leery of false advertising as they sought to make the best use of their money. Celebrity endorsement was one means of reassuring cautious customers. This is what motivated B. F. Goodrich to reach out to Canadian badminton superstar Jack Purcell in the early 1930s, but rather than asking for a simple endorsement, B. F. Goodrich invited Purcell to collaborate on the design of a new sneaker that would bear his name. Not only would B. F. Goodrich design the new sneaker to Purcell's specifications, the company also planned to capitalize on the association in its advertising. When the sneaker came out in 1933, Purcell's tips and pointers on how to play badminton and other court sports were offered in pamphlets and promotional materials.[1] One thing B. F. Goodrich did not immediately do was put Purcell's name on the sneaker.[2] The credit for that idea goes to Converse, which in 1934 added Chuck Taylor's name to the "license plate" of its famous All Star basketball sneaker.

Converse had long used coach endorsements to promote its Non-Skid and All Star models, but Chuck Taylor was the first person to have his name incorporated into the design of a sneaker. Taylor had been working with Converse since 1922, making a name for himself by hosting basketball clinics all over the country that fostered the popularity of the sport while also promoting Converse sneakers. Taylor was talented and charming, and his clinics increased consumer confidence in Converse sneakers to the point that Converse considered it an asset to have people believe that Taylor had helped refine the design of the All Star.[3] Although it is not known how much Taylor was actually involved in updates to the All Star, his tireless travel ›

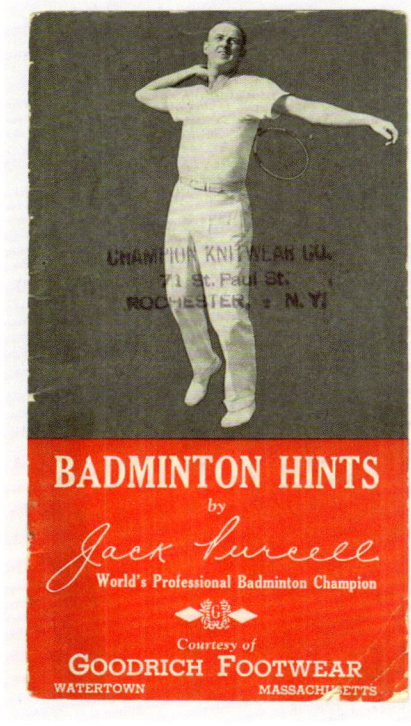

Badminton Hints by Jack Purcell, c. late 1930s. Converse Archive

Opposite: Chuck Taylor All Star advertisement, 1935. Converse Archive

13

and engagement with basketball teams across the country gave his endorsement weight. While Taylor may not have been a collaborator in the contemporary sense of the word, the importance of his name to the Converse brand identity was immeasurable.

Adding Taylor's name to the All Star was not the only innovative marketing strategy employed by Converse in 1934. The company also collaborated with Walt Disney on its line of "lifestyle" shoes called Skoots. In the 1930s, advances in manufacturing and materials made sneakers an inexpensive choice of footwear for families with growing children. The cheapest sneakers were made primarily in Japan and Czechoslovakia, and those shoes flooded the American market, placing severe pressure on U.S. manufacturers.[4] This competition from abroad led Converse to experiment with new ways to promote sneakers that appealed to children and parents alike, including products created in conjunction with Disney.

In the 1930s, Walt Disney was eager to both capitalize on the enormous popularity of his cartoon character Mickey Mouse and exert control over the quality of merchandise associated with it by granting licenses to select manufacturers, such as Converse. The agreement between the two companies resulted in a highly successful line of Converse Skoots that featured the characters Mickey and Minnie Mouse.[5] Converse assured shoe retailers that the sneakers had "tremendous 'repeat sale' value" and were proven to attract new customers.[6] Although the extent to which these Converse x Disney shoes should be regarded as collaborations is debatable, the agreement was a harbinger of the synergistic brand-to-brand partnerships that would follow.[7]

New Target Market

Growth in potential for collaborations and cross-brand marketing ground to a halt when war was declared in Europe toward the end of 1939. Rubber was a central component in the manufacture of everything from tires and life rafts to gas masks and pontoon bridges for the war, and by the time the United States entered the conflict in 1941, Japan had taken control of the largest rubber producing regions in the world.[8] The sudden dearth of rubber caused the U.S. government to impose strict limits on its use. This, combined with shoe rationing, left sneaker manufacturers struggling to remain relevant to their customers. Some forward-thinking companies began to target the principal sneaker-wearing demographic—teenagers—with the goal of ensuring the existence of an interested customer base once production returned to normal after the war. An article from 1944 discussing one manufacturer's approach stated:

Box for Mickey Mouse Skoots by Converse. Artwork by F. J. Armstrong, 1934. Converse Archive

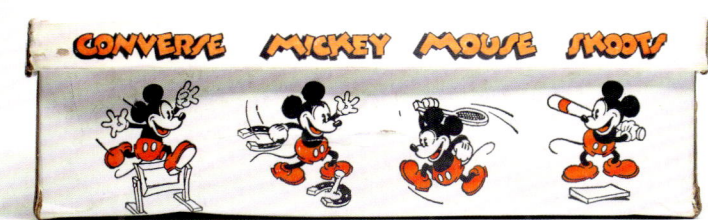

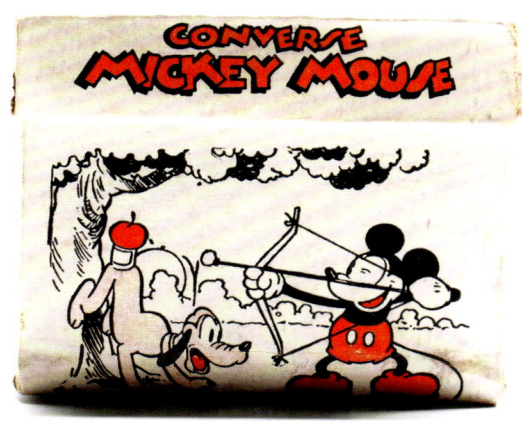

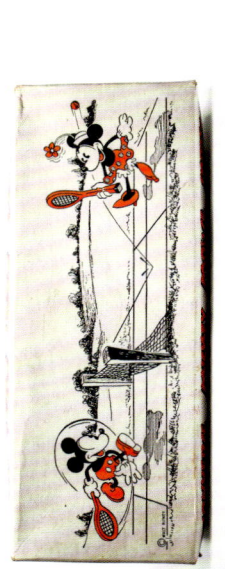

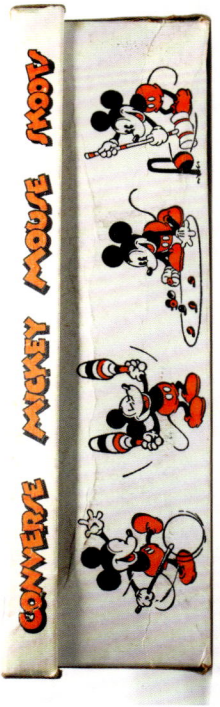

Hanover has realized that, contrary to past notions that plugs should be slanted at parents who fork over the dough for their children's commodities and necessities, it is really the teen-agers who have the final say as to what they buy and wear. With this realization, Hanover is starting out to build a wartime under-19 public and a potential postwar adult consumer market for their dog covers.[9]

This early focus on teens would become central to the successful marketing of sneakers in the ensuing decades.

In 1946 *Women's Wear Daily* featured the article "Self-Expression Shoes Continue to Catch Teen Eyes," about a display of sneakers at the Famous-Barr department store in St. Louis, Missouri. On view, it reported, were canvas sneakers hand-decorated by teenagers "with such juvenile catchwords as 'Hubba-hubba,' 'Reet!' and the names of boys and girls, the idea follows the trend for writing names and drawing hearts" on sneakers.[10] Although the sneaker artists whose work was displayed at Famous-Barr reportedly used India ink, this trend of drawing on sneakers was assuredly propelled by the introduction of inexpensive ballpoint pens and felt-tip markers, which became widely available after the war. An article in the *Washington Post* titled "'Teen-Age Set' Their Fads for '55 are Simply Cra-a-zy and If You Don't Understand Them You Are an Absolute Square" included a discussion of how teens, specifically teen girls, would carve words into the soles of their sneakers and cover the uppers with words rendered in colorful ink.[11] Teens were also increasingly wearing sneakers as items of fashion, and sneaker manufacturers leapt to take advantage of both trends. Converse, Keds, B. F. Goodrich, and Randolph Rubber Company all made sneakers with white canvas uppers that were ripe for illustration, but they also began to offer them in a wider range of colors and fabrics. A front-page 1961 *Wall Street Journal* article noted that in order to lure "fad-minded teenagers," sneakers were now offered with uppers made from "flannel, corduroy, cotton plaids, and blue denim."[12] The article also noted that younger children were being drawn to brands through the use of televised advertisements.[13] Certainly some brands exploited the new medium of television in the late 1950s and early 1960s. For example, Keds ran television commercials featuring the cartoon character Kedso the Clown, and Randolph licensed the CBS Saturday-morning cartoon character Mighty Mouse.[14]

The popularity of sneakers in the United States was rising so quickly that sales of traditional leather shoes began to suffer. Manufacturers of such footwear bemoaned everything from society's willingness to allow sneakers in church to concerns for children's foot health in a bid to recapture a share of the market.[15] Attempts to stem the tide were of no use, and by 1962 sneaker consumption had increased dramatically. American manufacturers weren't the only ›

ones seeing improved sales. European companies were also rapidly expanding, especially the two German firms created after the Dassler brothers parted ways following World War II—Adidas, founded by Adi Dassler, and Puma, established by Rudi Dassler.

Postwar Potential

Perhaps because sneakers were steadily growing in popularity at the time, sneaker manufacturers did not seek to use collaboration as a means of increasing sales or brand recognition. Instead, sneaker companies relied on consumers, predominately teens, to invest their sneakers with meaning. Teenage girls did this by continuing the tradition of drawing and writing the names of their friends, as well as inside jokes, on their sneakers to establish group and individual identity. The manufacturer of Wing Dings expanded on this concept when it attempted to capitalize on the Beatles craze in 1965. By emulating the work of a gifted teenage girl who had customized its shoes for a friend, Wing Dings created a sneaker that enfranchised a wider range of Beatles fans while maintaining a sense of subculture exclusivity. It was a strategy that would become important in future collaborations designed to speak to niche markets.

Randolph Rubber Company, particularly its Randy's division, which was established after the company bought the Rubber Corporation of California in 1963, actively pursued niche markets through licensing agreements and true collaborations with artists such as Peter Max. The artwork Max produced was specific to the architecture of each sneaker he created for Randy's (see page 50).[16] However, by the early 1970s, Randolph was bankrupt and its marketing innovations, including collaborations, were left for others to develop.

Paul Van Doren, one of the founders of Vans, worked for a time at Randy's, where he became frustrated with retail middlemen who separated manufacturers from consumers and in doing so ate into manufacturers' profits. He was determined to deal with customers directly, and founded Vans in 1966 on a direct-to-consumer model that was able to customize sneakers for an extra dollar per pair if customers provided the fabric.[17] This responsiveness to customers ultimately led to the first commercialized collabs from Vans in the late 1970s.

Signature Shoes

The most influential change to pave the way for future collaborations was the focus in the mid-1960s on "signature shoes," one of the most important being the tennis shoe that came to be known as the Stan Smith. In 1965 an all-leather tennis shoe that Adidas had created

Top and center: Stan Smith/Robert Haillet tennis shoe, 1973–76. adidas AG

Bottom: Wing Dings, 1965. Michael Stern Pop Culture Collection

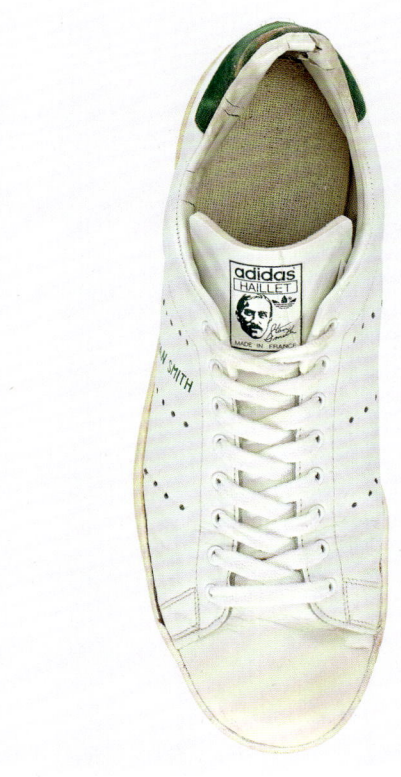

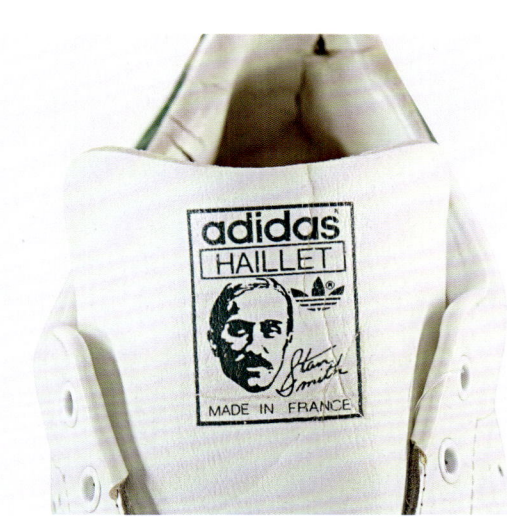

was offered to French tennis star Robert Haillet for endorsement. As part of the deal, Haillet's signature was printed on the side of the sneaker. By the early 1970s, Haillet was ready to retire and Adidas was interested in gaining a greater foothold in the U.S. market, so at the French Open in 1971 the brand approached American tennis champion Stan Smith with an endorsement deal.[18] Adidas offered Smith the Haillet model with a few revisions: Haillet's name was replaced with Smith's, and a portrait of Smith, along with his signature, was added to the tongue. Unexpectedly, this change was met with resistance in the United States where the name Haillet had become synonymous with the high quality of the sneaker. In order to keep its American customers, Adidas decided to reinstate Haillet's name on the sneaker. Thus, for the first seven years of the Stan Smith, the tongue featured Stan Smith's portrait with the words "adidas HAILLET" squeezed in above it, creating a confusing double-endorsed sneaker.[19]

Puma was also early to the signature shoe game. The company signed basketball star Walt "Clyde" Frazier in 1970, and in 1973 it came out with the Clyde, an updated version of its Basket sneaker.[20] In contrast to the Adidas Stan Smith, the Puma Clyde was marketed with the suggestion that its namesake might have made some contribution to the design of the shoe.[21] This was a subtly suggested but important detail with implications for later collaborations. Another major difference between the two sneakers was that Walt Frazier's Clyde was as much about fashion as it was about basketball. By the middle of the 1970s, televised sports had become a highly lucrative form of entertainment, and many sports heroes were celebrated as much for their charisma and style as for their sports skills. Frazier made headlines with his bold outfits, his flashy Rolls-Royce, and his wide range of lucrative sponsorship deals.[22] Frazier was not just a basketball player—he was also a fashion icon who frequently made best-dressed lists in the 1970s. Puma's decision to offer the Clyde in soft suede and in a range of attractive colors ensured that the Clyde would be purchased not only for playing basketball, but also for wearing as an item of fashion. The then-exorbitant price of twenty dollars per pair also guaranteed that the sneaker would become a signifier of status, especially in New York City, where Frazier played ball for the Knicks.[23]

The emergence of hip-hop and the dance form of "breaking" in New York City during the early 1970s created another market for sneakers like the Clyde. Breaking was highly competitive and required equal parts skill and style. It was also extremely athletic, and, like urban basketball, it required footwear that was both functional and "fresh." Bobbito Garcia, author of *Where'd You Get Those?*, remembers:

> From 1970 to 1987, the goal in New York was to assert your individuality within a collective frame. The collectives were ▸

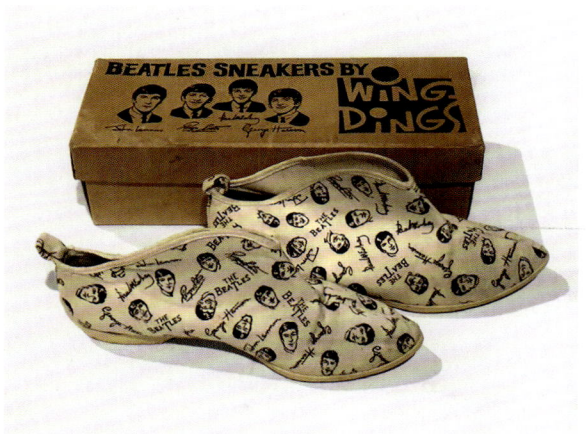

17

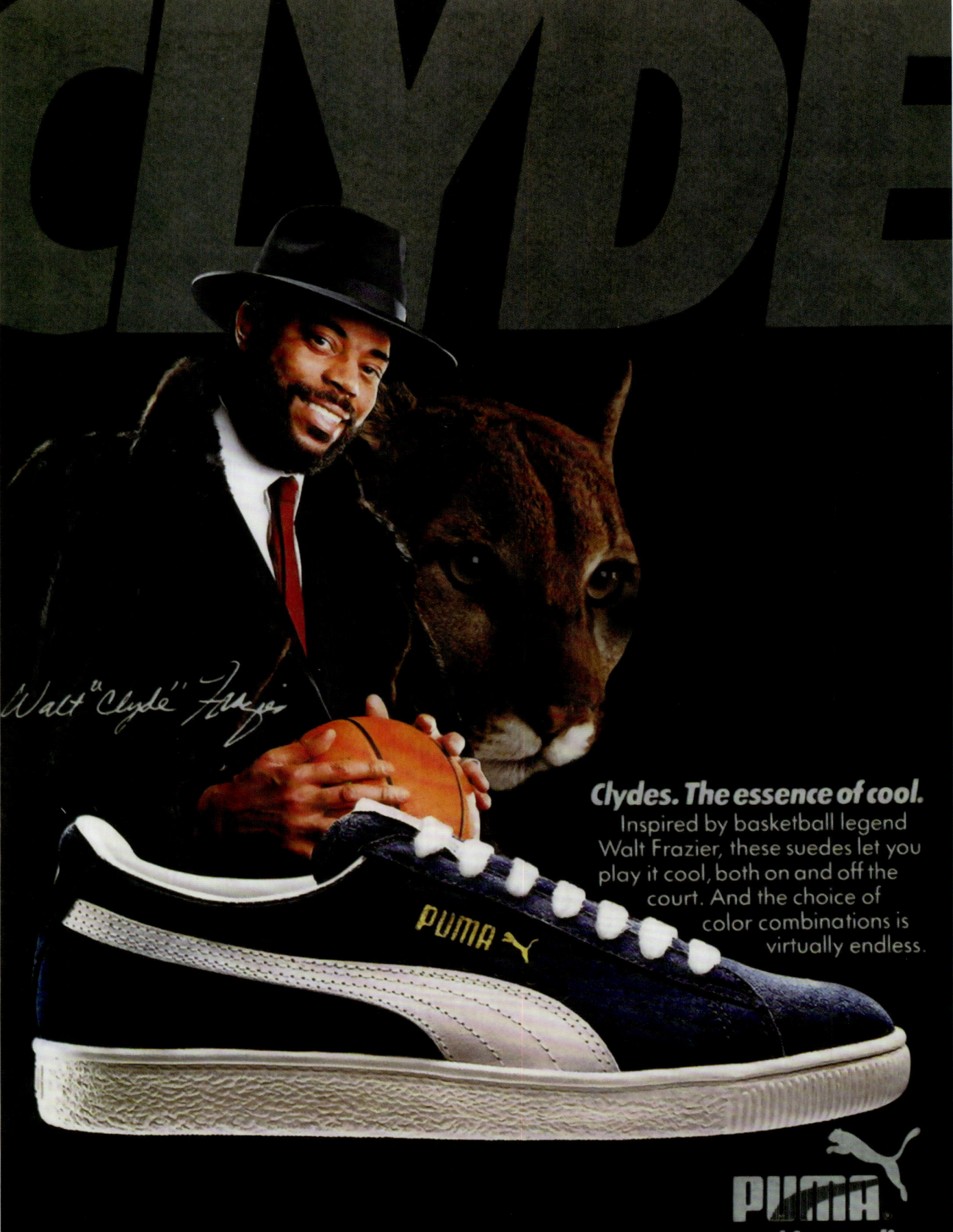

playground ballplayers, graffiti writers, b-boys and b-girls, DJs, MCs, and beatboxers. The spirit was competitive and progressive . . . whether it was coming up with a new boogie move on the court or a new freeze on the linoleum, ballplayers and hip-hop heads alike were pushing the creative envelope at all times.[24]

As hip-hop, rap, breaking, and basketball increased in popularity, specific brands and sneaker models started to become invested with layers of meaning and stories, which coincided with a larger growing trend in American society that suggested both individual expression and group identity could be achieved through brand identification.

Despite the increasing importance of sneakers on the East Coast, it was on the West Coast that the potential for collaboration was beginning to be fully understood and realized. In the mid-1970s, Vans took the advice of two teenage skateboarders and created one of the most enduring skate sneakers of all time. While Puma hinted that Walt Frazier might have helped design the Clyde, there is no question that skateboarders Tony Alva and Stacy Peralta recommended substantive changes to the Vans #44 Deck Shoe, which led to the creation of the #95, the first-ever Vans skateboarding shoe, later called the Era. Unlike Smith and Frazier, Alva and Peralta had not been courted for an endorsement—they simply offered their advice and Vans listened. Both Alva and Peralta had been wearing Vans for years, and while each felt that the Vans gum sole was essential to the utility of the shoe, they suggested to Vans that the design incorporate more padding and that the footbed be made softer to give skaters even greater feel for the board. They also suggested that the sneaker be made in a two-tone red and blue colorway. Vans responded with a skateboarding sneaker that remains as relevant and influential today as it was in 1976.[25]

Crafty

Despite the explosive potential for collaborations at the dawn of the 1980s, the majority of sneaker companies still did not recognize their value. Some companies sought to reinvigorate the idea of people customizing their own shoes. Adidas took this approach in 1983 with the adicolor, an all-white sneaker sold with a set of markers. The adicolor ad campaign was primarily directed at girls and was an update on the tradition of teen girls customizing their sneakers that began in the 1950s. The cultural associations connecting femininity and crafting were more evident when Reebok reached out to Los Angeles–based artist Kate Knudsen. Knudsen had been gaining notoriety among celebrities for the jackets and t-shirts she decorated with her witty artwork.[26] Using her new wave/punk aesthetic and acrylic paint and wielding the newly popular crafter's glue gun, ›

Puma Clyde advertisement, 2002.
Puma Archive

Knudsen created one-of-a-kind customized Reeboks for celebrities such as Whoopi Goldberg, Billy Crystal, Kirk Cameron, and Wolfgang Puck. The success of these commissions led Reebok to offer Knudsen a collaboration in 1987 that resulted in the 1989 Painted Freestyle Hi collection for women. Reebok further capitalized on the crafting trend by holding sneaker-painting contests around the country. Knudsen's collaboration with Reebok could have marked a transformative moment in the history of collaboration and sneakers, but her ironic tongue-in-cheek approach and unabashed enthusiasm for kitsch expressed through female-coded crafting was ultimately in opposition to sneaker culture, which was increasingly focused on ideas of authenticity and masculinity.

Vans took a different tack when it created its checkerboard slip-ons. The pattern, which had been inspired by doodles sent in to Vans by kids, retained an artsy sensibility but distanced the shoe from any direct connection to hand-drawn customization. The checkerboard sneaker was made famous by the actor Sean Penn as Jeff Spicoli in the 1982 film *Fast Times at Ridgemont High*, connecting them firmly to male teen culture.

The Jump

Perhaps the two most important moments in the development of collaborations were the signing of Michael Jordan by Nike in 1984 and the signing of Run-DMC by Adidas in 1986. Although neither deal was a full-fledged collaboration, Nike's work with Michael Jordan on the Air Jordan came the closest. In the 1980s, Nike began to realize that it needed to focus more on basketball. Andrew Pollack wrote in *The New York Times* in 1985 that Nike had been "caught off guard . . . when fashions began changing."[27] Nike's earnings had dropped by a precipitous 29 percent in 1984, but the one bright spot was its Air Jordan. The article went on to quote a Nike representative, who noted that the company was "going back to what we know best, athletic wear with a little fashion thrown in."[28]

Peter Moore designed the first Air Jordan, one of the most important sneakers in history. The first iteration was in the Chicago Bulls colorway of red and black, supposedly prompting Michael Jordan to call them "devil shoes." The first time Jordan wore them on the court he received a reprimand from the NBA for not conforming to the "uniformity of uniforms rule."[29] For Nike, this was pure gold. The Air Jordan would have stories to tell, especially after Jordan wore them when he won NBA Rookie of the Year, when he was chosen to be an NBA All-Star starter in 1985, and when he scored a phenomenal sixty-three points against the Celtics in the 1986 NBA playoffs.

The signing of the rap group Run-DMC to Adidas was another watershed moment that had a very different yet equally significant

Top: Run-DMC promotional poster, 1988.

Bottom: Vans Checkerboard Slip-ons, 2018. Vans Archive

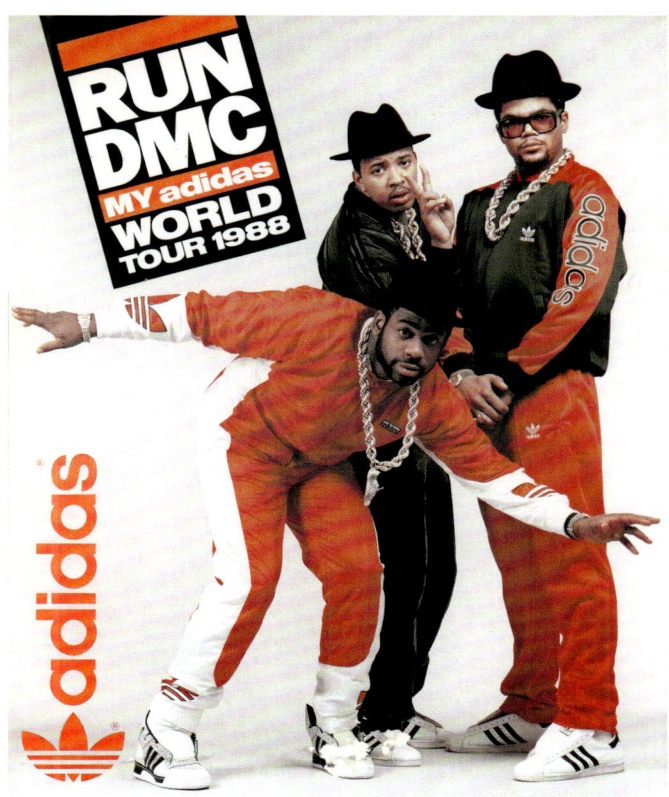

impact on the future of collaborations. Rather than a signature shoe, what Run-DMC got was an endorsement deal in recognition of years of brand loyalty. The deal also served to acknowledge the importance of Adidas in urban centers and helped to bring the stories and meanings that had been embedded into the sneakers by hip-hop to a much broader audience. As more and more rap songs referenced sneakers, and new Air Jordans were released each basketball season, basketball and hip-hop became ever more entwined, "like peanut butter and jelly," as basketball star Allen Iverson would later say.[30]

In the second half of the 1980s, urban style continued to embrace a wider range of luxury brands. Gucci, one of the first luxury labels to offer sneakers, initially sought to capitalize on this cultural moment, but ultimately became uncomfortable with the trend. Indeed, most purveyors of luxury goods were not welcoming toward anyone not part of their traditionally white and wealthy clientele. In the face of this overt racism, Harlem-based couturier Dapper Dan began to co-opt high-end fashion and adapt it for his community; as he has said, he "blackenized" it.[31] He deconstructed and transformed luxury-branded material, such as Louis Vuitton handbags, into bespoke garments and would often re-surface sneakers provided by his clients with designer fabric.[32] Like the rappers he was dressing, Dapper Dan was sampling and reimagining cultural signifiers in ways that would fundamentally shift fashion, although it would take decades for his impact and influence to be acknowledged by high fashion and eventually vaunted in the world at large.

A Corollary to the Great American Novel

One of the most storied sneakers in history was created by Nike designer Tinker Hatfield, who from the beginning understood the power of narratives, as well as the importance of seeing beyond the merely functional to, as he put it, "Design in romance and imagery and all of those subliminal characteristics that make an object important to people in less utilitarian ways."[33] Before designing his first Jordan sneaker, the Air Jordan III, Hatfield listened closely to Michael Jordan and incorporated many of his desires into the shoe, creating a design that was exceptional enough that Jordan felt compelled to reconsider his threat to leave Nike. Once Jordan began to wear the Air Jordan III, additional narratives were layered onto the model throughout the 1987–88 NBA season. Perhaps most important were the narratives crafted through Nike's promotion of the Air Jordan III, which brought Michael Jordan and Spike Lee together for the first time. Lee was an astute choice for the Air Jordan commercials. Not only was he a respected filmmaker, but he had already touched upon the growing cultural significance of Air Jordans when Mars Blackmon, the character Lee played in his 1986 ›

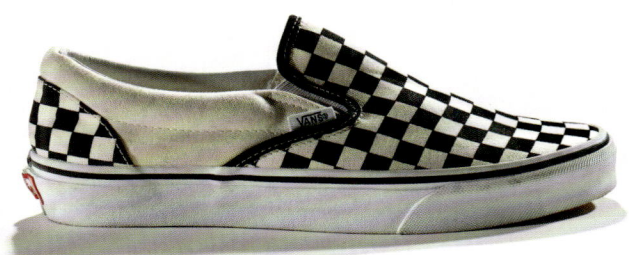

21

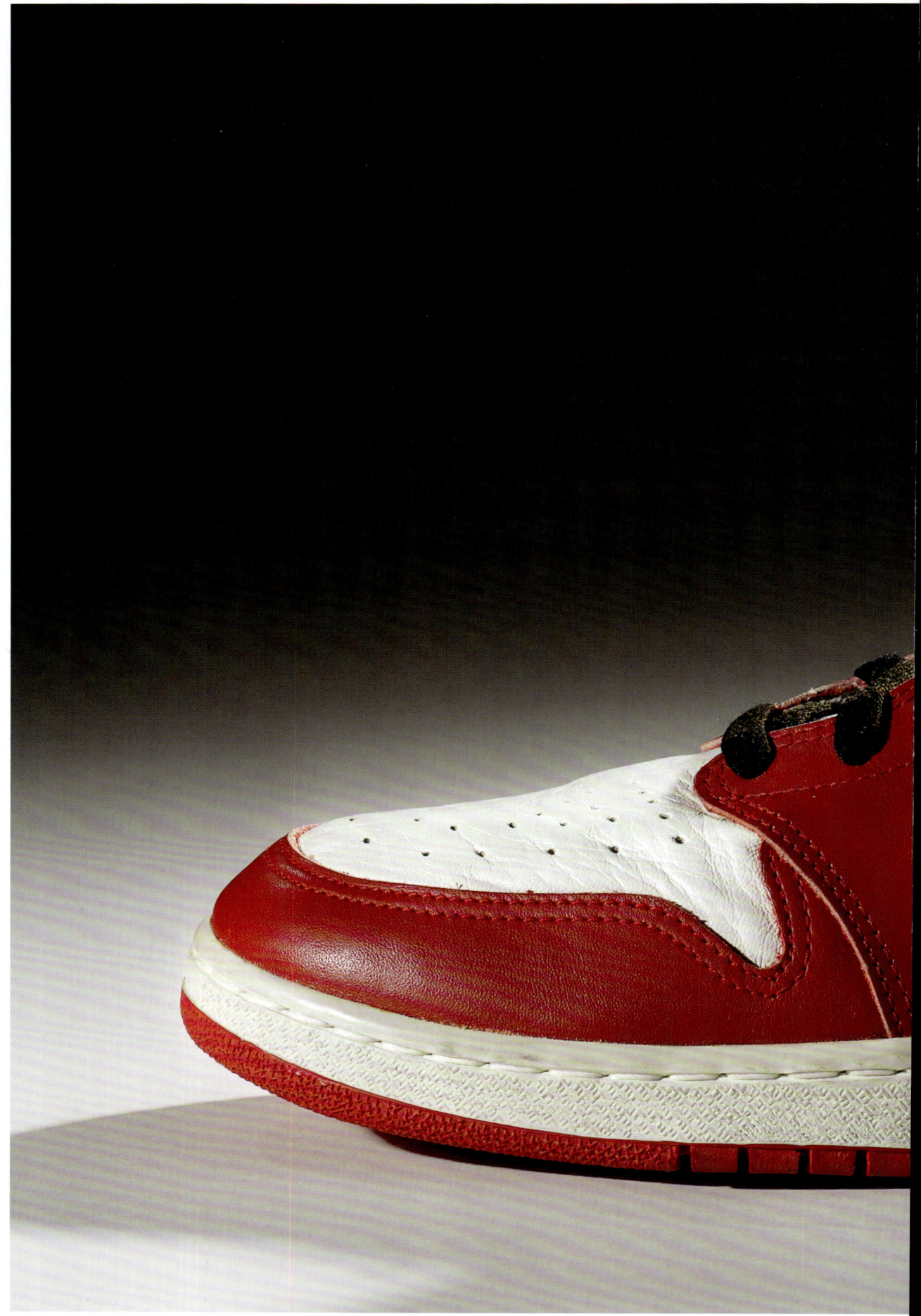

Air Jordan I, 1985. Nike DNA

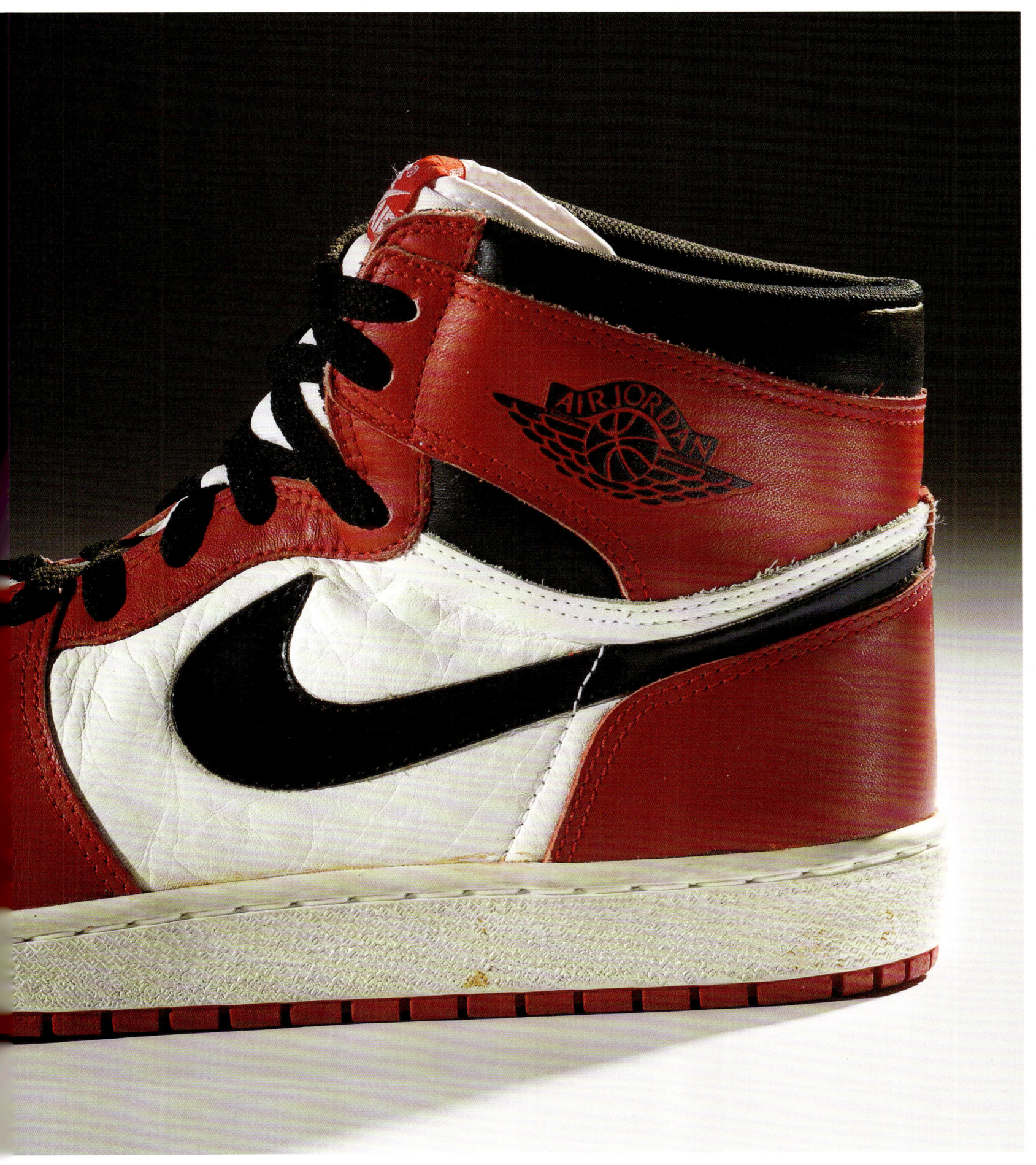

breakout film *She's Gotta Have It*, famously refused to take off his Air Jordans during sex.[34] For Nike, Lee directed commercials that captured a lighter side of Jordan's personality and also infused yet more meaning into the shoes. By the end of the decade, the possibilities for sneakers seemed boundless, and even those outside sneaker culture began to recognize sneakers' growing importance. As *Metropolitan Home* proclaimed in 1989, sneakers had become "the consumer corollary to the Great American Novel."[35]

Although collaborations were still few and far between, the 1990s saw both a huge increase in the number of sneakers offered by the big brands and the flourishing of smaller labels trying to get into the game. Exactly who was supposed to wear sneakers, how they were to be worn, and what they stood for culturally were questions that came to the fore. With the introduction of casual Fridays in the professional workplace and the debut of the Internet, many men found themselves contending with a wider array of sartorial obligations and situations in which sneakers were considered an acceptable form of footwear. Many of the traditional signifiers of masculine success, specifically business suits and brogues, were beginning to feel outmoded. Those at the vanguard were the new sneaker wearers, and they included many of the decade's heroes—whether they were basketball players, rappers, or tech entrepreneurs. However, these new models of masculinity did not wear just any kind of sneaker; specific brands, models, and affiliations, cultural or celebrity-based, became increasingly important and led to a wider range of sneakers being offered to male consumers.

As the cultural currency of sneakers grew, men began to be asked to do what women had been socially obligated to do for generations: show up at work and in public looking distinctly different from one another rather than appearing in the same business and leisure uniforms. Sneakers provided a way to meet these new obligations and to establish individuality while expressing a shared masculinity. It was clear that men were being inculcated into the fashion economy, but neither consumers nor companies were inclined to admit it overtly. As one *New York Times* article, published in 1992, reported, "While the companies' advertising appeals may be pitched to athletes, 80 percent of the sporting shoes purchased are never used in play. A large majority of these shoes are being worn as street wear. . . . The companies don't want to own up to that."[36]

Even if companies did not want to "own up" to the fact that their sneakers were increasingly used as items of fashion, they did want to capitalize on it. They aimed to do so by offering signature basketball shoes and endorsement deals to an ever-widening range of male athletes and musicians. While some men stuck to classic running shoes—a holdover from the 1980s' yuppie era and a style that in the late 2010s would come to be labeled the "dad shoe"—others, particularly younger men, preferred basketball shoes, which were ›

Air Jordan III, 1987. Nike DNA

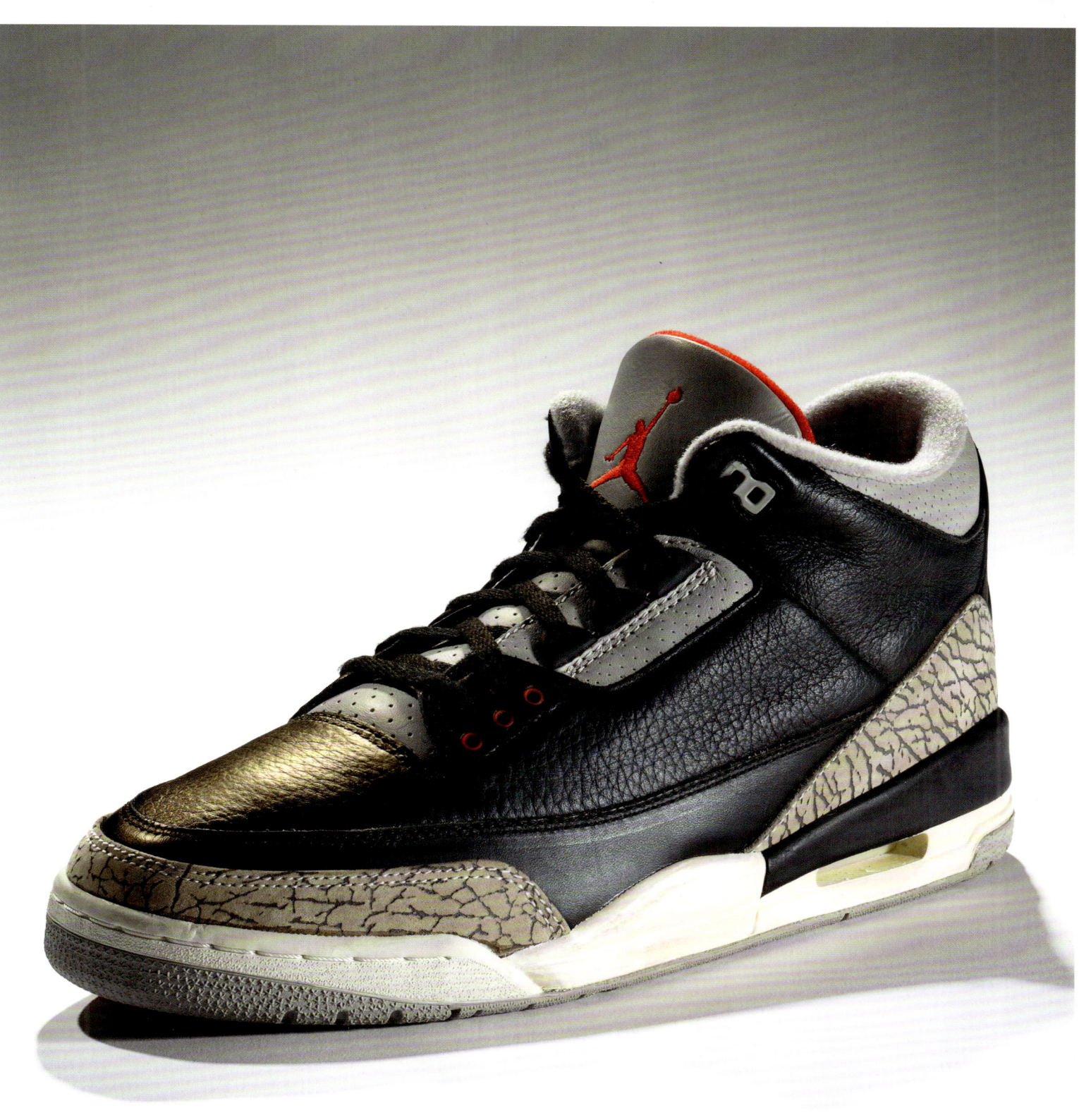

embedded not only in sports but also in hip-hop, skater culture, and streetwear. However, as company after company introduced new signature shoes, the market became oversaturated, and the plethora of "hero shoes" also began to feel calculated and inauthentic.[37] Signature shoes may have started out as a "cornerstone that brands built their credibility on," but by the late 1990s they felt more like a simple money grab.[38] With the credibility and authenticity of these deals called into question, interest began to shift to rare sneakers.

An Educated Consumer Is Our Best Customer

Knowledge of the history of sneakers and the hunt for rare "dead stock"—unsold sneakers often discovered in the dusty corners of old stores—had been central to the development of sneaker culture in the late 1970s and early 1980s in urban centers, but by the 1990s, this closely-held information by that small but sophisticated group of cognoscenti was about to go global through blogs, online magazines, and, eventually, social media. Suddenly, the history of sneakers became important to a much broader consumer base. Nike capitalized on this trend in 1994 by reissuing one of the most important Air Jordan models, the Air Jordan III, first released in 1988. Retroing, as the reissuing of previous models came to be known, not only stoked nostalgia but also promoted the concept that vintage sneakers had value to a larger audience. The premiere in 1995 of the online auction site eBay further fueled the market for vintage sneakers, as did reporting on the fact that collectors were eagerly buying up vintage stock. Resellers such as Tace Chalfa in Seattle became famous for her willingness to buy even the most worn-out vintage pairs to meet the desires of the emerging domestic market, as well as the flourishing resale market already established in Japan.[39] Suddenly vintage sneakers began to be seen as investments, and closets full of them were transformed into collections, giving sneaker collecting the same cachet as other forms of serious collecting. The sequential numbering of Air Jordans further intensified this culture of collecting.

Adding fuel to the flame were the debuts of collaborations between emerging streetwear brands and major sneaker manufacturers, such as the 1996 release of the Supreme x Vans Old Skool. Such sneakers were often released in limited numbers, in part due to the small customer base for them, but this sparked the practice of limited editions, sometimes composed of less than one hundred pairs, which would ultimately foster line-ups and fierce competition among collectors and consumers alike. Meanwhile, the prices for wide-release sneakers were rising and their high cost was increasingly sensationalized, often through overtly racist media coverage of thefts and even murders perpetrated in the quest for expensive sneakers; this only heightened their perceived value in mainstream culture.

Reebok Iverson Question, 1996. Reebok Archive, Reebok International, LLC.

Fashion Forward

Sneakers as a central feature of men's fashion finally began to hit home in the age of NBA star Allen Iverson. Iverson, selected first overall by the Philadelphia 76ers in 1996, was respected not only for his prodigious skill as a player but also for his uncompromising attitude and a true-to-himself style that made some uncomfortable, but was exhilarating to many others. In an article in the *Boston Globe*, veteran sports reporter Bob Ryan problematically wrote:

> Nothing alters Iverson's Anti-Establishment mind-set. Allen is going to do everything his way, and only his way. Allen is dedicated to Keepin' It Real, whether that means putting out an obscenity-laden rap album, dressing for every occasion in his chosen hip-hop manner or, very much to the point, either skipping, or walking through, practice. In Iverson's mind, there appear to be only two approaches to every situation: his way or the chump way. . . . Has Iverson heard of Michael Jordan? Jordan's zeal for practice was legendary. Or does he dismiss him as an irrelevant old has-been who actually owns a coat and tie?[40]

Ryan took umbrage at Iverson's refusal to be bound by the restrictions of white propriety and respectability politics, but that was exactly what made Iverson a hero to so many. He was anything but buttoned up and corporate, and his unflinching swagger, in great part expressed through the way he dressed, was refreshing to his many ardent fans. He was a figure who connected the dots between basketball, hip-hop, and fashion for a larger audience.

By the end of the 1990s, however, the athletic function of sneakers and the famous athletes who were associated with them began to matter less than their use as items of fashion and the statements that could be made by wearing them. Terry Lefton, writing in *Brandweek* in 1998, noted:

> It seems the times are a changin', especially for the urban teens who set the sneaker agenda for the whole country. Basketball shoes have become a kind of body art, or foot armor, for kids 12–17 who, while not old enough to drive, have transposed the same kind of brand equity and in-ness to sneaker brands as their parents and older siblings have for Mercedes-Benz and BMW. Teens today, say marketers and the legion of consultants specializing in the youth market, are looking more for footwear and apparel that expresses their individuality rather than the fact that they are fans of Shaquille O'Neal or Scotty Pippen.[41]

Sneakers were also being challenged by other forms of footwear, such as Timberland boots. These had become extremely popular,

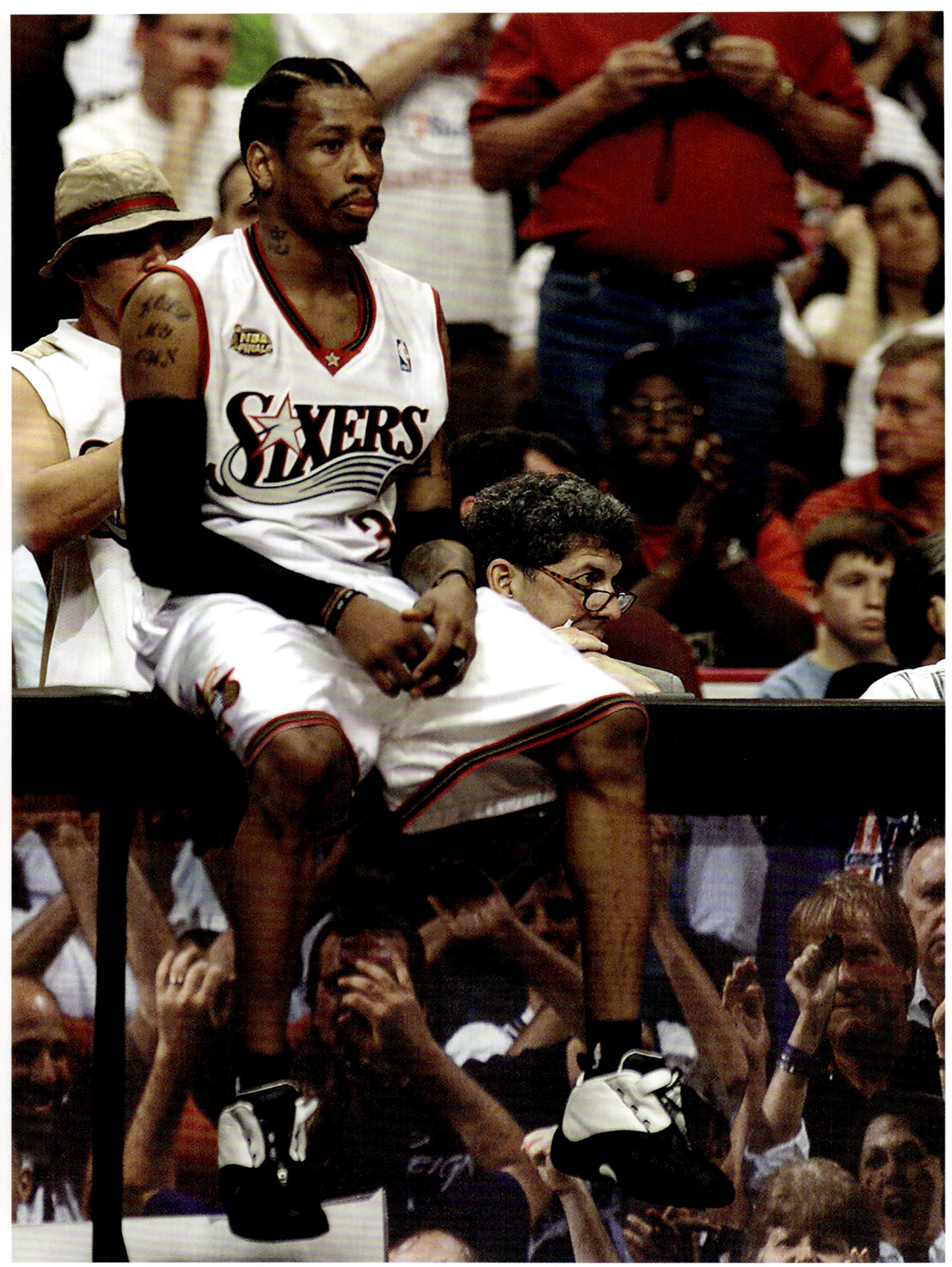

partly due to their connection to authenticity cemented by the fact that the company was a heritage brand that predominately made durable work boots.[42] In the scramble to keep up, sneaker companies tried new strategies. In 1999 Nike, noting that sneakers were increasingly being worn to express individuality, introduced NIKEiD, which a company press release described:

> [It] allows consumers to personalize their footwear to match their own individual style. Initially available only in limited numbers, NIKEiD will for the first time put consumers in the designer's seat. . . . "The future of NIKEiD has amazing possibilities," said Mary Kate Buckley, vice president of nike.com. "The Internet provides a forum for Nike to communicate with its customers like never before. We are able to have a dialog with consumers through which we can develop innovative products and unique online experiences."[43]

NIKEiD was an innovative customization tool that gave customers the ability to select components of certain Nike sneakers, but the project misunderstood what people actually wanted. In the main, consumers did not actually want hyper-personalized self-customization, they wanted access to sneakers that functioned within the broader fashion market and expanded the wearer's style vocabulary. In other words, consumers wanted to make nuanced statements about themselves through clever consumption and juxtaposition of brands and histories that would be understood by others.

By the late 1990s, many sneaker consumers were fully literate in the basics of sneaker culture and its subtexts. Although the majority of consumers still wanted to make simple statements, or just repeat statements they had picked up from mass culture, many others were genuinely interested in changing the conversation by rifling through the past and mixing "high" and "low," be it culture or price point. At the end of the decade, hip-hop, rap, skateboarding, and streetwear were all deftly playing with established and emerging signifiers to make new "wholes," and sneakers were increasingly being used as a conduit for compelling new narratives.[44]

Y-3

In the early years of the 2000s, the demarcation between athletic wear, streetwear, and high fashion began to blur. The signature shoe of the 1990s, which had connected sneakers to superstar athletes, gave way to collaborations that linked sneakers to streetwear brands, high-fashion designers, and couture houses. The first major high-fashion collaboration happened in 2000, when Chanel reimagined Reebok's Instapump Fury in pale gray for its Spring/Summer 2001 ›

Philadelphia Sixer Allen Iverson during a late-game timeout in game three of the NBA finals against the Los Angeles Lakers, 2001. Photo by Gina Ferazzi/ *Los Angeles Times* via Getty Images

ready-to-wear show (see page 60).[45] Yohji Yamamoto asked Adidas to supply sneakers for his Fall/Winter 2001 ready-to-wear runway show, leading *Vogue* to proclaim that it would be "the colorful sneakers with red soles, silver racing stripes, and floral designs that will have customers lining up next fall." Pleased with the results, Yamamoto began to collaborate with Adidas, and the relationship was cemented with the creation of Y-3, a partnership that continues to this day.

Jeremy Scott and Stella McCartney also began collaborations with Adidas in the early 2000s. Perhaps most important to the history of collaborations was the creation of Adidas Originals, a division of the company dedicated to a more fashion-focused approach to sportswear, established in 2002. This initiative opened the door for Adidas to work with a wide range of designers, including Rick Owens, Raf Simons, Pharrell Williams, and Kanye West, to create style-conscious sneakers rather than athletic footwear.

Although the first fashion collaborations were in womenswear, their potential would be more fully exploited in the male market, where they would not only expand the range of sneakers available but would also help shift many men's attitudes toward high fashion, or "luxury," as it euphemistically came to be called. For centuries, the world of fashion had been associated with artifice, fakery, and femininity, but high-fashion collaborations with male-aligned streetwear brands and sneaker companies invested these new products with an authenticity that was reassuring to male consumers and reinvigorating to many designers. When asked why he had originally reached out to Adidas, Yohji Yamamoto responded, "Around fifteen years ago, I felt that I had come too far from the street. I was almost losing my enthusiasm for making clothing."[46] As high fashion increasingly turned toward streetwear, this sentiment would be repeated by others in the industry.

Central to sneaker collaborations with fashion designers and streetwear brands were ideas of rarity, exclusivity, and, most importantly, narrative. As Erik Fagerlind, co-founder of Sneakersnstuff, said about sneaker collaborations in a *Highsnobiety* interview, "You have to understand that product is not always enough. You have to have a story attached to it. Whether it's the big story or a small story, you have to tell something."[47] These narratives not only fueled consumer desire for sneakers, they allowed sneaker collecting to fit more neatly into traditional modes of male collecting. By framing their appreciation as being grounded in connoisseurship, sneakers were transformed into canny investment rather than frivolous expenditure. Sneakers as collectables was further stoked by the flourishing of the resale market, where prices for rare sneakers skyrocketed. In these ways, extremely limited-release high-fashion sneaker collaborations came to signal erudition and status, as well as allowing wearers to make complex statements of individual and group identity.

Adidas sneaker for Yohji Yamamoto, 2001. adidas AG/studio waldeck photographers

As the importance of storytelling grew, collaborations provided opportunities to stitch together widely disparate narratives, and soon the range of creative individuals involved in these partnerships began to explode. Designers, artists, musicians, and exclusive retailers all got into the game, extending their cultural reach and gaining new customers. In an interesting twist, Nike leveraged both the authority of streetwear brands and the power of narrative in order to launch its skateboarding division, Nike SB, successfully in 2002. The company had attempted to get into the skateboarding market before, but it was not until the visionary Sandy Bodecker, the first general manager of Nike SB, reached out to Supreme that Nike truly became popular with skaters. The Nike SB x Supreme Dunk not only was a highly sought-after sneaker, but set off a cascade of Nike SB collabs. One of the most important was the limited-release Staple Dunk Low Pro SB Pigeon designed by Jeff Staple (see page 87), whose 2005 release famously led to a riot.

With each successive collaboration, sneakers have become more fully entrenched in fashion, be it streetwear or luxury. The biggest influencers continue to come from outside the sports world and include musicians, such as Kanye West and Pharrell Williams, and luxury streetwear designers, such as Virgil Abloh and the collective Vetements, to name but a few. Even when influencers are athletes, such as LeBron James, James Harden, and P. J. Tucker, they are increasingly hailed not only as athletes but also as style icons. All of this cross-fertilization has transformed once fashion-phobic sneaker brands into fashion empires in their own right. In 2018 *GQ* magazine declared Nike the largest fashion brand in the world:

> And while Nike is new to the world of fashion, it's increasingly operating—and spending—like a fashion company. The company recently projected it would hit $50 billion in sales by 2022. That's an intergalactic number: according to *Forbes*, Google's parent company Alphabet did $89.92 billion in sales in 2017, Walt Disney's were $54.94 billion. In the world of apparel, Zara's sales in 2017 were $29 billion. Perhaps a better comparison: Christian Dior, the current largest fashion brand in the world from a sales perspective, did $49 billion in sales last year.[48]

Just as sneaker companies are expanding the potential of fashion, the way in which fashion is being used is also changing. Concerns about environmental sustainability, gender inclusivity, racism, and animal welfare have found their way into collaborations. For example, not only are Parley for the Oceans x Adidas sneakers manufactured using recycled ocean plastics, but Adidas has made a commitment to stop using virgin plastic by 2024 (see page 166). One of the most interesting developments is that an increasing number of visual artists are turning to sneaker collaborations as a means of breaking down ›

the boundaries between art, social commentary, and commerce. Artists doing collabs now range from Futura, Haze, and Brian Donnelly, who all started as graffiti artists, to Tom Sachs, Damien Hirst, and Kehinde Wiley, who came to prominence as blue-chip artists. Daniel Arsham, for example, has explored his interest in the concept of time through his work with Adidas by allowing the stories embedded in each of the collaboration's three sneakers—Past, Present, and Future—to unfold across their release dates. Thanks to such work, the potential for storytelling through sneakers continues to grow.

The Future

Sneaker collaborations represent only a small fraction of sneakers that are produced, yet their cultural impact continues to grow in importance. Today, sneakers and sneaker collaborations speak to a wide range of interests, from social justice, representation, and inclusivity, to celebrity, identity, and status. Yet, is there something about the idea of collaboration itself—the idea of working together and being acknowledged for that work—that also speaks to consumers? Collabs are designed to sell, so can we glean insights into where we are headed by examining consumer demand and reception?

Fashion is often prescient, signaling emerging cultural shifts. Perhaps this increasing desire for collab sneakers hints at developing societal movements toward collectivism and new forms of both brand and in-dividual identity that rely on a multitude of narratives. Will consumers eventually demand representation and recognition of all the individ-uals involved in production? Most significantly, does the increased importance of storytelling through sneakers express a new willingness to hear a wider range of voices and see things in new ways? Certainly, the collaborations featured in this book provide concrete examples of the cultural importance of crossing boundaries, making connections, and representing diverse voices and viewpoints. ✱

Tom Sachs x Nike Mars Yard Overshoe, 2019. Collection Tom Sachs

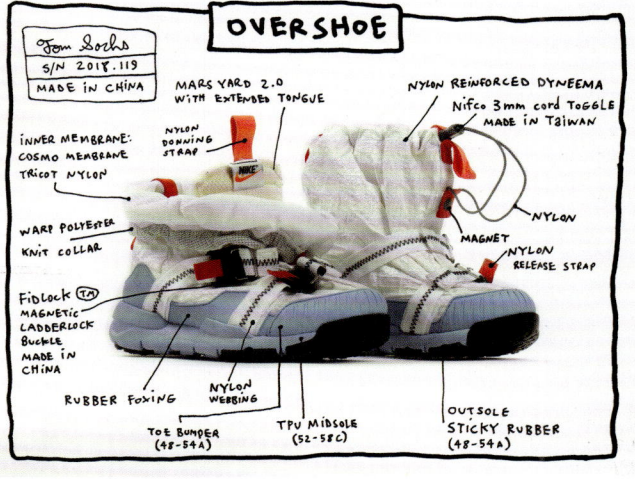

COLLABORATION IN DETAIL: CHRIS HILL BREAKS IT DOWN

The complexities of bringing collaborations to fruition are often hidden from view, glossed over by the success of the finished products. However, collaborations are complicated ventures and require the work of many people coming together, from the outside collaborators to the in-house teams, including project managers, in-house designers, developers, factory workers, and marketing experts. In order to understand the design process better, I spoke with Chris Hill, Reebok's design manager for statement footwear, on the phone and by email in November 2018.

One of Hill's principal responsibilities is to help collaborators transform their visions into tangible and wearable footwear. For him collaborations are a means of pushing the envelope of design, but he also guides each collab process so that it results in the best possible product.

Elizabeth Semmelhack: What kind of person makes a good collab partner? Do they need to be familiar with Reebok's history and its most famous models?

Chris Hill: It's definitely a benefit to the project and process if the partner has an affinity for the brand. It comes off as much more organic, authentic, and meaningful if there is previous history there. At the end of the day, if the two partners are coming from an authentic point-of-view, it gives them a base to build on for a great collab. They can be from completely foreign worlds, but if they're mashed together organically, they can create great products. Obviously, the storytelling and product need to be good as well. ›

E.S.: What are the very first steps?

C.H.: The first step is usually a meet and greet, where the partner will share their ideas and vision or mood boards. We use this first meeting to brainstorm and pitch ideas back and forth. It is an opportunity to understand what is in their head. It's up to me and my team to interpret that and transform it into a great wearable product that represents both sides authentically while not compromising either partner's ethos. Typically, as a brand, we have a handful of key models for that season that we're trying to promote, so the partner will have one or a few of those chosen before we get together. I always do a lot of research and thinking before we meet so I'm well versed in what the partner is all about and have an understanding for their style and what their consumers want to buy. I normally will have ideas already sketched or mocked up to kickstart the conversation. Based on those initial discussions, I will leave with more direction to continue sketching and refining ideas. I might draw ten to thirty versions, very loosely, then refine six to ten of those, and then present three to six to the partner.

E.S.: Can you tell me more about sketching? Do you hand-sketch ideas and then have them computer rendered?

C.H.: I almost always start with pencil sketches. I keep them quick and loose, so I can get out as many ideas as possible. During the process of editing those ideas, I will scan six to ten into the computer and redraw them in SketchBook Pro, using the rough sketch as an underlay. It's still a hand sketch, but in a computer program, so it speeds up and cleans things up easily. Hand-drawn sketches always seem to have so much character and emotion in them.

E.S.: What happens after you finish these drawings and show the ones that you think will align with the vision of the collaborator?

C.H.: Usually there is a bit of back and forth. People don't realize that one of the most important skills required to make collaborations successful is the ability to be a good communicator. That's when the true meaning of collaboration comes into play. We will make edits on the spot, draw over the sketches, and mix and match details inspired by different perspectives, all of which can take a collab in new, unexpected directions.

E.S.: I imagine that one of the challenges in this process is helping the person see how a 2-D idea will be translated into a 3-D sneaker.

C.H.: We won't typically cross that bridge until we get the pullovers back from the factory. Translating 2-D images into a 3-D object often requires interpretation and adjustments by the designer. From the partner's perspective, it's probably like magic. They ask for a shoe and then they get to hold it in their hand a month later.

> "PEOPLE DON'T REALIZE THAT ONE OF THE MOST IMPORTANT SKILLS REQUIRED TO MAKE COLLABORATIONS SUCCESSFUL IS THE ABILITY TO BE A GOOD COMMUNICATOR."

E.S.: Tell me what happens after the design or designs are winnowed down to the chosen few. What's the next step?

C.H.: The next step is to create the tech pack designer's blueprint with manufacturing specifications in Illustrator. For the tech pack, we will create cross-sections for molded parts, orthographic views, and a general idea of materials and some loose measurements here and there. This is basically a guide that gives clear instructions to the factory on how we want the shoe to be built.

E.S.: What happens after the tech pack is created?

C.H.: Once the tech pack is complete, I sit with a developer. We will then discuss solutions together and get the tech pack much tighter. Development's expertise is in building shoes that actually function at a doable cost, so they play a big part in the process. From there the tech pack is sent to the factory. A pattern engineer will translate the 2-D sketches into patterns that he or she wraps around a last, which is a 3-D form that the shoes are built on, in order to create a pullover, which is basically a prototype. The factory then sends the pullover to me.

E.S.: Once you have the first pullover, what happens?

C.H.: The pullover is then looked over by myself and sometimes the collaborator to make any adjustments needed. The pullover is never exactly the way you envisioned it for a couple of reasons. You're having a 2-D drawing translated to 3-D by a completely different person who doesn't know what's in your head. There can also be misinterpretations on my end as to where a line will land once it is on a 3-D form. And sometimes you or the collaborator just change your mind about the design of the shoe completely. The first pullover is really just a rough 3-D version of your sketch and gives you a baseline to build from. Pullovers are made from the materials the factory has on hand; these materials will vary greatly from the ones that will be used once the shoe is put into production.

E.S.: What do you do once you have drawn all of your changes?

C.H.: When the factory sends a pullover, they also send along a flat digital shell pattern. A shell pattern is all the pattern pieces of a shoe connected but laid out flat, so you can draw corrections directly over the top of it. To start, I will do a tape up. A tape up is literally applying wide masking tape over the prototype and drawing the corrected lines on the tape, so that I can visualize them better than I could with a 2-D drawing. The pullover is acting as a 3-D reference for the 2-D shell pattern. Once all changes have been made, I draw the revisions on top of the original shell pattern in Illustrator and send it back to the factory to have a new pullover made. We will do this process three to five times before we start making samples. Samples are the next stage once patterns are confirmed. It is at the sample stage that we get to see the shoe in the colors and materials we spec'd. ▸

37

E.S.: This seems like a lot of back and forth. Is the collaborator involved in each of these steps? Does it all have to be done in person?

C.H.: It is a lot of back and forth! It depends on the level of knowledge the collaborator has about the process and whether they want to be involved. The collaborator's role isn't to project-manage the process. We are experts at that, so we don't expect them to be in the weeds. With someone like Kerby [Jean-Raymond], who is himself a designer and who really loves to be involved, every round of pullovers is reviewed in person. Later, when we are in the second or third round of samples, we may just do it over Skype because the changes are minor at that point. One major difference between working with an outside partner versus doing an inline, or in-house, project is that the partner can change direction at the drop of a hat. You and the partner can also have a difference of creative opinion and work may have to be redone. It's not always a linear process. The project itself is a collaboration not only between partner and brand, but also between product marketing, designer, developer, factory, and so on. Making footwear is rarely a solitary task, but instead is a communal activity. It takes a lot of skill and knowledge to communicate to all the different functions in product building so that in the end the vision is understood by all involved. We do a lot of communicating with the factory to explain what it is we're trying to accomplish. This is always challenging when you're trying to do something new that pushes the envelope of design.

E.S.: This can't be done overnight. How long does it take between stages?

C.H.: Collaborations typically exist on an expedited calendar. A lot of times we're creating the most complex product in the shortest amount of time. It usually takes a factory two to three weeks to deliver a pullover, with revisions done in a few days. When you multiply that process by three or four rounds, you begin to understand the timeline for these projects a bit better. By the time the project has reached the sampling stage, we have begun using the real materials in the real colors chosen for the collab, and this also adds a bit of time as the suppliers now have to meet our specific requests. You'll have two or three sample rounds, and then the sneakers go into testing. Testing is done to determine how the shoe fits and if the materials chosen will work well on a commercialized shoe. Once testing is passed you go into production. Production typically takes three months or so.

E.S.: A lot of people who have been involved in collabs talk about hitting that sweet spot where both parties are feeling the magic. Is that how it is for you?

C.H.: Both sides definitely need to be excited about the project. I think the consumer can tell when an asset or partner isn't feeling the product when it's released. Probably the most uncomfortable part of a collaboration is telling the partner their ideas or executions won't work, but then we always find ways to figure out solutions together. ›

Pyer Moss x Reebok, DMX Daytona Experiment 2.

39

At the end of the day it's not me getting credit for designing the shoe—it's the partner and the brand. It's my goal to make sure the product is the best it can be from the partner's perspective, the brand's perspective, and my perspective as well, meaning that it's something the consumer is going to want to buy. That's not always easy.

E.S.: Once the sample comes in, the project is very far along. What kinds of changes are generally made at the sample stage?

C.H.: Usually not many changes can be made at this stage. We should be looking only at colors, materials, and fine details at this point. But that doesn't mean we don't sometimes have to make radical changes. The first season with Pyer Moss there were some intense creative moments that included creating new designs and some very late nights for everyone working on the project, but it was rewarding. I was blown away by the excitement Kerby had for the new designs. In the end, Kerby was so pleased he wrote about his appreciation and the journey of this project in the sock liner for the final design. That was a really cool moment for me.

E.S.: That sock liner is an example of storytelling details incorporated into sneaker design, especially collabs. Can you tell me more about those details?

C.H.: For me, the storytelling is almost as important as the function of the shoe. I am always thinking about these details, or Easter eggs, early on in the design process. If you add them too late it can come off as an afterthought. I am big into integrating the story, design, color, materials, graphics, packaging, and fine details from the start. The product always feels cohesive and intentional when you design that way.

E.S.: How are narratives incorporated into the design of the sneaker? Messages can be sprinkled all over the surface of a shoe, inside and out.

C.H.: I enjoy both hiding Easter eggs for people to discover and also making the structural elements in the shoe part of the storytelling. Hiding messages, like stamping the initials of Kerby's beloved parents on the inside of the pull tab or having the words "Fuck You" written in Braille-like Morse code on the medial side of the shoe as a subtle way of responding to people who didn't believe in him, is a clever way of layering stories onto the shoe. I pride myself on being clever and always having a reason for doing something. Even the shapes of the patterns on the shoe serve a purpose and have a reason for being. Same with materials and colors. Everything is intentional and serves a purpose and contributes to the story we're trying to tell.

E.S.: Have you ever been surprised by the public's reaction, or lack of reaction, to a collab?

C.H.: Any time you create something, people are going to react and have an opinion, whether they're qualified to or not. That's life

> "FOR ME, THE STORYTELLING IS ALMOST AS IMPORTANT AS THE FUNCTION OF THE SHOE."

and you can't let it affect you in a negative way. Everything I've designed in the last few years of my career has been either loved or hated. For me, that's always been the goal. I think the worst thing is when a product releases and no one talks about it, good or bad. I've never created anything that was hated without someone also loving it. It's impossible to please everyone. But to answer your question, I've had big releases with marketing support that didn't fly off the shelves in minutes like I would have hoped. And I've also had risky inline releases I snuck through with zero marketing support that sold out on their own strength. So, you really never know how a shoe will do, but collabs are typically more of a sure thing. ✱

JOSEF WAITZER X GEBRÜDER DASSLER SPORTSCHUH- FABRIK MODELL WAITZER

COLLECTION OF ADIDAS AG

One of the earliest collaborations in the history of athletic footwear was between German track star and coach Josef Waitzer and the Gebrüder Dassler Sportschuhfabrik (Dassler Brothers Sports Shoe Factory), which was started by the Dassler brothers, Adolf "Adi" and Rudolf "Rudi" Dassler, in 1923. From the very beginning, Adi Dassler was focused on creating sports-specific footwear to meet the needs of athletes in different sports. To this end Adi turned to Josef Waitzer, an Olympic track star turned coach of the German national track and field team, to help him refine his designs with the goal of improving performance. Waitzer agreed and their collaboration lasted years, with Waitzer continually offering Adi's designs to runners and reporting back on how the shoes performed.

The first Modell Waitzer was a running shoe created for the 1928 Olympics. It was made of fine, lightweight leather with six spikes under the ball of the foot and three under the heel (now missing), and was worn by German runner Karoline "Lina" Radke. While wearing the shoes she not only won gold, but broke the world record for the 800-meter race, giving the Dassler brothers confidence that they were on the right track. *

1928

JACK PURCELL X B. F. GOODRICH, JACK PURCELL

COLLECTION OF CONVERSE ARCHIVE

In 1933 B. F. Goodrich released the Jack Purcell sneaker, named after the famous Canadian badminton player. The company began working with Purcell in the early 1930s. Not only did he help design his namesake sneaker, but B. F. Goodrich also promoted his participation by advertising that the shoe had been made to his specifications. These included smooth toe-box construction to minimize chafing and blistering; a white non-marking crepe sole; a flexible, snug-fitting shank; and a special toe guard for extra wear decorated with what would later be called the blue "smile" line. Although Purcell was acknowledged for contributing to the sneaker's design, exactly when his name first appeared on the sneaker remains to be determined. This Purcell from 1939 features his signature on the sole, but his signature on the sneaker's "license plate" on the back of the heel would not appear until the 1950s.[1]

When the sneaker was first released, it was marketed to both men and women. However, by the 1950s, the Purcell was increasingly advertised as a lifestyle shoe. James Dean famously wore them, increasing their cachet, and by the 1960s, Purcells were being promoted to men of style and means through advertisements that featured handsome Purcell-clad men getting into sports cars, studying at university, and enjoying the country-club lifestyle. Converse acquired the right to produce Jack Purcell sneakers in 1972. ∗

1933

CHUCK TAYLOR X CONVERSE, CHUCK TAYLOR ALL STAR

COLLECTION OF CONVERSE ARCHIVE

In 1922 Chuck Taylor started working for Converse promoting its All Star sneaker, which had launched only a few years earlier, in 1917. Taylor played basketball in high school and then semi-professionally for the Akron Firestone Non-Skids before turning to coaching and conducting basketball clinics across the United States on behalf of Converse. Taylor was charming and skilled. As one journalist put it in 1935, "Chuck revealed a magical touch that bespoke years of experience with the blue bloods of the game. He showed the strong how to be fundamentally clever and deceptive and actually made it look easy. He demonstrated his legion of tricks as rapidly and expertly as a stenographer rattles off letters."[2] Taylor's popularity became so widespread that people began calling the sneakers he recommended "Chuck Taylors" when placing their orders with the company.[3]

It was in 1934, at the height of the Great Depression, that Converse first added Taylor's name to the license plate on the heel of the shoe. The economic stress of the period called for new ways of engaging customers with products, and celebrity endorsements became an important promotional tool. Taylor stayed with the company until his retirement in 1969. Unlike many collaborators today, Taylor did not receive additional compensation from the company for the use of his name; nevertheless, his name lives on as one of the most recognized in all of sneaker history. This example from 1936 is one of the earliest Chuck Taylor All Stars held in the Converse Archive collection. *

1934

WALT DISNEY X CONVERSE, SKOOTS DART

COLLECTION OF CONVERSE ARCHIVE

In 1934 the same year that Chuck Taylor's name was added to the Converse All Star, the company also did its first brand collaboration when it secured a licensing agreement with Walt Disney. By the mid-1930s, the cartoon character Mickey Mouse was a superstar, and his image began to appear on a range of products, including 11,000 Mickey Mouse watches that were sold out at Macy's department store the day they dropped. Poor-quality knockoffs proliferated, and in an effort to control unauthorized uses of the character, Disney began to officially license the image of Mickey Mouse to a select number of companies, including Converse.

For the sneaker collaboration, Converse adapted some of its pre-existing Skoots models, the company's line of "Canvas Shoes for Every Sport." The high-top Skoots Dart was marketed for boys and featured the word Mickey Mouse on the bumper strip and ankle patch, as well as a picture of Mickey in color on the side. The low-top Patter for girls was "a smart Oxford with Mickey and Minnie on the sports flaps."[4] In addition to featuring Mickey and Minnie Mouse on the shoes, the pairs also came in specially designed boxes that featured Disney characters. The Dart box depicted Mickey Mouse and Minnie playing tennis on the lid, with Mickey engaged in a range of amusements on the sides, including playing croquet and baseball, and shooting an apple off Pluto's tail end with a bow and arrow. Ironically, neither Mickey nor Minnie was depicted wearing sneakers.

The Mickey Mouse sneaker did not spark the same furor as the watch, but Converse's advertising promoted it as having "tremendous 'repeat sale' value and both have proven to be the most prolific 'new-customer' producers developed in the Converse Rubber Company's twenty-five years of Business."[5] The economic stress of the 1930s required innovative marketing, and Converse was in the vanguard. ✱

1934

PETER MAX X RANDY'S, GRINNERS

COLLECTION OF THE MICHAEL STERN POP CULTURE COLLECTION

By 1969 at the age of 32, Peter Max was arguably the most popular artist in the world. He had inspired the cover of the Beatles' album *Yellow Submarine*, gone hunting for kitschy cookie jars with Andy Warhol, appeared on the cover of *Life* magazine, and had over fifty commercial licensing agreements.[6]

Max's psychedelic artwork was countercultural in style yet uplifting and extremely marketable. One commercial venture was his collaboration with Randy's to create a series of sneakers for men, women, and children adorned with Max's exuberant work. The most ambitious of the series was called the "Grinner." It featured wide-open cartoon eyes printed on the upper and a large toothy grin on the foxing, which was formed by a second layer of red foxing tape suggesting red "lips" cut away to reveal painted "teeth."

As people clamored for ever more Peter Max products, a friend from Max's art school days reached out to warn him that if he wasn't more discerning, all he would be remembered for would be these commodities rather than his artwork. Max was shaken to the core and quickly withdrew from business to focus solely on his painting for nearly two decades.[7] The strict cultural hierarchies that divided art from commerce in the minds of many at that time led Max to cease licensing his work, but his many collaborations, such as the Randy's sneakers, set a precedent for the artist and sneaker collabs that would follow. ✱

c. 1969–1971

TONY ALVA X STACY PERALTA X VANS, ERA

COLLECTION OF VANS

The Van Doren Rubber Company, or Vans, was founded by brothers Paul and Jim Van Doren along with two business partners, Gordon Lee and Serge D'Elia. The company's first store opened its doors in 1966 in Anaheim, California. Priced to sell, the sneakers attracted a wide range of customers, and by the early 1970s skateboarders had become devoted patrons. The first shoe that Vans produced was the #44 Deck Shoe. It was a straightforward model but had been designed with an eye toward durability and comfort, with an extra-thick sole made of solid vulcanized rubber. Robust enough to withstand the abuse of skateboarding, the shoe's sole gripped the board, yet also allowed skaters to feel the skateboard deck.

In 1976 on the advice of skateboarding legends Tony Alva and Stacy Peralta, who had both been wearing Vans for years, Vans decided to alter the #44 to make it even more skater-specific. Changes included padding around the collar as well as on the tongue to offer greater protection. Alva and Peralta also suggested that the footbed be made slightly softer to give skaters even more control, and that the sneaker be made more colorful, with a two-tone red and blue colorway. Vans originally named the new collaboration #95, but this was eventually changed to Era, while the classic #44 came to be known as the Authentic. Both models remain in production today. ✶

VAN'S NEW SKATEBOARD SHOE

Made in U.S.A.

AVAILABLE *NOW* AT ANY VAN SHOE STORE *OR* BY MAIL!

"OFF THE WALL" T.M.

I wear nothing but VANS, they're dependable for critical situations.
— Stacy Peralta

- The long wearing, pure crepe, super grip Van's exclusive
- Padded collar for comfort
- Super duck canvas
- Cushioned insole and arch support
- Reinforced heel

Van Doren Rubber Co.
704 E. Broadway
Anaheim, California 92805 or call (714) 772-8270

Please send me _____ pairs of VAN (*Off-the-Wall*) Skateboard Shoes.
SIZE: _____ (2½ through 13)
WIDTH: ☐ Narrow ☐ Medium ☐ Wide
COLOR(S): ☐ Light Blue ☐ Navy Blue ☐ Royal Blue ☐ Brown ☐ Beige ☐ White ☐ Black ☐ Red and Gold
PRICE: STOCK (Combination of navy blue and red) is $13.00 a pair.
OTHER (Any three color combinations) are $14.00 a pair.

I have enclosed a check or money order for $_____
Send shoes to:
Name_____
Street_____
City_____ State_____ Zip_____

To order in Hawaii, call this number for FREE DELIVERY (808) 395-8344
Also add $2.50 for postage and handling. Allow 3-4 weeks for delivery of custom made shoes. Stock shoes are processed within 2-3 weeks of order.
California residents add 6% sales tax.

1976

JOHN WOODEN x BATA x WILSON, JOHN WOODEN

COLLECTION OF BATA SHOE MUSEUM, GIFT OF BOBBITO GARCIA

In the mid-1970s, the brands Bata and Wilson collaborated on a range of sneakers, including a pair of basketball shoes endorsed by John Wooden, one of America's most successful college basketball coaches of all time. Wooden was first inducted into the Basketball Hall of Fame as a player in 1960; he was also inducted as a coach, becoming the first person to have achieved both honors.[8] Part of the secret to his success, which included ten NCAA men's basketball championships, was the attention he gave to seemingly insignificant details, such as players' feet.

Kareem Abdul-Jabbar remembers that Wooden encouraged players to pay special attention to how they put on their socks and tied their shoes in order to prevent injury. It was a simple lesson, but he used it to teach the players humility and to help them remember that success relies on being aware of small details.[9]

With such focus on details, it is not surprising that Wooden would come to endorse a pair of revolutionary basketball shoes featuring injection-molded polyurethane soles that made them 40 percent lighter than other basketball shoes on the market at that time. Although the sneaker was not endorsed by Wooden and was worn by a number of players, including Magic Johnson, the shoe was discontinued by 1979, making it a rare collector's item today. *

1977

KATE KNUDSEN X REEBOK, FREESTYLE COWS

COLLECTION OF REEBOK ARCHIVE, REEBOK INTERNATIONAL, LLC.

In the mid-1980s, Los Angeles–based artist Kate Knudsen began attracting attention among celebrities for her witty embellishment of clothing and sneakers. In 1987 Reebok commissioned Knudsen to produce a series of customized sneakers for celebrities, including Whoopi Goldberg, Elton John, and Ronald and Nancy Reagan. Each received a pair of hand-painted Reeboks decorated with trinkets such as small plastic toys that reflected the wearer's individual interests.

The success of these commissions led Reebok to offer Knudsen a collab on a commercialized sneaker. The resulting Painted Hi collection for women came out in 1989 and featured the Reebok Freestyle shoe decorated with one of three themes: bowling, which featured tiny bowling pins; dogs, which featured toy bones; and cows, which featured paintings of cacti printed on the counters, a cow-hide-patterned upper, and small plastic cow figurines attached to the vamps.[10]

Knudsen was not alone in making art that was situated between the edgy postmodern and punk/new wave aesthetics of the period and the traditional female-coded practices of crafting. The commercialization of the hot-glue gun and the increased availability of flexible fabric paints, combined with a larger cultural ideal of individualism, saw many women seeking to customize elements of their wardrobes. Reebok capitalized on this moment, promoting Knudsen's new line by holding sneaker-painting contests around the country. These contests were led by the Boston-based artist David Chick, who noted prophetically that members of the MTV generation wanted their sneakers to be unique and special.[11] *

1989

ALLEN IVERSON X REEBOK, ANSWER IV

COLLECTION OF REEBOK ARCHIVE, REEBOK INTERNATIONAL, LLC.

In 1996 Reebok took a chance and signed the phenomenally talented but controversial and defiant rookie NBA player Allen Iverson to a ten-year sneaker deal. Iverson launched his professional career as a Philadelphia 76er wearing his signature shoe, the Question, a sartorial reply to his nickname, "The Answer."

Subsequent Iverson sneakers were called Answers. For many, the Answer IV is one of the highlights of the series. Worn by Iverson in the 2000–2001 season, it was also the most personal design up to that date. Iverson closely collaborated on its sleek styling, which included a shrouded upper with a zippered closure and a portrait of himself on the sole.

Iverson wore the black-and-white Answer IV on May 9, 2001, during the Eastern Conference finals, when he scored an incredible fifty-four points. He wore the sneakers again to the NBA finals on June 6, 2001, when he scored forty-eight points for the 76ers in game one, helping them defeat the Los Angeles Lakers. The Answer IVs were also on his feet when he was named the All-Star Game MVP and the league's MVP in 2001. *

2000

CHANEL X REEBOK, INSTAPUMP FURY

COLLECTION OF REEBOK ARCHIVE, REEBOK INTERNATIONAL, LLC.

The Chanel x Reebok Instapump Fury was one of the first, if not *the* first, high-fashion sneaker collaborations. It was also the first collaboration based on the Instapump Fury, a sneaker that has since been central to numerous fashion collaborations at Reebok. Exactly how the collaboration came to be remains a mystery, but Stephanie Schaff, Reebok's senior archive specialist for footwear, has established that the sneakers were created in 2001 for Chanel's Spring/Summer collection. The elegant dove-gray and soft white colorway of the Chanel version marked a dramatic departure from the original bright yellow and red hues of the Instapump. The prominent placement of the word "Chanel" on the tongue and the use of the brand's iconic interlacing Cs on the heel tab likewise declared that it had taken the Instapump in a different direction.

The Instapump Fury was originally designed by Steven Smith as part of a series of innovative Reebok sneakers that used inflation technology in the early 1990s. The concept was to create the lightest running shoe possible by lessening its weight through a radical reduction in materials used to make the sole and upper and the use of an inflation device situated at the instep, which enabled the shoe to be secured to the foot without laces.

According to Smith, the epiphany came when he and Paul Litchfield realized that they were hiding the pump, one of the coolest parts of these innovative sneakers, inside the uppers. Smith decided to pull out the air bladder and wrap it on a shoe last. This mock-up made it immediately clear to the pair that all they really needed to add to the design was a sole. Smith became motivated to "put the absolute minimum number of components back into the design to make it wearable. Basically, we were making the equivalent of a concept car for the sneaker business. We were able to reduce the number of components from roughly 150 parts typically needed to make a traditional pair of sneakers to just twenty-five."[12] The design was first tested at the 1992 Summer Olympic Games and commercialized in 1993. Despite the Instapump Fury's success as a performance shoe, it was its radical architecture that garnered the most attention. More than a quarter century later, it remains one of the most innovative sneaker designs and a perennial favorite for collaborations. *

2001

YOHJI YAMAMOTO X ADIDAS, YY PRO MODEL 2G

COLLECTION OF ADIDAS AG

Japanese fashion designer Yohji Yamamoto first approached Adidas in 2001, seeking to create footwear for his own fashion line as a way of reenergizing his vision. Yamamoto was an indisputable fashion legend, and his brand was firmly established, but he had grown tired of high fashion.[13] He began to question who was wearing his clothing and feared that he was making designs that would only live in museums. In particular, he felt that he had moved too far from street culture.

Athleisure made sense for Yamamoto, who often designed with the comfort of the wearer in mind. His runway models typically did not wear heels, so turning his attention to sneakers seemed natural. When Adidas sent a selection of shoes for Yamamoto to consider, the ones he gravitated toward all happened to have been created by the promising young designer Nic Galway, who later would become the brand's design director.

After the success of his runway show, Yamamoto began an official collaboration with Adidas under the new label Y-3. The Y stood for Yohji Yamamoto, the hyphen for the connection between the brands, and the 3 for Adidas's trademark three stripes. This joint venture made Yamamoto the first couturier to collaborate with a sportswear company, and the partnership sent shock waves through the fashion world.

Yamamoto's YY Pro Model 2G high-tops date to the inaugural year of Y-3. Since that first collection, in his quest to make elegant yet futuristic footwear, Yamamoto, a self-proclaimed lover of extremes, has produced some of the industry's most daring sneaker silhouettes. ∗

2002

HTM x NIKE, AIR FORCE 1

COLLECTION OF NIKE DNA

HTM was established in 2002 by Hiroshi Fujiwara, the founder of Fragment design; Tinker Hatfield, vice president of creative concepts at Nike; and Mark Parker, president and CEO of Nike, as a collaborative incubator where the three could innovate and play with new designs and concepts, unencumbered by expectations that their work would be put into mass production. The three enjoyed a natural collegiality, easily exchanging ideas when they met and occasionally working together on designs, so when Parker suggested that they actually make their collaboration official within Nike, all three agreed. Fujiwara created the code name HTM using each of their first initials.

Over the years, this meeting of the minds has resulted in more than thirty-two releases, including some of Nike's most cutting-edge designs. The trio's first collaboration, however, was less about innovative technologies than it was about a keen awareness of the burgeoning market for luxury sneakers. One of HTM's first releases was a retooling of the iconic Air Force 1. In contrast to the classic all-white colorway of the original, the HTM version was made in premium black leather, with the details of its construction picked out in white stitching, giving the shoe a hand-tailored look. The subtle embossing of the initials HTM on the eyestay also spoke to luxury branding. The midsole remained white, but the word "AIR" was in black, and the outsole was black as well, which added elements of graphic tension to the design. Only 1,500 pairs were made, and they were sold only in Europe, Hong Kong, and Japan. ∗

2002

JEREMY SCOTT X ADIDAS, MONEY FORUM

COLLECTION OF ADIDAS AG

American fashion designer Jeremy Scott first collaborated with Adidas in 2002 on a reinterpretation of its classic basketball sneaker, the Forum. When the model was first released in the early 1980s it gained instant notoriety for its shocking hundred-dollar price tag. Inspired by the buzz over the high cost of the original shoes, Scott decided to cover the entire Forum in a print pattern, mimicking what appeared to be one-dollar bills. Closer inspection, however, revealed that Scott's portrait stood in for George Washington's. Only one hundred pairs of Money Forums were produced. Each one was crafted by hand in Germany, making them treasures for collectors.

The Money Forum, however, was only the beginning of the collaboration. Over the years, Scott designed increasingly outrageous sneakers, including a collection with stuffed animals on the tongues and numerous models featuring wings. ✶

2002

STELLA McCARTNEY X ADIDAS, MONZA SNM

COLLECTION OF ADIDAS AG

"Each decision we make is a symbol of our commitment to defining what the future of fashion looks like. From never using leather or fur and pioneering new alternative materials to utilizing cutting-edge technologies, pushing towards circularity, protecting ancient and endangered forests, and measuring our impact with ground-breaking tools."

—Stella McCartney, mission statement

Creating ecologically sustainable and cruelty-free clothing has been a driving force in Stella McCartney's work since the beginning, and she brought this ethos to her collaboration with Adidas. She worked with Adidas for the first time in 2002 to create the Monza SNM, a pastel-hued vegan wrestling boot for her runway show.

In 2005 McCartney began collaborating with the brand officially, becoming the first high-fashion designer to sign with the company's sports-performance division to create a range of women's sneakers and apparel.[14] All of McCartney's Adidas shoes have been vegan, but none have garnered as much attention as her 2018 vegan take on the classic Stan Smith. This limited-edition sneaker featured McCartney's portrait on the tongue of the left shoe, while Smith's iconic portrait remained on the tongue of the right. Other changes included the addition of grosgrain stripes up the back seam and a black heel tab featuring McCartney's name in her brand's signature font. ✳

2002

ATMOS X NIKE, AIR MAX 1 SAFARI

COLLECTION OF NIKE DNA

Hidefumi Hommyo began his foray into streetwear by buying sneakers for resale in Japan while he was a student at Temple University in the early 1990s.[15] After returning to Japan, Hommyo first opened Chapter, a vintage clothing store, and then in 2000 he established Atmos. What began as a small sneaker store in Ura-Harajuku Tokyo quickly grew to become one of the most important streetwear brands in the world. Only two years after the store opened, Atmos teamed up with Nike on one of the most revered collabs in sneaker history, the Atmos x Nike Air Max 1 Safari.

In honor of the model's fifteenth anniversary, Koji, the head designer at Atmos, decided to reimagine the sneaker as a premier lifestyle shoe rather than a running shoe. To achieve this, he combined aspects of the Air Max 1 with the Air Safari, the first lifestyle shoe ever released by Nike. Both sneakers had been created by Nike designer Tinker Hatfield in 1987. The Air Max 1 was inspired by the postmodern architecture of the Centre Pompidou in Paris; Hatfield created a window in the midsole that revealed the encapsulated air bag of Nike Air. The Safari, on the other hand, was created by Hatfield to look more like a luxury dress shoe. Its patterned upper, inspired by an ostrich-skin couch Hatfield had seen, functioned as a nod to a man's high-end business shoe made with exotic skins.

Although the collab was undertaken in celebration of the fifteenth anniversary of the Air Max 1 specifically, Koji's clever combination of the two models from 1987 honored both, and the resulting sneaker became an instant classic. ✱

2002

JAY-Z X REEBOK, S. CARTER

**COLLECTION OF REEBOK ARCHIVE,
REEBOK INTERNATIONAL, LLC.**

In late 2002 Reebok signed rapper Jay-Z to a multiyear sneaker deal. It not only marked a turning point for Reebok but also set a new standard in the industry. Musicians had long been aligned with sneakers, and some, such as Run-DMC, had even signed with brands, but this was the first time that a musician had been given the opportunity to collaborate on the design of a signature shoe. The idea was born out of Reebok's interest in expanding its reach beyond athletics, after someone suggested in a brainstorming session that the company take the same approach with musicians that it had used with NBA stars. Paul Fireman, the chairman and CEO of Reebok, asked who the first musician should be and the unequivocal answer was Jay-Z. As Todd Krinsky, Reebok's vice president of RBK products at the time, put it, Jay-Z was more than a mere cultural icon—he moved culture.[16] Steve Stoute, who had just started a new marketing agency and was working with Reebok, agreed to set up a meeting. Krinsky recalled, "Basically I found myself forty-eight hours later in Steve's office in New York and Jay walked in alone. We vibed and quickly found a common space talking about the sneakers that we both liked in the 1980s."[17] Krinsky left the meeting with an idea of the design direction for the first sneaker, and the deal to create the S. Carter Collection was quickly inked.

The first sneaker for the collection was an all-white low-top model, with a mid-1980s Gucci-inspired look, and as word got out, the excitement around its debut was palpable. The first drop, on April 18, 2003, in Philadelphia, one day prior to its worldwide release, caused pandemonium.[18] Krinsky drove to Philadelphia with the sneakers in the trunk of his car and upon seeing the lineup realized the shoe release was going to be a defining moment for the brand.[19] The shoe sold out in less than an hour at both the RBK store and certain area Foot Lockers that carried it, and within days the shoe was being resold on eBay for $250.[20] Those were the early days of limited-release sneakers and exploding resale value, and the dedication of those who wanted his sneakers impressed Jay-Z. He commented to the press, "People waiting in line to buy the shoe at 6:00 a.m. and waiting for hours in Philadelphia on a cold and rainy day has just been love."[21] ✱

2003

HAZE
x
NIKE,
DUNK

COLLECTION OF ERIC HAZE

Eric Haze began his career as an underground graffiti artist in New York City in the late 1970s, and by the mid-1980s he had established a studio in New York. There he designed album covers, logos, and identity graphics for many hip-hop superstars, including Public Enemy, the Beastie Boys, LL Cool J, and EPMD. In the 1990s, after establishing a second design studio in L.A., Haze launched his eponymous streetwear brand, which now has an international presence. He also began doing a series of sneaker collabs with Nike, beginning with the Nike Dunk in 2003.

In 2000 Nike had begun developing a new overspray technique that allowed pigment to be applied in gradations, simulating the effect of spray paint, and the company reached out to Haze to do a collaboration. The spray paint–like effects spoke to him, and he agreed to use the technique on the Nike Dunk, both high- and low-top. In Haze's hands, the overspray made the sneakers luminous. He also did a limited-release box for a handful of the shoes. The box was decorated with his tag, as well as his name stenciled using the overspray, and it, too, became an object of desire. ✱

2003

50 CENT x REEBOK, G-UNIT G-XT

COLLECTION OF REEBOK ARCHIVE, REEBOK INTERNATIONAL, LLC.

Curtis James Jackson III, a.k.a. 50 Cent, rose to fame as a rapper in the early 2000s with his 2003 album, *Get Rich or Die Tryin'*. That same year 50 Cent also founded G-Unit records, established the G-Unit Clothing Company with Marc Eckō, and signed with Reebok to create G-Unit sneakers. "G-Unit" stood for Guerrilla Unit, the name of the hip-hop group founded by 50 Cent along with Tony Yayo and Lloyd Banks.

50 Cent was the second musician to sign with Reebok and was part of the company's move to gain traction in the world of streetwear. It was a strategy that was immediately successful. Like Jay-Z's Reeboks, the first G-Unit sneaker sold extremely well. His second shoe, the G-Unit G-XT cross trainer likewise had record sales. According to Todd Krinsky, vice president of the RBK division at the time, the design of the G-XT was inspired by Reebok's archive of cross trainers, including the CXT, and 50 Cent's devotion to daily physical training. ✱

2004

DAVE'S QUALITY MEATS X NIKE, AIR MAX 90

COLLECTION OF NIKE DNA

The small East Village streetwear store Dave's Quality Meats, known as DQM, was started by Dave Ortiz and pro skateboarder Chris Keeffe in 2003. The store was famously decked out to resemble a neighborhood butcher shop, complete with T-shirts packaged like meat and displayed in a repurposed refrigerator case. The goal of the shop was to offer only the freshest merchandise, and the ever-changing selection of limited-release sneakers secured the store's status among skaters and sneakerheads.

When Nike approached DQM to do a collaboration in 2004, Ortiz was inspired to make a bacon-themed Air Max 90. As Ortiz describes it in a "Beyond the Box" video for *Sneaker News*, he had been given a few months to think of a concept, but his idea came only days before the deadline when he was inspired to design a shoe that looked like bacon after having a bacon, egg, and cheese sandwich for breakfast.[22] With less than forty-eight hours to design the shoe, Ortiz bought three packs of bacon, grabbed a Pantone book, and went to a friend's house. Together they keyed all the variegated hues in a strip of bacon to Pantone colors and then assigned the corresponding colors to the various parts of the Air Max 90. Jesse Leyva at Nike gave the design the green light, but Ortiz wanted one more detail to make the collaboration complete. He requested that the sneakers be packaged with small packets of bacon bits so the shoes would smell like bacon fresh out of the box.[23] ✲

2004

EMINEM X JORDAN BRAND, AIR JORDAN IV RETRO ENCORE

PRIVATE COLLECTION

Marshall Mathers, a.k.a. Eminem, was the first musician to collaborate on a pair of Jordans. His Air Jordan IV sneakers and his fifth album, *Encore*, were released simultaneously in 2005. The blue, red, black, and gray colors reflect the colors on the album cover. It is rumored that only fifty pairs were made, with the majority released in a Friends and Family edition. This scarcity has made it one of the most coveted, and expensive, sneakers of all time. The rare times that a pair becomes available, the prices on sites such as StockX typically run in the tens of thousands of dollars.[24]

The original Air Jordan IV was itself a storied sneaker. Released in 1989, it was Tinker Hatfield's second contribution to the Jordan line. For this iteration, he used mesh and nubuck leather for the uppers and introduced innovative straps that offered Michael Jordan greater ankle support.

Jordan was wearing IVs when he made "The Shot," his at-the-buzzer series-winning basket in game five of the first round of the 1989 Eastern Conference between the Chicago Bulls and the Cleveland Cavaliers. The sneaker was featured in TV ads shot with Jordan and actor/director Spike Lee's character Mars Blackmon and was featured prominently in Lee's 1989 film *Do the Right Thing*. ✱

2005

JEFF STAPLE

Jeff Staple became a sneaker legend due to the unprecedented success of the Nike x Staple Dunk Low Pro SB Pigeon in 2005. While the collab marked a defining moment in sneaker culture, the Pigeon is just one of Staple's many collaborations over the years.

E.S.: Can you tell me what you were doing B.P., that is, "Before the Pigeon"? How did you get into sneaker design?

J.S.: I love B.P. That's an awesome term. In my head I have always been a sneaker designer. In sixth grade, the era of the Air Jordan I, I was already sketching shoes, copying shoes, recoloring shoes. So for me the transition is kind of blurry between when I started to do sneaker design and when it became official. I know that an important moment was in 1998 when I was the art director for *Fader*, a New York–based music/lifestyle/fashion magazine. I was the art director, but I had studied journalism at NYU before going to Parsons School of Design for communication design. So occasionally I would write articles for *Fader* and one day I pitched a story about Nike Japan.

E.S.: So, you pitched going to Japan?

J.S.: Back then Nike Japan had a tiny sub-line called Co.jp—basically a riff on their website Nike.co.jp—that had products for distribution in Japan only. Back then there were a couple of really small boutiques in America that would fly over and pack as many of these shoes as they could into a suitcase and bring them back to the States for resale. What I'm describing is obviously nothing new but some of these shops, many of them no more than 200 square feet, would have these Nikes you had never seen before. Nike was a multi-billion-dollar corporation, and it saw that people were transporting these goods across borders, but why were they doing that? Why weren't they just releasing the shoes in larger quantities and across a larger area when they knew there was demand for them in the U.S.? So I wanted to get to the source and I convinced the publisher of *Fader* to fly me to Japan to interview somebody at Nike Japan.

E.S.: What happened?

J.S.: When I got to Japan, I interviewed a particular group of people there who were responsible for the Co.jp collection. When I went to Japan, I had no links, no appointments with anyone at Nike Japan, and no schedule. I literally landed and then like a detective I had to figure things out by asking people at stores—the clerks and managers—and I kept working my way up to get to the top of the ladder. That was when Nike and I started to have a relationship. They loved what I did—not only from the journalism side but also the fact that I was a "sneakerhead," a term that hadn't even been coined yet—this is the late 90s—and that I already had my Staple clothing line, which was one of the early pioneers of street culture. My first contact with Nike came through the Japan office. They were like, "We should work together." And I was like, "Yeah, we definitely should." So then, the next thing was to schedule a meeting at Nike headquarters in Beaverton, Oregon.

E.S.: After that what happened?

J.S.: Originally there were a lot of shoes we did at Staple Design that weren't quote-unquote collaborative. We did the Nike Navigation, Nike Nordic, and Nike Laser Tattoo packs. We did Nike Collab CO+LAB, which was a series done out of the Hong Kong office.

E.S.: You started to be involved with Nike in a number of ways, right?

J.S.: We also worked closely with the New York office on internal stuff that they were doing, like annual reports and recaps and just basic day-to-day graphic design. I was also the commissioner and founder of a Nike influencer basketball league called the NRF (Nike Recess Federation), which was an after-work industry-only hundred-person max, ten-team league that was sort of like Fight Club with basketball. I was the commissioner for the NRF for a good five or six years, so there was a lot of stuff happening pre-Pigeon. Finally, in 2005, the Pigeon happened and that really put us on the map. A lot ›

of people know us for that, but not a lot of people know that from 1998 to 2005 there was a deep long history between Nike and Staple.

E.S.: How did the Nike Considered collab come about? When did sustainability become an important concern for you?

J.S.: Nike Considered launched in 2005, I believe, after the Pigeon Dunk riot happened. To be frank, sustainability was not a concern for me; I was educated about it by the people at Nike. They taught me what went into shoemaking traditionally and how they were trying to change that with the line. My role on Nike Considered was the branding-identity side of things, and, of course, I worked on the marketing and retail launch of it, and I gave it the name Nike Considered. Originally when the team that was working on the actual footwear briefed me on the project it was called Nike Eco-Tech. I thought that was a sort of corny name, and I wanted it to be more subversive and subdued and less "ERRR! Eco-Tech!" I put on my journalism cap, listened to what they were trying to do, and I wrote the manifesto distilling their concerns into a set of rules and parameters to define what would make a potential Considered product. So what is it that makes something Considered? Do you just do 10 percent back-to-the-earth, and it's "Considered," or do you have to do more? Setting up those strict guidelines was my job, and it was just an incredible working experience. I went to Beaverton multiple times for that project. The launch point for the entire Considered line when it went to retail was at my shop in New York, Reed Space. We redid Reed Space into this whole Considered studio where you could see into the dissected parts of the shoes, and it was awesome to get a crash course on environmentalism and sustainability through Nike.

E.S.: Now you have to tell me a little about the Pigeon.

J.S.: The Pigeon Dunk was part of an anniversary year. I believe it was the twenty-fifth anniversary of the Dunk in 2005. Nike SB, the skateboarding division of Nike, had just re-emerged, and it was getting some decent energy behind it. People were pretty excited about what the team was doing. We were part of that relaunch, we actually designed the entire first Nike SB website and that was pretty awesome. There are some brand books and catalogs that some OG historians might have; we designed and laid out those catalogs. So we were really close with the Nike SB team. In fact, one of the people I interviewed when I went to Japan was promoted and had been sent back to Portland to help launch the Nike SB division along with Sandy Bodecker, may he rest in peace.

E.S.: What were the parameters of the collab?

J.S.: The parameters of the Pigeon collab were really simple. This is what's great about working with Nike: the briefs are always succinct and direct. Nike SB wanted to create some Dunks that were dedicated to key cities—Paris, Tokyo, London, and L.A.—and when it came to the New York City Dunk they called on me and said—I will never forget it—they said, "Hey, it's an anniversary for the Dunk. Would ›

> "IT'S NATURAL FOR THOSE PEOPLE WHO GET INTO SNEAKER CULTURE TO THEN DIG INTO THE HISTORY…"

Nike Considered and Staple x Fila
Original Tennis

you be interested in doing the New York City edition of the Dunk for Nike?" Of course doing a Dunk, which is probably the second most iconic Nike silhouette behind the Air Force 1, doing a Dunk, designing a Dunk, dedicating it to the city where I live, the city I represent and possibly the greatest city in the world, New York—that was a no-brainer. The great thing was that it was very short and sweet. They really trusted us and our decision-making process. We presented the idea of the Pigeon. For someone who doesn't live in New York City it might be a head scratcher. They don't understand what that means exactly. I explained a little bit, and then there was a lot of trust on their part to say, "If you think a pigeon represents New York, then go for it."

E.S.: So when did the Pigeon become the concept?

J.S.: We were already developing the Pigeon as a logo for Staple at the time. We hadn't released it yet and, talk about the stars aligning, what better way to release? What better way to launch a new icon for your brand than on the heel of a Nike shoe? That was really how it all started. But at the time Staple was already a fairly successful clothing brand—we had distribution all over the world. We were as far as Tokyo. I think at the time I had five employees. We had an office in downtown New York City. So Staple started in 1997 as a brand, and in 2003, when we got the initial Dunk brief, Staple was already a six-year-old streetwear brand. At the time we already had a pretty decent fan base, and this really put lighter fluid on the whole thing and catapulted our brand to the highest stratospheres.

E.S.: The story of the launch has become famous. Can you tell me about it?

J.S.: Definitely the story has been told, but from my standpoint, I would say I was very naïve about the whole thing. Sneaker culture in general was very naïve at this time. There wasn't Instagram and Twitter. The most social media thing around back then was blogs. People would go home and type up a blog report and upload photos, so the information wasn't spreading *that* fast. Not to say the release of the Pigeon Dunk at Reed Space created the first lineup for a sneaker ever; it wasn't, but it was the first lineup that hit the front pages of newspapers and became a worldwide phenomenon. Before that, if you didn't live in the direct vicinity you wouldn't know that a lineup happened. There might be lineups at a store on the Lower East Side, but if you lived in Union Square just ten blocks uptown you wouldn't even know. The information wasn't spreading. I think what happened with the Pigeon Dunk is that because of the intensity of the lineup, because of the situation getting out of control, which definitely was not planned, it created a media sensation. Ironically, I think maybe if I had planned the drop better and had anticipated better what could happen, none of this would have happened. Fortunately or unfortunately, I was unprepared for the demand, and the rest is history.

E.S.: The next day, did you realize something had changed?

J.S.: I definitely did. I don't think a picture of Nike had ever been on the front page of a New York City newspaper before—so that was historic, and being on the evening news was pretty historic. And then the clientele just changed that week. Right away all different sorts of people started coming into Reed Space. We had all these brands coming in, and that's actually how we met Timberland. I definitely noticed immediate change after that drop.

E.S.: How did that play out long-term?

J.S.: To be honest, one of the things that's most impressive to me about it is not so much the impact of the change but the longevity of that change. The most surprising thing to me is that almost fifteen years later, we're still talking about the Pigeon Dunk. By no means am I sick of it, but I'm shocked that even after one year people were still talking about it, and then still five and ten years later. I think as sneaker culture just expands and expands, as the community expands, more people get into it. It's natural for those people who get into sneaker culture to then dig into the history of sneaker culture, right? It's like you're a young kid and all of a sudden you get into rock and roll. It would be normal for you to then stumble upon the Beatles and the Doors, and the Eagles, right? So you get this perpetual audience of new people coming into the culture. That's what's happening with sneaker culture. You're getting this new influx of individuals getting into the culture, and they do their digging, they do their due diligence, and they're like, "Wow! There was this riot that happened in New York City in 2005!" So the sort of lore and mythology of the Pigeon Dunk just continues onward forever. Being a part of that is a blessing and it's amazing.

E.S.: It was clearly an important moment. Has it ever been an albatross?

J.S.: I guess sometimes it's an albatross because some people don't know about B.P. Nike isn't going to invest in you unless they feel you bring some sort of impact or value proposition to them. What we had created before the Pigeon was obviously something that was enough for them to call us to do the Pigeon Dunk. I do think the power of the Pigeon eclipses everything we did before that, and maybe even everything we do after that. It's such a powerful force. We have a clothing line that is twenty-one years old; actually, by the time this book comes out it will be twenty-two years old. There are people who collect sneakers who are like fifteen years old, so the brand that I created is older than some of its consumers, and that's no small feat, but I think some people overlook that and just say, "Oh, you're the guy who made the Pigeon Dunk." I also have had a clothing line for a quarter of a century, but, yeah, I did this one shoe. There is a bit of that. It doesn't bother me too much, since I'm proud of everything that I've done and I have an amazing fan base. I think my fans know what I've contributed to this culture even outside of the clothing line: there is the design studio; the creative agency; there is the retail store, Reed Space; Extra Butter; there are the Skillshare classes; all the talks I do; there is the podcast I have on Hypebeast, *Business of Hype*; and all the mentoring I do. ▸

Nike SB Dunk Low Pigeon

E.S.: Is the Pigeon a constant inspiration?

J.S.: Is it a constant inspiration? I think I lean more toward saying no, because it's more like a family crest. Like if I asked Ralph Lauren about his polo horse, I don't think it's his source of inspiration; I think it's the umbrella under which everything lives. It's not necessarily the thing that you use to beget new information, if that makes any sense. The Pigeon is us, and we are the Pigeon, we are one and the same, but I don't ask the Pigeon what I should do next year [*laughs*]. The inspirations come from everywhere else. We take that outside inspiration and funnel it through the lens of Pigeon. Did it affect some of the collabs that came after? Yeah, I think one of the things that we noticed about the Pigeon is its signature colorway—and by no means was it a crazy colorway. It was a coral pink for the feet and then grays on the uppers and a splash of white. It wasn't anything crazy like a Tiffany blue or some crazy gold color, or some ultraviolet fuchsia. It was a combination of very normal colors that identify what a pigeon is, and I think that is sort of a testament to the bird itself, how it is sort of ubiquitous and everywhere—everyone knows it. I think because we realized that we sort of had this trademark on this colorway, it was an exercise in branding on my part then to flex that colorway onto as many different surfaces as possible, whether it was other shoes, or headphones, or a car, even. Anything we could put our branding on. It worked well, I think. Today, someone on Instagram commented on a photo, "This colorway reminds me of Jeff Staple. It's very Staple-ish." It had nothing to do with Staple. It wasn't a Staple shoe; I didn't design it. It's great that I have created a vocabulary that has influenced others and, more importantly, that other people recognize that influence. That was a deliberate move on my part, to try to brand that colorway, the Pigeon grays and the Pigeon pink, and I use it sparingly, I don't overuse it. I realize, especially from the Nike Pigeon Dunk, how powerful that Pigeon concept is, so I only reserve it for projects with our most impactful partners.

E.S.: Do Puma and Fila share the same Pigeon DNA?

J.S.: Yes, Puma and Fila are two historic brands that I grew up with, so when I had the opportunity to work with them I wanted to share that Pigeon DNA. To take the influence of what Puma or Fila or Timberland or New Balance, even New Era or Beats by Dre, had and see what their influence looks like through the lens of the Pigeon. And again, that's something I'm very very deliberate about.

E.S.: You have done so many collaborations. Is there still a particular collaboration you would love to do?

J.S.: Really there isn't. I think I have reached a point in my career where I feel so blessed that if I were to somehow close the book on this career now, whether it was done because of outside forces, or whether I wanted to do it myself, I would be so proud of everything that was created out of it. I feel like I designed and created five lifetimes' worth of stuff, and I'm really proud of everything, so I don't really have a reason to be, like, "Man, I really want to work with this company!" I have worked with the greatest of the great in every industry and I want to continue to do that. I'm into projects that make a significant, massive sea change, but added onto that I really like to work with creatives who work from the heart, no matter how big or small they are. I'm trying to think of an example. Recently we did a collaboration with Shake Shack. Why would Staple Design work with a burger chain? I think because what they bring to the table is an audience that is not tuned in to street culture necessarily, but there is a synergy between the things we do: we put a lot of love and passion into the products we create. When we did that collab, it was dope to just be able to share audiences and the crossover audiences, meaning the ones that are into both Staple and Shake Shack. Now I'm working on a project that should be out in 2019 with shoemakers in Amsterdam, two women who are shoemakers. They don't have a big company. They have one atelier, Peterson Stoop, in Amsterdam, and we're probably going to make fewer than fifty pairs of shoes together, but I love what they do and I love the blood, sweat, and tears that they put into their work, so it's an honor for me to be able to work with them. So whether you're dealing with a publicly traded food and beverage organization or a single-studio shoemaker, both of those really resonate with me. I want to continue to do collaborations that really share knowledge, share passion, and also push awareness of what all of us are doing into different spheres. ✻

Staple x Puma Suede and Nike SB
Dunk Low Pigeon (worn)

89

MISSY ELLIOTT X ADIDAS, 35TH ANNIVERSARY SUPERSTAR RESPECT M.E.

COLLECTION OF ADIDAS AG

Missy Elliott began collaborating with Adidas in 2004, making her the first female rapper to get a major sneaker deal. Eighteen years earlier, in 1986, Adidas had made a groundbreaking endorsement deal with Run-DMC, but the company had not signed a recording artist since then.[25] One of Elliott's first sneakers with Adidas was a pair of Superstars released in celebration of the thirty-fifth anniversary of the Adidas Superstar.

The Superstar debuted in 1969 as the first low-top leather basketball sneaker. Its distinctive toe earned it the nickname "Shell Toe," and it quickly became popular with both professional and amateur basketball players. However, it was the embrace of this sneaker in urban fashion that transformed the Superstar into a cultural icon.

Elliott's anniversary Superstar was number twenty-one of thirty-five collaborations commissioned for the anniversary. Among other musicians involved in the anniversary collabs were Run-DMC, Red Hot Chili Peppers, and Ian Brown. Elliott's version featured a purple and orange colorway and had details such as embossed suede uppers, Elliott's portrait on the heel tab, and her signature crown and initials embroidered on the lateral quarters. The sneakers also sported purple M.E. deubrés on the laces. ✱

2005

KENZO MINAMI X REEBOK, INSTAPUMP FURY

COLLECTION OF REEBOK ARCHIVE, REEBOK INTERNATIONAL, LLC.

In 2005 Reebok approached artist/designer Kenzo Minami to do an Instapump Fury collaboration. The resulting limited edition went on to become a highly coveted shoe.

E.S.: How did your Instapump Fury collaboration come about?

K.M.: My collaboration with Reebok originally started as a project for a pop-up store. I was approached to do an extremely limited-release Instapump Fury. As I recall, we were talking about only twenty-four pairs—I think twenty-four pairs was the minimum to produce at the factory. But apparently, the sneaker got great reactions when the sample came out, so Reebok decided to produce it in larger numbers. Around the same time, I was also approached to be a part of Reebok's "I Am What I Am" campaign. After doing collaborations with musicians and athletes—Jay-Z, 50 Cent, Allen Iverson—Reebok was thinking of doing a series with artists. Combining the two projects made sense. My ad and shoes came out with the Basquiat ad and model.

E.S.: How did you approach the collaboration?

K.M.: When I began, I was consciously trying to decide which mode and mind-set I needed. I had a background in product design, and I had worked in TV production/video/motion graphics, yet somehow I was being approached to do collaborations as an artist. So, I questioned myself: Am I approaching this project as someone ›

2005

with a product design background, or as an artist? This was tricky for me. I was being considered an artist, but I still hadn't gotten a grasp of what that meant. Since the original project was only supposed to result in twenty-four pairs, I figured that people probably wouldn't actually wear them on the street, so I decided to approach the collaboration as an art project, making them as crazy as I wanted. I still wonder if I would have approached the project differently had I known that the release was going to be larger.

E.S.: What did you think of the Instapump? Your work seems very sympathetic to the shoe's architecture.

K.M.: The legendary Instapump is so un-shoelike that I could almost approach it like I was creating a unique three-dimensional sculptural object as opposed to a shoe. Specifically, I worked with its construction, using each layer to convey different feelings. I designed the inner layer to be more pop, geometric, and colorful. The outer shell (the air bladder) was more ornamental and gothic in black and white. The design was done during a specific two-week period when I was coming into and developing a style that in retrospect was sort of like my own version of the Memphis design movement aesthetic. The funny thing is that I moved on from that fairly quickly, so by the time I sent in the final design, I didn't know how I felt about it anymore. People told me that the design was ahead of its time—but really it was even ahead of me. It took me years to "get" the sneakers myself and know that they are good—to finally catch up with myself and start to appreciate them and essentially rediscover my own work. *

> "PEOPLE TOLD ME THAT THE DESIGN WAS AHEAD OF ITS TIME— BUT REALLY IT WAS EVEN AHEAD OF ME."

COLLABORATION VANGUARDS: NIC GALWAY ON WORKING WITH LEGENDS

E.S.: How did you get into sneakers? Through design?

N.G.: I got into sneakers because I was interested in making things. That is the key for me. When I was a student I studied to be a car designer. However, while I was studying I started rock climbing. I used to spend my weekends rock climbing and my weekdays designing cars, and I started making rock climbing equipment in the evenings, stitching harnesses and backpacks and things like this. I found over time that I actually enjoyed making the equipment. I could test it; I found out if it worked. When I graduated, I went into product design, working in the car industry and transport, but I really missed the hands-on world, so when I saw an advertisement in the back of a magazine for a job at Adidas, I took a chance. That's how I got here. It's really about reconnecting through sport. That's what drew me to the brand.

E.S.: It is interesting that you turned to shoes after cars. Other sneaker designers seem to have made the same leap. Do you see a connection between the two?

N.G.: Yes, there are quite a few people who trained as car designers in the shoe industry. I think there is something to the style side of that, the way we were taught to create, that overlaps. When I came to Adidas I worked very differently from everyone else here. I'd never drawn a shoe until I walked into the building. When we drew cars we did big expressive sketches, so I was drawing sneakers in the same way—on a massive scale. It was a different way of designing. I wasn't interested at all in trends back then, or in fashion. I was simply creating and exploring what shoes meant to me. As a result, I had quite a unique "handwriting" and that's what appealed later to some of the collaborators. I wasn't trying to follow any of their trends. I was just creating a "building," and they found that quite intriguing. ›

E.S.: Did you work with Yohji Yamamoto on the sneakers for his first runway show?

N.G.: No, we did the second one. The first one really was just a curation of Adidas sneakers. He reached out and asked if he could put some shoes on the runway, and they were sent to him. It was very low-key, but people were intrigued, so he said he wanted to go further with it. So back at the end of 1999 or the beginning of 2000, he [Yamamoto] reached out to our then-creative director and asked him to send Yamamoto what he thought was the most interesting stuff that Adidas was making. A big box of sneakers was sent to Tokyo, and Yohji made a selection of around five sneakers. Luckily for me, he only picked mine. Back then, if I'm honest, I didn't know who Yohji was. I had no background in fashion at all. I really, to this day, think the reason he picked my sneakers is that I wasn't trying to do fashion, and he saw something utilitarian and different in my designs. So he asked to meet me and that completely changed everything I've ever done since.

E.S.: Amazing.

N.G.: It's a bit of luck [*laughs*].

E.S.: Life is like that. Serendipity, right?

N.G.: Exactly. Sometimes it's better like that because if you know too much about something you also bring your own limitations to it. I think this level of naïveté and not being an expert in something was really interesting in those early years with Yohji and myself. I simply knew nothing of his world, so I didn't have any restrictions, which was good for us.

E.S.: I sometimes think you can ask the question "why" more easily in situations like that because it's such an innocent question, because you literally don't know, right?

N.G.: Yeah.

E.S.: From 2002 on, did you work with Stella McCartney and Jeremy Scott as well?

N.G.: Back in 1999 and 2000 the idea of collaborating was not proven—no one had done that. There was an element of hesitation: Should we do this? Because we were 100 percent sport back then. The Originals hadn't started; there were no collaborations. It was a very bold thing to work with Yohji. Obviously, that was hugely successful and led to the start of Y-3. But it also made us think—what can we do with this? I didn't work with Jeremy, actually, until much later, but I worked with Stella from day one. The difference between Yohji and Stella was that if Yohji was looking at sport through the lens of fashion, Stella was asking, What if fashion looked through the lens of sport? Stella was all about making her collection through the eyes of Stella McCartney for sport, whereas Yohji was about taking

"I DIDN'T KNOW WHO YOHJI WAS. I HAD NO BACKGROUND IN FASHION AT ALL."

sneakers and putting them into an avant-garde context. So we wanted to kind of test the formula. It was an exciting time for Stella, because when we started talking to her she had just left Chloé and it was the season she did her very first show as an independent brand. She was just starting to establish her own brand as an independent designer at that point, and it was amazing to be on that journey with her, to see her brand grow, and of course to watch the partnership grow.

E.S.: This book features a pair of Stella's runway shoes from before she signed with Adidas.

N.G.: Those are amazing—the boxing boots, the vegan ones.

E.S.: Exactly, yes.

N.G.: What I love is that Yohji and Stella have such strong principles about who they are as creatives. Stella was clear from day one with the shoe you just mentioned that it would be vegan. That is what she stood for, and, fast-forward to today, she changed the industry. It's a credit to her that she would have that strong an opinion and stand by it all those years. It is quite inspiring.

E.S.: It's interesting to me, too, that Adidas has collaborated with those kinds of voices. From Pharrell Williams to Parley for the Oceans, Adidas always seems to be willing to step into the unknown.

N.G.: It is who we are. The brand's always been like that, and, honestly, that aspect of the brand is the reason people like myself stay—I've been here twenty years this year. The brand is always moving, it's always exciting, and when they talk through the collaborations we do now, I think back to those amazing times, meeting these people, and reflect on how that has never stopped. We are always learning something new.

E.S.: Can you tell me about working with Pharrell on the NMD?

N.G.: Pharrell is great. Pharrell has such a unique view of the world. If I've learned one thing in the time I've been doing partnerships and collaborations, it's that everyone is so different and you've got to withhold your assumptions and get to know the people you're working with. We've talked about Stella and Yohji and their approaches to creative collaborations. Pharrell was completely different and opened our eyes to a different way of thinking. Pharrell always thinks big, and he always thinks about how people feel, the emotion you can put into something. He thinks about how you can connect to people, how you can take people out of a bad place and put them into a good place. He's very, very good at that. We met him at Coachella when he was performing there, and straight from the day we met him, at the first meeting, he was saying to us that he saw our brand as the "people's brand" and that's what made us unique and it's great that everyone can wear a Superstar, everyone can wear a Stan Smith, and you never feel badly dressed if two people are wearing it. He kind of joked at that moment, asking why don't we do these styles in fifty colors. He said, "You guys are going to tell me to make just five [colors] or something like this." He pushed us on that, and we actually made fifty colors of the Superstar and they were really successful and it really displayed who Pharrell is. From that first collaboration, we all got to know each other very well and we created the NMD. That was an interesting shoe because the NMD was already in development, but Pharrell brought a completely different angle to it. He opened our eyes to how this product could be different. He said to me very early on that he wanted to put slogans on the sneakers because he felt words were very powerful. That was the brief, and we worked from there. I remember showing him the first samples from the factory in Nuremberg. We were in the city because the office was closed that day. He opened the box and I could tell straight away that he liked it. He wanted to leave with them on the spot, which is always a good sign. That's where it came from—it was all about empowerment and positivity.

E.S.: We are increasingly asking our sneakers to convey narratives, to have stories embedded in them for wearers to take away and use in their own way. I think collaboration is part of this complicating of the narrative, allowing people to make these more nuanced statements, and I think that Pharrell, in particular, is linked to these ideas of narrative. Do you agree?

N.G.: I think you are right. Like I said, Pharrell is very much about this. He has a strong opinion on the end product. What he always goes back to is the bigger message. Just the words "human race," for example, sum up exactly what his viewpoint is: celebrating what people can do and bringing people together and giving a voice to others. He absolutely stands for that, and I read that back through the products. The campaigns we create together have a very unique point of view. I always say to the design team that you should be able to tell what product is from which partner through its identity. Pharrell products really stand out.

E.S.: You often go to the archives and look at Adidas innovations from the past, and you ask your designers to do the same thing, but I sense that rather than slavishly recreating items, you want people to be inspired by the innovative spirit of Adidas.

N.G.: Absolutely. I feel you can go into the archives and take a picture and then sit at your desk and you aren't entering into that in the same spirit as the person who originally created the object in the first place. We came from a review just now where we discussed that if you look at products from the mid-1980s, a pair of sneakers, a BMW, a computer keyboard, whatever, you'll see similarities. It's the colors used, it's referencing an era. It's also, what do you remember? If it's memorable, you can use it; if it's not memorable, then why start with it? I encourage that a lot—you should be able to look at something, and the few things you remember from it are the things you should be taking somewhere new. Otherwise you're just doing ›

a one-to-one archive reference and celebrating what it was. I am not a fan of "a bit like the past but a bit different." That, to me, is the wrong approach to design.

E.S.: Can you tell me about working with Alexander Wang? I am very interested in his unisex designs.

N.G.: Alexander Wang's work is unisex, but from a different angle. I've known Alex quite a while now and he's a really interesting designer because he's so connected with culture. I have always felt that Alex is the one who broke down the boundaries between fashion and streetwear for young women. He captured that so well in New York City and changed the way people dressed. At Adidas we had always approached unisex from a man's point of view. Alex approaches it through a different lens, and that challenged my thinking about what unisex could be. You can read people's handwriting in a product. Alex is young, and I feel that when we create together. He is not locked into one particular reference. Alex likes to mix eras; he likes to play with references, much as the culture does. I find that quite exciting.

E.S.: What is Kanye West's working style like?

N.G.: Kanye said to me, "My compromise and your compromise are so different." That was really powerful, because when you work in a big company you may think you are pushing a boundary, but to someone else it might be a compromise. When you can unlock that and understand it, you can go so much further. I found working with Kanye absolutely challenging and incredibly inspiring. He just really pushes you. When you think you're finished, you haven't really started. That's very, very inspiring. The other thing that's incredible about Kanye is that he is amazing at connecting people you wouldn't imagine coming together. He will ask you your opinion on something and you will say, "Why are you asking me? Someone else will know better." And he's like, "Well, I'll ask them as well." He is very good at that, you know, connecting people and challenging people. He's a visionary, and I found it just incredible to work with him and be surrounded by his thought process. He reignites you as a creative.

E.S.: Can you tell me a little bit about the 750?

N.G.: The 750 was the first shoe that Kanye did with Adidas, and we worked together on its development. There is so much in the 750 that has influenced Yeezy since—the rib on the sole, the use of muted colors for the suede. There is such a vision in that first shoe. Kanye knows where he's heading—he is always exploring. You see that from the 750 through to the 500.

E.S.: He seems to be interested in the architecture of the shoe as well as its materials.

N.G.: He's interested in architecture and how things are made. He's a very curious individual, and he wants to know how it works and how it performs. He's interested in how it looks, too. He connects all that together.

> "YOU SHOULD BE ABLE TO LOOK AT SOMETHING, AND THE FEW THINGS YOU REMEMBER FROM IT ARE THE THINGS YOU SHOULD BE TAKING SOMEWHERE NEW."

Pharrell Williams x Adidas Originals, NMD Human Race, 2016. Courtesy of Nic Galway/adidas AG

E.S.: Some believe collaborations have been over-played, but personally I think they are just getting started. How are you feeling about the future of collaboration?

N.G.: Well, I'm very positive about it, obviously. I would say collaboration is how things are made.

E.S.: So what else can be gained from collaboration?

N.G.: If you ask me what I have gained out of collaboration, I'd say I'm very proud of the products we've created, and I love a lot of the shoes, but what I've really taken out of collaboration is different ways of working and different ways of looking at things. Provided the collaboration is genuine—both sides are real—it takes you to places you couldn't have gone on your own, and it opens up new doors and new ways of thinking and keeps everything moving. Honestly, I think as we go forward over the next ten or fifteen years, collaboration is simply going to be how things are done. The future is open source, networks, collectives. We played a role in starting that with Yohji and with Stella. But it's evolving fast, and I believe that collaboration is the future of productivity and how we will communicate as we move forward. *

ALEXANDER McQUEEN X PUMA, RIBCAGE

COLLECTION OF PUMA ARCHIVE

British fashion designer Alexander McQueen was a visionary whose radical approach to fashion and lavish, highly controversial runway shows often veered into the realm of performance art. Despite this penchant for the rarefied, McQueen was interested in making accessible fashion, and in 2005 he began a collaboration with Puma as a means of combining his avant-garde designs with Puma's forward-looking technology to make his work available to a wider audience.

McQueen's first Puma sneakers were part of his Spring/Summer 2006 collection. They were divided into two sections: My Left Foot sneakers, which were literally based on McQueen's own left foot, and Anatomical Vein models, including the Ribcage sneaker, which drew inspiration from the anatomy of the human body. This design gave the illusion that bones, sinew, and underlying muscle were structural elements of the sneakers. McQueen's striking use of high-gloss and translucent materials contributed to this association with viscera.

McQueen collaborated with Puma until his unexpected death in 2010. Sarah Burton took the helm, and the company continues its collaboration with Puma, carrying McQueen's vision forward. *

2006

ALIFE X REEBOK, COURT VICTORY PUMP BALL OUT

COLLECTION OF BATA SHOE MUSEUM, GIFT OF ALIFE

One of the most game-changing sneakers in the history of athletic footwear was the 1989 Reebok Pump created by Paul Litchfield, then the head of Reebok Advanced Concepts. Litchfield had been given free rein to innovate, and one of his quests was to make the lightest and most custom-fitting basketball shoe ever created. In the late 1980s, the idea of using air to make sneakers lighter was catching on. Inspired by the inflatable bladders used in some ski boots, Litchfield made this concept a reality by designing sneakers that were lightweight and allowed for a customizable fit.

Litchfield's design featured a bladder in the upper that could be pumped full of air by pressing a button on the shoe's tongue. The Pump's cutting-edge technology and individualized fit, as well as its cheeky basketball-shaped pump, earned instant attention, while its bold marketing campaign, and an unprecedented price tag of $170, made it one of the most sought-after sneakers of the period. Litchfield's work led to the creation of a number of other Reebok models that made use of the pump, including the Court Victory Pump tennis shoe designed for tennis star Michael Chang in 1990.

In 2006 Alife, a New York–based skate-focused streetwear brand, collaborated with Reebok in reimagining the Court Victory Pump. Its Balls Out version featured uppers in a fabric reminiscent of the fuzzy material used to surface tennis balls. The shoe was released first in classic tennis-ball yellow, followed by a number of other bold colorways. *

2006

BOBBITO GARCIA

Bobbito Garcia made history in 1991 when he wrote "Confessions of a Sneaker Addict," the first article on the cultural importance of sneakers, for *The Source* magazine.

His interest in sneakers began when he was a boy and grew as he became an internationally recognized basketball player as well as a member of the legendary Rock Steady Crew, plus a DJ. In 2003 he published the groundbreaking book *Where'd You Get Those?: New York City's Sneaker Culture, 1960–1987*, and in 2005 he became the host of the ESPN TV series *It's the Shoes*. Today, Garcia is a renowned filmmaker; his most recent documentary is *Rock Rubber 45s*. He is also a host on the popular National Public Radio podcast *What's Good with Stretch & Bobbito*.

E.S.: You've loved sneakers since you were a kid. Did you have a favorite back in the day?

B.G.: I was fortunate to have been born in 1966, and I had a brother who was as focused as one could be on being completely unique about the sneakers he wore. He didn't want anyone wearing a shoe before or after him. I took to his beliefs, and I started painting sneakers in the late 1970s. In those days, cats might put initials or a uniform number on the upper. I would paint the entire stripe. Then in the 1980s I started painting entire uppers, and I wasn't the only person who did that. There was a very small community of us like-minded people pushing the envelope. Did I have a favorite shoe? The first shoe I probably did the entire upper of was a Nike Franchise.

E.S.: Your favorite?

B.G.: Yes, it was tops in my childhood. I was very proud when I did the Franchise, because one of the most coveted shoes in that era was the Columbia University Lions Franchise, which was black and light blue. So although I didn't paint my stripe light blue, the stripe was already red. I did the upper in black and the goal was to mimic the Lions Franchise, which was successful.

E.S.: Did you have a dream of making your own sneaker?

B.G.: In that era there was no such thing as collabs. It didn't even register. There wasn't even such a thing as people from the street becoming designers. That wasn't a path that could be imagined. So all of this is new territory—it couldn't have been fathomed.

E.S.: If back in the day you couldn't even dream of impacting the design of a sneaker, do you think collaborations now—maybe this is hokey—do they open up the idea of dreaming?

B.G.: Absolutely. I think collaborations have been one of the singular game changers for the culture as well as for the industry—because both get benefits, right? The brands get the sales from the collabs, and they get the long-term marketing, as well as the authenticity of having collaborated with movers, whether it's me, or it's Clark Kent, Stash, Jeff Staple, Vashtie—whoever it is, the brand benefits, but the people who really benefit are the cultural movers and shakers like ourselves. I could customize a shoe for days, but it's a lot different to customize a shoe and to have it be manufactured, marketed, and then available for other people—I don't care about people buying them to own, I care about people buying them to wear. I can go to any country in the world, and if there's a sneaker event, there is going to be someone there wearing one of my collabs. And it's a joy. It's a joy that people can have a sense of pride, that it can strengthen their affinity for the people like myself, and Clark, etc. It becomes a badge of honor for them, since most of these collabs are such limited-edition pieces. You know they brag about it, like, "Yo, look what I got." To see my collabs being sold for $600 a decade later—I don't see any money off of that—but to know that something I created has an increased value in someone's eye, that tickles me. But ultimately the main thing that makes me happy is seeing them on someone's feet. Seeing them decked out on someone who knows how to wear them, who creates an outfit, who wears them with pride. It's an even more powerful connection when I see someone who's like, "Yo, I bought these because you did them." That's something I couldn't have ever imagined. The full power of it is that I'm not an NBA player; I'm not a platinum recording artist. I'm a heavyweight in sneaker culture, and because of that I have been afforded this opportunity to put my spin, my fabric choices, my colors, my name, my emblems, on a shoe. I don't think people can really grasp how huge that can possibly be. If you look at the collabs with Chris Paul and Carmelo Anthony—the signature shoes—Steph Curry, these guys are the millionaires. You think about 50 Cent, who did Reebok, about Jay-Z with Puma—these people are mainstream fixtures. And then you get a guy like me, and Clark, and Vashtie, and we're not mainstream at all. We're counterculture, and you're getting the biggest shoe brands in the world to collaborate with basically counterculture people. There's a power there that I think goes over people's heads.

E.S.: One of the things I want to talk about is the genuine aspects of collabs, because I think we're at the tip of the ›

iceberg. There are so many more stories that can be told. That brings me to my next question: What was your first official collab?

B.G.: My first official collaboration was with a small German brand called K1X, in 2004. The model was the Chiefglider. At the time I was editor in chief of *Bounce* magazine, so I didn't put my name on them. What I did was design them in an attempt to raise awareness of a project that was dear to me, because *Bounce* was and still is the only year-round publication dedicated to outdoor basketball in the world. I designed them with the colors of the magazine and with the logo. My face was behind it. When they did the campaign I made a number of appearances, but officially, it was the *Bounce* magazine Chiefglider. Then in 2005 I did the thirty-fifth anniversary of the Adidas Superstar, which was an honor for sure.

E.S.: Did you have a say in your shoe with Adidas?

B.G.: Did I? They battled me. With the thirty-fifth anniversary of the Adidas Superstar, which we call the "Shell Toe" in the 'hood, I went to Adidas and I said, with my brother Ray in mind, "Look, I'm going to bring this back." Because, that's what I do with a lot of shoes. I bring them back to their foundation. That's what I did with the Puma Clyde, the Puma Suede, what I did with PRO-Keds Royal Flash, even with Air Force 1. People forget these were designed for basketball performance—it escapes people. So when I looked at the Superstar I still saw a basketball shoe. I told them, "Look, I'm going to use inspiration from the playground to design this shoe with regards to how one would have worn it in the 1970s." I was paying homage to my brother. No one knows this, right? Basically, I said, "I want to take off the stripes and I want to take off the tag in the back," and they were like, "What? Are you crazy? How dare you?" And I was like, "Nah, nah, nah. If you think about customization-inspired collaborations that have lasted, then you'll do it." I told them to think about authenticity. They thought about it and they were like, "All right. Cool. We're going to build it like you want." They took off the stripes for the Superstar. Stan Smith didn't have the stripes. They had the perforations, but I don't know that a Superstar had ever been released that did not have stripes on it.

So they took the stripes off and I did the Superstar and it was *beautiful*. I picked out the UCLA colors but played with the shades, the blue and the gold, and at the time I had a basketball performance group called Project Playground, and we were doing halftime shows at Madison Square Garden, for the Dallas Mavericks, at University of Tennessee, at UConn, at all the top-tier programs in the country, and again, in order to pump up another love project of mine, I was like, "Yo, let's put the Project Playground logo on the side." And, that was a smart move because it was almost like I was saving my name for the big whopper, which came in 2007 with the Nike Air Force 1. I mean, that's as iconic a shoe as you can get in the universe. What I did was seven colors. I did four high-tops and three low-cuts, and to this day it blows people away. I don't know anybody who did seven different colors of one model in one year, for the Air Force 1 or for any model. Certainly not for Air Force 1. Not previously, and I don't think it's

"ULTIMATELY THE MAIN THING THAT MAKES ME HAPPY IS SEEING THEM ON SOMEONE'S FEET."

happened since. It was a big year for them. They had a Kobe Bryant shoe, they had a Moses Malone shoe, they had a Bobby Jones shoe, they had all the original NBA players that wore the Air Force 1, and it's like, "Yo, little Bob with his 'Kool Love Bob' shit." People were going nuts. Nike never released the numbers they manufactured, but I know they moved. I think it was a win-win for everybody.

E.S.: If you look online people rank them high.

B.G.: Sure. Nice Kicks rated them number-one, collab of the year. Matt Halfhill is a great guy and he showed me a lot of love. Nice Kicks was a young website at that point; all the sneaker blogs were young at that point. *That*, I was happy about.

E.S.: What followed?

B.G.: In 2009 I did the PRO-Keds Royal Flash thirtieth anniversary, which was cool because it was a shoe that had never gotten reissued. The Air Force 1 and the Superstar had been out as a new shoe, but here was the Royal Flash, which had never been reissued since it came out from 1979 to 1980, and upon return, they bring it out with my name on it. We did four colors—one a Burgundy wine that was inspired by my time playing ball in Spanish Harlem, growing up as a teenager. PRO-Keds was the first brand I'd ever worn as ▸

Bobbito Garcia x Nike Air Force 1 collaborations

a kid. I bought skippies up until I was age nine, so it was a big deal for me to have an opportunity to work with them. Then in 2016 I did the Puma Clyde, which, like the Air Force 1 and the Superstar, is as iconic a shoe as you can get, and in 2018 I did the Puma Suede. In each of these cases my inspiration was just to bring it back to the essence: New York City outdoor basketball and what I would see someone wearing on the court if they were playing in the 1970s. When you do collaborations, it's like, "Oh wow! I could do any color I want! I could do fifteen thousand fabrics!" I take a left turn from all of that and am like, "You know what? I'm going to keep it simple. I'm going to keep it simple and beautiful." Puma gave me some slack with the Puma Suede because I did a burnt orange with a natural suede, and on the toe box the suede was a different shade of white than the stripe and they were like, "Oh, you can't do that. It's not going to look good." And I was like, "You know, you actually did it yourselves back in 1982 with the Puma Sky, and here's a photo of it." And they were like, "Oh." I'm not trying to make them look bad, but the brand approached me because I'm a historian. I'm like, "It worked then, and I think it can work now, because you haven't done it in a long time." And they are like, "Cool. Let's rock with it." I'm fortunate in that I'm sure other collaborators come up with ideas and designers are like, "Hell, fucking no. No way." But they listen to me. They trust me. And it works out because the shoes come out and people get excited and the brand gets what they want, which is that branding and that word of mouth.

E.S.: And that authenticity, right?

B.G.: Yeah. And all of our collabs have done well. None of them are sitting on the shelf.

E.S.: What was it like finally to design your own sneaker from the ground up with Piola?

B.G.: Piola is a small French brand. They reached out to me with the idea of doing a collab. Something that should be said about collaborators is that—I speak for myself—it's a little disconcerting at times because I feel, to give a baseball analogy, bases are loaded, and your pitcher is up to bat, and you're like, "Fuck! He's going to strike out. Let's bring in a pinch hitter." That's kind of what I feel like. I'm not in the starting five in the basketball game. I'm the designated shooter who comes off the bench to hit a three-pointer to win the game. So when Piola reached out to me, I was like, "You know what? This is cool. I appreciate the respect, but why don't we push the envelope?" No one, no brand, has ever given me the chance to design a sneaker from the ground up. Actually, no brand that I know of has given anybody of caliber that chance. From the ground up. You're not giving me a preexisting model. The designer hasn't created a model and said, "Hey, what do you think of this design?" and then tweaked it. No, ground up. I didn't go to engineering school. I didn't go to design school. I didn't go to FIT. I wasn't at the Pensole school. None of that shit existed. I sketched up a bunch of models, and we did a lot of back and forth. They were in France, and there was a language barrier, and the time zones were different, but I think we nailed it after a bunch of attempts and a bunch of samples. It was exhilarating to create a shoe. My goal was to do a running shoe—which is what I normally wear to DJ, to walk, to live—but do it with a basketball aesthetic so that I could keep the quality I'm known for but also keep the comfort of how I function. So the Piola Por Fin was the name of the shoe. In Spanish *por fin* means "at last." I was happy with it. I don't really know how they performed as far as sales, but I hope I've opened up the door for other brands and other collaborators to consider the possibility.

E.S.: The possibility to start from scratch, you mean?

B.G.: Yep.

E.S.: You've always been about giving back. Can you tell me how you use sneakers and basketball to make connections and to give back?

B.G.: Absolutely. The story, as documented in my film *Rock Rubber 45s*, is I was the host/creative producer of the first TV show dedicated to sneaker culture, *It's the Shoes*. Because of the platform's reach with professional athletes, it was clear we were going to be going into some millionaires' closets to see their collections, their signature shoes. They styled it like *Lifestyles of the Rich and Famous*. You know, "Champagne wishes and caviar dreams." You remember that show? I told the producers, "Look, let's do something a little bit deeper than that." So Jon Hock, the executive producer, came up with an idea: Why don't we get some sneakers autographed to be auctioned off? And I was like, I have the perfect nonprofit—that was Hoops for Hope—let's do a segment on that. We did it for the final episode of season one in 2005, and then the program started getting so much support nationwide. Sneaker donations quadrupled, and the funding increased, and the auction they held with the sneakers we had gotten autographed raised thousands of dollars. They wound up erecting a court in Harare, Zimbabwe, and they dedicated it in my name.

E.S.: And that's where you go in the film, right?

B.G.: Yeah, In *Rock Rubber 45s* I actually get to go to the court in Zimbabwe for a basketball clinic and really have a profound experience. I use that as an example to say that—similarly to how I feel about the collaborative experiences—never in a million years could I have fathomed as a kid from 97th Street playing ball at the park that there could even be something such as "sneaker fame," or that it could be used as a conduit for me to travel the world. I was the guest of honor at Str.Crd, which was the first event for the culture in Africa back in 2010. I was guest of honor at Sneakerness, the first European event for the culture in Switzerland. There's the Oslo Sneaker Fest, the Indonesian Jakarta Sneaker Fest. I'm being called from around the world to sign books, to sign sneakers, just to talk! Not even to play ball or DJ? It's like, "What? Are you serious? You're going to fucking fly me to the other side of the world just to show my face?" That's serious. It's crazy, Elizabeth, crazy. And I'm grateful. Grateful. ✳

Nike Air Force 1, PRO-Keds, and Piola collabs by Bobbito Garcia

CEY ADAMS X ADIDAS, ALI CLASSIC SUPERSTAR II

COLLECTION OF BATA SHOE MUSEUM, GIFT OF CEY ADAMS

"Adidas gave me the opportunity to collaborate and honor a true American hero. Muhammad Ali is a symbol of strength, courage, and fighting through obstacles. I selected the image and colors in my painting to represent growth and new beginnings. Inspired by his life lessons, I've strived to use my art to motivate positive change in my community."

—Cey Adams

New York City's Cey Adams emerged as an important graffiti artist in the 1980s and, along with Jean-Michel Basquiat and Keith Haring, produced work that helped define the decade. Adams was the first creative director of Def Jam records, where he created album covers, logos, and campaigns for musicians such as Run-DMC, Beastie Boys, Public Enemy, and Jay-Z that brought his artwork to millions.

In 2007 Adidas launched the Ali Values Project inspired by Muhammad Ali and the core values of respect, confidence, dedication, conviction, spirituality, and giving that guided Ali's life.

In consultation with Ali, Adidas reached out to six artists: Adams, LeRoy Neiman, Shepard Fairey, Eric Bailey, HVW8, and Usurgrow and commissioned them to each craft an artwork and collaborate on a collection of apparel and sneakers using one of Ali's values as inspiration. Cey Adams chose "confidence." Employing images from the newspaper coverage of Ali's remarkable rematch with Floyd Patterson in 1972, Adams created a graphically bold sneaker for the collection. *

2007

KANYE WEST

Musician, producer, and fashion and sneaker designer Kanye West is a polarizing figure in many arenas, but his impact on sneakers is undeniable. West has collaborated with Nike and Louis Vuitton, and in 2013 he began working with Adidas. Few sneaker collabs have created as much furor as those by Kanye West, and few have been so highly desired.

X

LOUIS VUITTON, DON, 2009

PRIVATE COLLECTION

In 2009 Kanye West, the self-styled "Louis Vuitton Don," released a line of sneakers with the luxury fashion brand Louis Vuitton. The collaboration solidified the connection between high fashion and street style. The sneakers were the epitome of luxury and featured premium materials and 24-karat-gold shoelace rings. Each sneaker in the collab was named after a person in West's circle. This style was named after his then manager, longtime friend and fellow Chicagoan Don C. ›

115

ADIDAS, YEEZY BOOST 750, 2015

COLLECTION OF ADIDAS AG

Kanye West began working with Adidas in 2013 and released his first sneaker, the Yeezy Boost 750, in early 2015. It was one of the most anticipated sneakers of that year; its minimal design and luxe materials marked a break with traditional athletic footwear. Nic Galway, Adidas's vice president of global design, credits West's discerning eye and hands-on approach to the collaboration for the success of the design. He commented in an interview with *Sneaker Freaker* magazine that West is a perfectionist who went to the factory on his own to see the sneakers. He wasn't satisfied, and they went back.[26] Appreciation of West's work extended beyond consumers; the footwear industry also took notice and in 2015 *Footwear News* named West's 750 the shoe of the year.

ADIDAS, YEEZY 500, 2018

PRIVATE COLLECTION

The monochromatic Yeezy 500 Desert Rat Blush is a study in silhouette and texture. The design features sophisticated patterning with cutaways and appliqués that highlight the various textures of the materials used, which include tumbled leather, smooth leather, suede, and mesh. The 500 marked West's engagement with the "ugly sneaker" trend and caused a stir when it was first released. ✶

CLARK KENT X NIKE, AIR MAX LEBRON VII ALL BLACK EVERYTHING

COLLECTION OF CHAD JONES

DJ Clark Kent, born Rodolfo Franklin, is one of the most influential figures in sneaker history. His career in music as a DJ and producer includes working with both Jay-Z and Notorious B.I.G. and introducing them to each other in the mid-1990s. He has likewise worked with many of the biggest names in the sneaker game. His first official collaboration was the Nike 112 pack in 2008 honoring Brooklyn, his hometown—112 being the first three digits of Brooklyn Zip codes.[27]

One of the rarest of his exclusive collaborations is the Air Max LeBron VII All Black Everything. Inspired by the line "all black everything" in Jay-Z's song "Run This Town," Kent decided to create an all-black Air Max LeBron paying tribute to both LeBron James and Jay-Z. The monochromatic shoe that he designed is a study in texture, from its ostrich-skin toecap to its perforated suede upper. Jay-Z's "Diamond Cutter" hand gesture is reproduced on the tongue, and the insoles list the achievements of the two superstars. Only twenty-four pairs of these PEs (Player Exclusives) were made, and of those only three came in specially made wooden boxes—one for LeBron James, one for Jay-Z, and one for Clark Kent.[28] *

2010

DAMIEN HIRST X CONVERSE, PRODUCT (RED) CHUCK TAYLOR ALL STARS

COLLECTION OF CONVERSE ARCHIVE

In 2010 the controversial and highly acclaimed British artist Damien Hirst collaborated with Converse to translate his artwork *All You Need Is Love* onto a sneaker to raise money for the charity (RED). The vibrant red textile embellished with photorealistic butterflies was based on a painting that Hirst had donated to Sotheby's 2008 auction for the charity. It fetched $2,420,000 in support of (RED)'s Global Fund to Fight AIDS, Tuberculosis, and Malaria. The 2010 collaboration between Hirst, Converse, and (RED) of a limited-edition Converse Chuck Taylor All Star likewise raised money and awareness of the charity. In Europe, the shoe dropped on November 5, 2010, and in the United States it became available on December 1, World AIDS Day.

Hirst has often focused on issues of mortality in his work. The painting that served as inspiration for this sneaker features butterflies adhered to the blood-red canvas as though they had been lured to their death by the scent of the fresh paint. Hirst's use of butterflies—traditionally symbols of the ephemerality of life that remain beautiful and vibrant even in death—made this work particularly poignant for a collaboration dedicated to raising awareness about AIDS. In an effort to remain faithful to Hirst's original work, the sneakers were crafted out of finely woven textiles printed using a high-definition laser printer. Only 400 pairs were made available worldwide. ∗

2010

VASHTIE KOLA X JORDAN BRAND, AIR JORDAN II RETRO

COLLECTION OF VASHTIE KOLA

In 2010 renowned director, filmmaker, DJ, designer, creative director, and style icon Vashtie Kola became the first woman to collaborate on an Air Jordan. She was also the first person to collaborate on the Air Jordan II.

E.S.: How did you arrive at the design for your version of the Air Jordan II?

V.K.: The year I was offered the opportunity to design a Jordan was the twenty-fifth anniversary of the "II." Jordan Brand was looking to do something in honor of it. I intentionally added hints of amber and silver in the design to honor the occasion.

E.S.: Why did you decide to make the shoes violet?

V.K.: It's an extension of my brand Violette, whose name was meant to symbolize a merging of female and masculine through the representation of color (red + blue = purple). I chose a pale lavender with gray tones to increase its masculinity, so as not to read as a "girl's shoe." ›

2010

E.S.: As the first woman to collaborate with Jordan Brand, do you think that women are going to be increasingly embraced as collaborators for both men's and women's sneakers?

V.K.: Absolutely. Oftentimes, behind the scenes, women are already designing for men's brands. But I think the shift of brands collaborating with female designers to create women's and men's footwear is about to explode.

E.S.: What do you think is the future of collaboration?

V.K.: I think it will be a continuation of brands finding authentic people to create a collaboration that speaks to the brand and the individual in a unique and honest way, leaving behind celebrity/influencer-endorsed "collaborations" that feel empty and flat. We are evolving, and people want to invest in things that are cool, have a history, and also have meaning. ∗

"I CHOSE A PALE LAVENDER WITH GRAY TONES TO INCREASE ITS MASCULINITY, SO AS NOT TO READ AS A 'GIRL'S SHOE.'"

125

SWIZZ BEATZ X REEBOK, KAMIKAZE III MID

COLLECTION OF REEBOK ARCHIVE, REEBOK INTERNATIONAL, LLC.

Record producer, DJ, rapper, art collector, and entrepreneur Kasseem Dean, also known as Swizz Beatz, began collaborating with Reebok in 2010. In 2011 he was named its creative director and announced his new role with a reimagined heritage model, the Kamikaze.

The first Kamikaze came out in 1994 as the signature shoe of NBA star Shawn Kemp. Its bold graphic design was meant to reflect the electrifying energy and power that Kemp brought to the game. Kemp's second shoe pushed the design envelope even further. For the Kamikaze III, Swizz Beatz retained the graphic punch of the earlier models but reinterpreted the design in a range of colorways, including this more subdued steel gray and blue. He also emphasized the materials, from the Hexalite midsole to the patent-leather toe cap. The large, suede-covered tongue sporting a bold R is a nod to basketball shoes from the late 1980s and early 1990s. ✶

2011

CONCEPTS

For twelve years, beginning in 1996, Concepts operated out of the back of The Tannery in Cambridge, Massachusetts. It was a hidden haunt with a reputation for stocking rare sneakers. What started as a small store catering to local insiders went on to become an international brand with stores in Boston, New York, and Dubai. Many point to Concepts as the impetus behind the introduction of the retro runner into sneaker culture and credit it with helping to revive the New Balance brand.

X

NEW BALANCE, 999 "KENNEDY" RETRO, 2017

COLLECTION OF CONCEPTS

One of the most memorable Concepts collaborations was the 2011 New Balance 999 Hyannis, also known as the "Kennedy," designed by Frank "The Butcher" Rivera, the brand manager at Concepts at the time. Rivera was inspired by sailing and decided to use a range of nautical elements to evoke the Cape Cod lifestyle. When Simon "Woody" Wood, founder of *Sneaker Freaker*, decided to put the shoe on the cover of the magazine, he asked for its name. Rivera realized that he had not actually given the sneaker a name and, with images of former President John F. Kennedy on vacation in Cape Cod on his mind, blurted out, "the Kennedy."[29] When it turned out that name could not be used, the sneaker was officially renamed the Hyannis, although "Kennedy" remains a popular nickname.

In 2017 Concepts decided to make the "Kennedy" its first retro release. The updated version was manufactured in the United States at New Balance's premium facility. It features a number of tweaks to the original design, including switching out ripstop material for perforated suede on the back quarters. Typical of Concepts collabs, it also came in a specially designed box. ›

129

X

NEW BALANCE, 997 ROSÉ, 2014

COLLECTION OF CONCEPTS

The opening of a new Concepts pop-up boutique in New York in advance of a permanent store was commemorated with a Concepts x New Balance sneaker inspired by a luxury edition of Piper-Heidsieck rosé Champagne, which for a limited time was sold in mock-croc packaging. The New Balance 997 was done in rose-colored suede with hints of silver 3M Scotchlite reflective material embossed with a crocodile pattern used throughout the design. Like the Hyannis, the Rosé graced the cover of *Sneaker Freaker* magazine and became a cult favorite.

X

NIKE SB, DUNK LOBSTER, 2009

COLLECTION OF CONCEPTS

Concepts creative director and coowner Deon Point believes one of the brand's strengths is telling stories through sneaker design. One of the most storied Concepts collabs is the series of Lobsters with Nike SB, starting in 2008 with the red version. The Blue Lobster came out the next year. That was a highly anticipated drop with a long customer lineup outside the Boston store. Playing up the rarity of blue lobsters in the wild and heightening the drama, individuals dressed in orange hazmat suits delivered the sneakers to the venue. The dark blue sneakers featured blue-and-white-checked lobster bib–inspired linings, and rubber bands around the foreparts alluded to the bands placed around the claws of live lobsters for shipping. Each pair came in a clear specimen bag and was boxed in a Styrofoam container. ✱

131

HUSSEIN CHALAYAN X PUMA, URBAN SWIFT

COLLECTION OF PUMA ARCHIVE

"My curiosity is about understanding the dullness of life in general and creating a world where I can propose other ways of looking at the body and its role in culture, consequently creating one that fills the gap between fantasy and reality."[30]

—Hussein Chalayan

Hussein Chalayan is one of the most innovative fashion designers of the twenty-first century. His embrace of technology and new materials consistently results in clothing that blurs the boundaries between fashion, art, and social commentary. Many of Chalayan's designs have captured the attention of the fashion world, including his Fall/Winter 2000 collection, which featured a coffee table that transformed into a skirt, and his Spring/Summer 2016 collection, which featured water-soluble clothing. Over the years, Chalayan has collaborated with numerous brands, including Puma, where he was appointed creative director in 2008.

Of the numerous sneakers that Chalayan designed with Puma, the Urban Swift is perhaps the most striking. It was inspired by his Spring/Summer 2009 collection, which featured molded latex garments that appeared frozen mid-motion. Handcrafted by Italian shoemakers, the Urban Swift featured leather "spikes" created using injection-molded thermoplastic polyurethane under molded leather to suggest movement stopped in time. *

2011

DAVE WHITE X JORDAN BRAND, AIR JORDAN I RETRO WINGS FOR THE FUTURE

COLLECTION OF DAVE WHITE

British artist Dave White began making paintings of sneakers around 2002 after he was struck by the form of a pair of Air Max 95s. He was inspired by the architecture of sneakers and wanted to immortalize them while simultaneously expressing their essential ephemerality—meaning that sneakers are designed to be worn until they are completely worn out. His resulting paintings seem to pin the sneakers in time and space. He even mixed the paint that he used to depict the midsole of the sneaker with elements that would yellow over time, causing the artwork to age like the soles of sneakers themselves.

After completing his painting series in 2007, White continued to work on sneaker collaborations, including this 2011 project for Jordan's launch of its charitable initiative, Wings for the Future. The design of the shoes captures White's energetic style, complete with vigorous brushstrokes and paint splatters. Although the majority of these details were printed onto the leather, each pair was also hand-painted in parts by White to add depth to the design on the uppers. Other details representative of White's work include stars, a frequent motif, and canvas on the tongue and for the sock liner in a nod to White's work as a painter.

White noted, "I wanted to create a shoe that was incredibly special, one that captured the movement and dynamism of basketball and reflected something that a USA champion would be awarded. It was an incredible honor to have a signature Air Jordan I released and was a dream come true for me. Only twenty-three pairs were made, making this a very exclusive release in aid of the Jordan Brand charity Wings for the Future. The proceeds raised via auction were directly used for school and community projects."[31] *

2011

TOM SACHS X NIKE, MARS YARD

COLLECTION OF TOM SACHS

The Mars Yard retained the feeling of hand manufacture but also featured cutting-edge details, such as Vectran ripstop fabric for the uppers and Nike Special Forces outsoles. Vectran was originally designed at NASA's Jet Propulsion Laboratory outside Pasadena, California, for the purpose of making airbags for the Mars Excursion Rover. The Mars Yard 2.0 was released in 2017 and saw the Vectran replaced by knit mesh.

E.S.: What were you thinking about when you were working on the Mars Yard collab? Does the assemblage of materials tell a story?

T.S.: There are limitations and advantages that come with any material, equipment, or collaborator. This is something that neither of us could have done without each other. Working with Nike is exactly like everything else I do: I work to always show the process and keep transparent about the materials. The Mars Yard is made of undyed or "native" color; only the advertising part is red. The donning straps tell you how and where to get in and out of the shoe. ∗

One of the most coveted sneaker collaborations to date, the Nike Mars Yard, was created by artist Tom Sachs and Nike in 2012. Sachs rose to art world fame with works that explored the fetishization of branding, particularly in connection to prominent global luxury fashion houses. Central to his work is the concept of bricolage, working with materials at hand, as well as highlighting makers marks in reaction to the anonymity of mass-produced consumer goods. Sachs's collaboration with Nike began after he had a conversation with Nike CEO Mark Parker on the value of individual handicraft versus uniform mechanized factory production.

Sachs began the collaboration by establishing whom he was designing the sneakers for—athletes, but not typical Nike athletes. Instead, his focus was on intellectual "athletes," such as those who work in aerospace engineering. As his booklet for the project states: "Long gone are the days of wing-tipped brogues, pocket protectors, and skinny ties. The rocket scientist uniform of today is faded jeans, a golf shirt, and sneakers. These shoes are built to support the bodies of the strongest minds in the aerospace industry."[32]

MARS YARD SHOE

From NIKECraft 2012

(NOTE: IN TIME, TONGUE FOAM MAY SHED. THIS DOES NOT AFFECT PERFORMANCE BUT PROVIDES FORENSIC BREAD CRUMB TRAIL.)

At NIKECraft, products are developed for athletes, not consumers.

Our athlete, Tommaso Rivellini, is a mechanical engineer at Jet Propulsion Laboratory in Pasadena, California. Among many other projects, Tommaso invented the airbags used on the 1997 and 2004 Mars rovers. Long gone are the days of wingtipped brouges, pocket protectors, and skinny ties. The rocket scientist uniform of today is faded jeans, a golf shirt, and sneakers. These shoes are built to support the bodies of the strongest minds in the aerospace industry.

Special features include: outsoles borrowed from the NIKE special forces boot (SFB), vectran fabric from the Mars Excursion Rover airbags, and detailing from Apollo Lunar Overshoes. These premium athletic shoes thrive in the rugged terrain of the simulated Mars Yard in Pasadena, CA - as well as stealthily creeping the mission-funding hallways of headquarters in Washington, D.C.

2012

137

MISSONI X CONVERSE, ARCHIVE PROJECT

COLLECTION OF CONVERSE ARCHIVE

Famed Italian knitwear brand Missoni began collaborating with Converse in 2009, releasing limited-edition sneakers sporting iconic Missoni patterns. Knit technology was just beginning to emerge in sneaker production, making the Missoni x Converse collaborations prescient. In 2012 the collaboration became even more exclusive when Missoni offered Converse actual deadstock material to use in the making of an extremely limited release of sneakers. In all, only twenty one-of-a-kind sneakers—ten Pro Leathers and ten Auckland Racers—were created, each incorporating a different fabric sample dating from 1994 to 2011. The sneakers were released at the famed Parisian boutique Colette on September 28, 2012, and sold out instantly.

Missoni was founded by Ottavio "Tai" Missoni and his wife, Rosita Jelmini. Missoni met Jelmini on the opening day of the 1948 Olympics, where he was competing as a sprinter on the Italian track team.[33] The company that the two established in 1953 focused on knitwear, and the popularity of their first offering, knit tracksuits with zippers integrated into the pants, would help push fashion forward to what would come to be called athleisure. ✻

2012

MELODY EHSANI

Halfway through completing a law degree, Melody Ehsani left school, got on a plane to China, and settled in Guangzhou, where she produced her first shoe collection. Months later, in 2007, she returned home, shoes in hand, and sold them out of her studio apartment.[34] From that bold beginning emerged a line of thought-provoking jewelry and clothing that quickly garnered attention. She opened her first brick-and-mortar boutique in Los Angeles in 2012.

Central to Ehsani's work is her belief in equal rights and opportunities for women, which is reflected in her designs and how she collaborates. Her positive messages and fashion-forward aesthetics led Reebok to reach out to her in 2012. Of all the sneakers she has collaborated on, Ehsani's favorites are the Reebok Classics Pump Omni Lite Love Me or Leave Me Alone, which came out in 2014; the Reebok Ventilator; the Reebok Blacktop Pump Wedge pack from 2015; and the 2016 Iverson Reebok Question.

E.S.: Did you select the silhouettes for your Reebok collabs, or were they suggested by Reebok?

M.E.: For the Pump Omni Lite Love Me or Leave Me Alone I expressed to Reebok that I wanted to work on the Pump, and they chose the style based on a current program they had going on internally. For the Iverson, it was an anniversary year, so I was a part of a collective of other influencers and designers who got to do their own versions of the shoe.

E.S.: Do you know if this was the first time these silhouettes were offered in women's sizes?

M.E.: I believe that the Question had been offered in women's sizing before. However, this collab was the first time it had been designed by a woman as a woman's shoe in women's sizing.

E.S.: All of your collabs are so visually engaging, especially the Pump. How was the pattern for the upper determined? Did it already exist, or did you design it? Clearly you designed the deubrés and the lock. The bold LOVE seems straightforward in its messaging, but what did the lock stand for?

M.E.: I designed the snakeskin pattern on the Pump Omni Lite. I was really inspired by python at the time and had already done some different renditions, so it was just the evolution of that stage that I was in. The lock was an attempt to bring a jewelry element into the design. When I was younger, I used to take the charms or key tags off of shoes and wear them on my necklace chain. The lock was supposed to be this kind of piece.

E.S.: I have read that the Iverson Question was inspired by Iverson's daughters and their mother. Can you tell me about that?

M.E.: Yeah, I wanted the shoe to speak to women. Often women are intimidated by basketball shoes because they're super bulky and not geared toward women. So, I tried to speak to women through the materials and design, but I also wanted to circle that around in the visuals and the imaging. Iverson's wife at the time, Tawanna, is a force, and she played a huge role behind the scenes in his life. I wanted to pull her out of the shadows and shine a light on her and honor her role in supporting her man in the way she did during his career. He also has three incredible daughters, each of whom is her own sort of female archetype. They are a testament to the multifaceted nature of Iverson and his personality. It was an incredible experience going to their home and spending the day with them. It connected me to the whole process in a special way, and I am thankful they invited me in because they're very private—rightfully so.

E.S.: I love that you are clearly interested in language and in the power of words to make statements or tell stories. Much of your jewelry and your clothing features ›

words, but it seems that your sneakers often have longer narratives. I like this one: *"It's my hope that every step you take in these shoes gives you memory of who you truly are and why you're here. You don't need permission to be amazing. Shine as bright as a supernova. We can handle you. Honor your history, but don't live it. You are designed to unfold in ways that have never existed in your family or in the world. Choose to create your path, unapologetically. Anybody can imitate— you were designed to create. Does that resonate? The movement is: freedom to move forward. Forward towards the life you were created to live, the individual you were destined to be. So Be! Be! Be!"* **I am interested especially in the fact that so many of the messages are hidden and seem to be intended specifically for the wearer, which makes your messages feel personal.**

M.E.: The words and messages are intended for the wearer. I really just want to spread love and support people in being who they are in the world. I think it's important we have reminders of our greatness, because it's so easy to get distracted and forget. It's hard to forget when you're putting your foot into it, though. ✱

"IT'S MY HOPE THAT EVERY STEP YOU TAKE IN THESE SHOES GIVES YOU MEMORY OF WHO YOU TRULY ARE AND WHY YOU'RE HERE. YOU DON'T NEED PERMISSION TO BE AMAZING."

The Question, Pump Omni Lite, Blacktop Pump Wedge, and Ventilator Reebok collabs by Melody Ehsani

143

GARBSTORE X REEBOK, OUTSIDE IN INSTAPUMP FURY

COLLECTION OF REEBOK ARCHIVE, REEBOK INTERNATIONAL, LLC.

For years, Ian Paley, the British designer, entrepreneur, and founder of the London boutique Garbstore, was interested in the fundamentals of building a shoe. The idea for his Outside In collaboration with Reebok grew out of this need to understand how sneakers are made. During his first meeting at Reebok, he was able to go into the archive and closely examine historic models. Intrigued by the construction of the archival shoes, Paley tried to puzzle out how they had been created and wished that he could turn them inside out so that he could examine all their details. It was this desire to see the interiors of the sneakers that led him to redesign twelve classic Reebok shoes "inside out."

Paley's seemingly simple concept turned into an extremely ambitious project. This collaboration was not about a simple change of colorway; Paley wanted the internal parts of the sneakers to be made visible on the exterior. This required a complete reimagining of each shoe and the technical skills of Ash Taylor, senior director of global product marketing at Reebok. Taylor remembers, "It was the combination of Ian's vision and the relative simplicity of the concept that was most inspiring to us. The more we understood the nature of Ian's attention to detail and dedication to materials, the more it became a passion project for us all. We, too, wanted our brand fans to see what was inside our shoes! The project has clearly stood the test of time, as many of our competitors, even now in 2018–2019, are applying this approach to their own products. Imitation is the sincerest form of flattery."[35]

The final shoes were true to Paley's vision down to the smallest details, including the sewing of the production tags onto the outside rather than the inside of the tongues of each model. The size of the collection was also remarkable. In all, twelve classic Reebok shoes were turned inside out, including the Instapump Fury. ✻

2013

MAISON MARTIN MARGIELA X CONVERSE, CHUCK TAYLOR ALL STAR

COLLECTION OF CONVERSE ARCHIVE

In 2013 the avant-garde French fashion house Maison Margiela collaborated with Converse to create a limited-edition release of Chuck Taylor All Stars and Jack Purcell sneakers. The collab was part of Converse's First String initiative, which focuses on high-end craftsmanship and collaboration in sneaker design. Each Maison Margiela x Converse sneaker was entirely hand-painted in coats of matte white paint, including all the exterior surfaces, uppers, soles, tongues, and even the shoelaces. This not only ensured that each individual pair was unique, but also reflected the fashion house's famous use of white paint. As the house noted upon release of the sneakers, "The Maison has always been obsessed with white; it is used as a layer to give an incognito feeling. A sort of poetry, with the passage of time, the shoe asserts itself."[36] The white paint also hinted at the mystery surrounding the house's reclusive founder, Martin Margiela, who eschews all press and photography.

Out of the box, the sneakers appear crisp white, but with wear the paint slowly flakes off, eventually revealing brightly colored canvas uppers in red, blue, black, or yellow. This process captures the unique relationship between the wearer, the sneaker, and the brand, as the sneakers become increasingly personalized each time they are worn. *

2013

BUN B x JORDAN BRAND, ALL STAR CP3. VI

COLLECTION OF BUN B

Bun B, born Bernard Freeman, is one of the most important voices in Southern rap and R&B. Hailing from Texas, he became famous as one-half of the rap duo Underground Kingz (a.k.a. UGK), but following the death of his other half in UGK, Pimp C, in 2007, he established himself as a solo artist. Bun B is also a lecturer on religion and hip-hop culture at Rice University and has a popular food blog. His deep interest in sneakers has resulted in a number of important collaborations, including the one with Chris Paul, player for the Houston Rockets, and the Jordan All Star CP3. VI, which he undertook for the 2013 NBA All-Star Weekend. Only twenty-three pairs of this collab were produced.

E.S.: You have done quite a few sneaker collaborations. Why did you choose to do the Chris Paul x Jordan All Star?

B.B.: Actually Chris Paul picked me! He had been chosen for the All-Star Game that year, which was happening in Houston. He wanted a practice shoe that spoke to the culture of the city, so he talked to Reggie Saunders at Jordan Brand and they decided I would be the best person for the job. I was flown out to Chris's house in L.A. with designers from Jordan, and we came up with the concept.

E.S.: Can you point out the details on the sneaker? There is a lot of Texas in this shoe!

B.B.: The star on the tongue and the navy/orange colorway were a tribute to the Houston Rockets. The stitching on the tongue speaks to how many people customize the seats of their cars here. It's known locally as having them "stitched and tucked." The silver on the shoe is meant to speak to the chrome rims that many people here have on their cars. The design on the toe is representative of people who customize the hoods and trunks of their cars. There are also a couple more homages to the city, like having "Hold up" on the pull tab, which is a phrase here that means, "What is that? That looks nice!"

E.S.: Can you say anything about communicating through the medium of sneakers?

B.B.: Sneakers help to define who you are. I can tell a lot about you by the sneakers you choose to wear. Who you are, where you're from, and what you represent can sometimes be deduced by what's on your feet. So in a room full of strangers, I can often find a like-minded individual by the shoes they're wearing. The shoes can become icebreakers! *

2013

RICK OWENS X ADIDAS, RUNNER

COLLECTION OF RICK OWENS

The inaugural shoe of the Rick Owens x Adidas collaboration was the unisex Runner; its bold silhouette included a hooflike sole, oversized tongue, and padded leather ankle collar. The Runner set the tone for the many collaborations that Owens would be involved in with Adidas.

E.S.: Have sneakers always been important to your work?

R.O.: I started going to the gym in the 1990s and hated how conventional and pedestrian sneakers looked, so I made a turbo monster-truck parody of them that had some drama. I never really expected anyone to respond, they were just a personal indulgence. That lesson taught me always to trust my personal whims.

E.S.: How did you start collaborating with Adidas? Is it true that you wanted to design a running shoe for yourself? Was it because you were interested in creating running shoes that the architecture of the Adidas collab footwear was so radical?

R.O.: I wanted their technical expertise to create an authentic running shoe for myself as motivation to do some cardio, but corrupting sneaker culture was also part of the fun. I have to say, they were extremely accommodating and never really blinked at what I proposed. And if I was going to do a collab with anyone, altering a shoe architecturally instead of superficially was always my main aim. But once my runners were produced, I realized I just hated running. ✱

2014

WU-TANG CLAN X HUF, HR-1

COLLECTION OF KEITH HUFNAGEL

Huf was founded in 2002 by professional skateboarder Keith Hufnagel in San Francisco as a skateboarding and streetwear-focused store and brand. Collaboration was central to Huf's identity from the beginning, and in 2014 the brand collaborated with legendary East Coast rap group Wu-Tang Clan on an exclusive capsule collection created in honor of the twentieth anniversary in 2013 of the release of the group's first album, *Enter the Wu-Tang (36 Chambers)*. In addition to the Huf HR-1 sneakers, the pack included a football jersey, a strapback hat, and jacquard woven socks.

In keeping with the black and yellow Wu-Tang palette, albeit with the yellow here represented by gold, the Huf HR-1 was styled with a hiking-boot upper and a runner sole, including a gold-speckled midsole. The rope laces were in gold and black and the tongue featured an appliqué patch embossed in gold with both the Wu-Tang and Huf logos as well as the words "20th Anniversary Enter the Wu-Tang 36 Chambers." The lateral quarters were stamped with the Wu-Tang logo in gold along with a Huf logo tab. The insole featured images from the original album cover art. *

2014

153

RAF SIMONS X ADIDAS, OZWEEGO

COLLECTION OF RAF SIMONS

Belgian fashion designer Raf Simons started out in industrial design focused on furniture, but he then turned to men's fashion, establishing his eponymous line in Antwerp in 1995. Over the years, in addition to maintaining his brand, Simons has also been the creative director at Jil Sander, Christian Dior, and most recently Calvin Klein, where he was the chief creative officer. He has also been collaborating with Adidas since 2013 to create sneakers for his own line.

From his very first collab, his interest in "the interplay of pure construction and new shapes with the body and psyche of the contemporary man"[37] has been keenly evident. His most enduring silhouette to date is his reimagined 1990s Adidas running shoe, the Ozweego. Seemingly composed of both a shoe and an overshoe, the Ozweego has a layered effect highlighted through the use of contrasting color. The overall look is fashionably bulky, and Raf Simons has been credited with helping to establish the "ugly-sneaker" trend. ✱

2014

RIHANNA X PUMA, FENTY CREEPER

**COLLECTION OF BATA SHOE MUSEUM,
GIFT OF PUMA**

In late 2014, superstar Rihanna, born Robyn Rihanna Fenty, was appointed creative director of Puma. Rihanna was brought on board to collaborate on women's footwear and apparel specifically. But when she reimagined the classic Puma Basket as the Fenty Creeper—with the design assistance of Los Angeles–based fashion label Mr. Completely—a rare fashion occurrence took place: despite being designed for women, the shoe was desired by men.

The Fenty Creeper updated the Puma Basket model by adding a heavy brothel creeper sole reminiscent of the footwear worn by British Teddy Boys in the 1950s and revived again in 1980s punk fashion. Rihanna was drawn to the idea of the extra-heavy sole after seeing the work of Mr. Completely, who had become famous for customizing sneakers by adding creeper soles to them. She turned to him for help with her Puma collaboration.[38] Rihanna contrasted the heavy gum soles with uppers of luxurious velvet. The Puma stripe was also in silky satin, as were the laces.

The drop was so highly anticipated that the shoes sold out in only three hours, with many men disappointed that the sneaker came only in women's sizes.[39] A men's version was dropped two months later and it, too, sold out in a single day.[40] The industry took notice, and in 2016 Rihanna became the first woman whose creation was named shoe of the year by *Footwear News*. ✶

2014

GE x ANDROID HOMME, THE MISSIONS

COLLECTION OF BATA SHOE MUSEUM, GIFT OF GE

In 2014 General Electric (GE) decided to celebrate the forty-fifth anniversary of the first moon landing by collaborating with luxury sneaker brand Android Homme to make 100 pairs of lunar boot–inspired sneakers using innovative GE materials. In the 1960s, GE worked closely with NASA to develop new materials for space flight. One of those innovative materials was silicone rubber, which GE had been working on since World War II. In contrast to natural rubber, silicone rubber is able to withstand extreme heat and cold without degrading, and it was chosen as the material for the boot soles of the original lunar boots worn by Apollo 11 astronauts Neil Armstrong and Edwin E. "Buzz" Aldrin Jr., the first humans to set foot on the surface of the moon.

For their mission, the astronauts actually wore two types of footwear: their Pressurized Garment Assembly (PGA) boots, which were integral to their pressurized space suits, but to walk on the moon they wore lunar boots pulled over the PGA boots. The lunar boots featured fabric of woven chromium steel and silicone rubber soles with ridges shaped to fit the rungs of the lunar module's ladder.[41] Aldrin immortalized the historic occasion in a photo that he took of his footprint on the pristine surface of the moon, later writing, "that single footprint shot became one of the most famous photographs in history, and a symbol of man's need to explore."[42]

The shoes created by Android Homme paid homage to this history by using a number of revolutionary GE materials, including stabilized carbon fiber, 3M Scotchlite reflective material, thermoplastic rubber, and a hydrophobic coating typically used to prevent ice from forming on wind turbine blades.[43] However, rather than the traditional NASA white, gray, and light blue color scheme, reflective and translucent materials were chosen for the Missions, giving them a futuristic look. The shoe was released by the online retailer JackThreads on July 20 at 4:18 p.m. on the East Coast, the exact date and time the lunar module landed in 1969. The sneakers were sold for $196.90 to honor the historic occasion. ✽

2014

SNEAKERSNSTUFF

Sneakersnstuff (SNS) was founded by Peter Jansson and Erik Fagerlind in 1999. They were frustrated by the limited selection of sneakers available in Sweden at that time and opened their first store in Stockholm. Since then, Sneakersnstuff has become one of the most significant streetwear retailers in Europe with stores in Berlin, London, Paris, Los Angeles, and New York. Sneakersnstuff has earned a reputation for the excellence of its designs since its first collab in 2003.

X

SOCIAL STATUS x ADIDAS, CONSORTIUM, 2017

COLLECTION OF SNS

Adidas created Adidas Consortium to allow independent retailers to have access to exclusive sneakers and to collaborate with each other through its Sneaker Exchange. In 2017 the Sneaker Exchange brought Sneakersnstuff and Social Status together. The pack the two retailers collaborated on included an Adidas Superstar and an Ultra Boost, which Fagerlind has called the Superstar of his generation. Through the collaboration, the sneakers were transformed into luxury lifestyle shoes using high-end materials, including tonal Primeknit uppers and leather accents across both designs.[44] ›

X

MOOMIN x KARHU, ALBATROSS PACK, 2014

COLLECTION OF SNS

In 2014 Sneakersnstuff collaborated with two Finnish icons, the legendary sneaker brand Karhu and the famous Finnish cartoon family the Moomins. Karhu approached Sneakersnstuff with the idea of doing a collab based on the Albatross running shoe. Sneakersnstuff suggested that the Moomins should also be part of the design. The Moomins characters were created by Tove Jansson and were first unveiled in Finland in the 1940s. The Karhu Albatross, originally introduced in 1982, was redone in two new colorways, each with graphics depicting scenes from Moomin life. One featured an allover floral design representing the valley where the Moomin family lives, while the other had a black colorway and featured the character Little My, who is known for her dark temperament. The famous Karhu bear icon was replaced on the shoes with the image of a running Moomin.

X

REEBOK, VENTILATOR BEES AND HONEY, 2015

COLLECTION OF SNS

For the twenty-fifth anniversary of the Ventilator, Reebok reached out to Sneakersnstuff. Central to the success of the Ventilator when it first came out in 1990 was the use of Reebok's new Hexalite cushioning material, which was based on honeycomb patterns. Inspired by this technology, Sneakersnstuff decided to focus on the modern-day plight of bees and included the Swedish organization Bee Urban, which promotes urban beekeeping, in the collaboration. Part of the collab included sponsoring beehives that would produce honey that could be given away with the sneakers. As the name Bees and Honey suggests, bees informed the design, from the black and yellow colorway to the yellow honeycomb pattern used on the tongue and shoe lining. The embroidered bees on the back counters made the association unmistakable. ✱

OVO x JORDAN BRAND, AIR JORDAN X RETRO

COLLECTION OF OVO

Collaboration has always been central to the success of OVO (October's Very Own), the brand established by Canadian musician Drake and his partners Oliver El-Khatib and Noah "40" Shebib in 2008. The very first OVO collabs were with Canadian brands Canada Goose and Roots, but in 2013 OVO began working with Jordan Brand.

The first official sneaker was the limited-edition OVO x Air Jordan X Retro, which came out in 2015—the X was chosen in honor of Drake's birthday in October, the tenth month of the year. The first drop was in an all-white colorway and featured tumbled leather uppers with touches of stingray leather. Subtle gold accents can be found throughout the design, including a gold-flecked translucent sole, the words "AIR JORDAN," and the number twenty-three in gold on the tongue, the Jumpman embroidered in gold thread on the back heel, and the signature OVO owl printed in gold on the insole. *

2015

PARLEY FOR THE OCEANS x ALEXANDER TAYLOR x ADIDAS, PARLEY FOR THE OCEANS

COLLECTION OF ADIDAS AG

In December 2014 the Sea Sheperd Conservation Society collected seventy-two kilometers of illegal deep-sea gill nets in the Southern Ocean.[46] In response to this shocking haul, Cyrill Gutsch, founder of Parley for the Oceans, and Adidas reached out to Alexander Taylor, founder of the eponymous industrial design studio, to help design the first sneaker with ocean-plastic thread for presentation at a United Nations x Parley for the Oceans event. Since the launch of this first sneaker, the collaboration between Parley for the Oceans and Adidas has grown to include clothing. In addition, Adidas has committed to reducing its use of plastics with the goal of eliminating virgin plastic from its supply chain.[47] ∗

"When I took a call from Cyrill [Gutsch] and Adidas asking if we could make a shoe from ocean plastic in eight days, I had no idea the impact it would have and continues to have today, as an object to tell a story, with a symbolic call to action, truly illustrating the power of design."

—Alexander Taylor

In 2015 Parley for the Oceans began collaborating with Adidas as part of its effort to innovate solutions that address the environmental challenges that threaten the world's oceans. Central to its work is the idea that "the power for change lies in the hands of the consumer ... and the power to shape this new consumer mindset lies in the hands of the creative industries."[45] One of its most important innovations to date is thread created from reclaimed and recycled ocean plastics that can be used in a range of products.

2015

TAKASHI MURAKAMI X VAULT BY VANS, CLASSIC SLIP-ONS, SKULL

COLLECTION OF ARNOLD LEHMAN

Renowned Japanese artist Takashi Murakami often challenges the high culture/low culture binary through his work. He boldly plays the vocabularies of fine art and popular culture to create small-scale collectables as well as large-scale paintings. He also frequently engages with fashion: one of Murakami's most famous collaborations was with Marc Jacobs at Louis Vuitton in 2003. Murakami's work has links to long-standing traditions in Japanese art, particularly the art of the Edo period (1603–1868), when revered painters would decorate clothing for important patrons and also design woodblock prints that were mass-produced for popular audiences.

In 2015 Murakami reached out to Vans about doing a collab because he was a fan of Vans slip-ons. One of the motifs he chose for uppers was his famous skull pattern. The roiling skulls suggest both the Western tradition of *vanitas* imagery and Buddhist concepts of *ukiyo*—the floating world where all is transitory—perfect for a pair of sneakers. ∗

2015

FUTURA x CONVERSE, CHUCK TAYLOR ALL STAR II

COLLECTION OF LEONARD HILTON McGURR

The first artist to do a collaboration with the Converse Chuck Taylor All Star II was pioneering New York graffiti artist Leonard Hilton McGurr, known as Futura. In the late 1970s and early 1980s, Futura began to gain attention for his bold use of abstract imagery in his graffiti. He is credited with helping graffiti move from a word-based art form to one given over more fully to abstraction. Futura has participated in a number of sneaker collaborations, but the Chuck Taylor All Star II marked his first time working with Converse.

The sneakers display a play between matte and sheen. The upper of the sneaker was made from a matte rubberized material printed in camouflage and embellished with Futura's signature graphics in fine high-gloss lines. The sneakers also came with interchangeable Velcro patches that could be attached over the traditional Converse ankle patch. Inspirational words such as "passion" were printed in high gloss on the laces, and the sneakers came with two Lunarlon insoles featuring details from Futura's paintings. ✱

2016

PHARRELL WILLIAMS X ADIDAS ORIGINALS, NMD HUMAN RACE

COLLECTION OF ADIDAS AG

Pharrell Williams is a renowned musician and producer with a deep interest in fashion and design, and he has an extensive list of collaborations to his credit. In 2003 he created the Billionaire Boys Club (BBC) and Icecream fashion labels with Bathing Ape founder Nigo. His work with Adidas began in 2014, and it offered Williams the opportunity to work on designs for existing sneaker models and to help create new silhouettes, using textiles made from recycled plastics produced by his company Bionic Yarn.

One of Williams's most famous sneaker collabs is the NMD Human Race, which features the words "HUMAN" and "RACE" in English, French, or Japanese knit into the uppers. His goal was to tell different stories through the sneakers, to show that "As society evolves, we realize the blend of cultures is an enriching thing. We are learning that we can celebrate our differences and not let them divide us."[48]

The NMD model was developed by Nic Galway, Adidas's vice president of global design. As is typical of Galway's work, the NMD, also called the Nomad, was inspired by several historic Adidas innovations, including the Micropacer, the Rising Star, and the Boston Super, which all date to 1984. It also moved sneaker design away from athletics and into lifestyle with its Primeknit uppers combined with boost soles. *

2016

SOCIAL STATUS AND A MA MANIÉRE

James Whitner grew up in Pittsburgh. After graduating from college he moved to Charlotte, North Carolina, where he opened his first store, Flava Factory. Realizing that there was an opportunity in so-called secondary markets, he opened a new store called Social Status in 2009. Social Status marked a shift in his retail focus toward luxury and more exclusive brands. Whitner now owns nine clothing and sneaker boutiques, including Social Status stores in North Carolina, Georgia, Pennsylvania, and Florida. His crown jewel is the exclusive A Ma Maniére in Atlanta.

SOCIAL STATUS X JORDAN BRAND, AIR JORDAN VI NRG, 2019

COLLECTION OF SOCIAL STATUS

The Air Jordan VI NRG marks the first collaboration between Jordan Brand and Social Status. In 2019 the NBA All-Star Game was played in Charlotte, North Carolina, for the first time since the first game was held there in 1991. Social Status chose to collaborate on the Air Jordan VI, the model that Michael Jordan wore during that first game. But rather than stay true to the classic infrared colorway, they ›

were inspired by Jordan's childhood nickname, the "Black Cat," and complemented the sneaker's range of rich blacks with dark purples and grays.

A MA MANIÉRE

X

DIADORA, N.9000 GEORGIA PEACH, 2016

COLLECTION OF JAMES WHITNER

The French phrase *à ma manière* translates as "in my way" and reflects this boutique's focus on giving clients access to the most exclusive styles so that they can craft highly individual fashion statements. In 2016 the retailer teamed up with Diadora to create a sneaker that was "an ode to the female beauty found all across the namesake state."[49] The peach, used in popular culture as an emoji representing the female posterior, is also the official fruit of the state of Georgia. This dual reference became the focus of the collab. The sneaker was fabricated using smooth, vegetable-tanned leather and came in a range of "skin tones."

SOCIAL STATUS

X

DIADORA, N.9000 RIO GOLD MEDALS, 2016

COLLECTION OF JAMES WHITNER

The Social Status take on the Diadora N.9000 was markedly different from the A Ma Maniére version. Rather than focusing on local iconography, the Social Status sneaker celebrated the Summer Olympics held in Brazil. The Gold Medal model colorway included a red suede vamp, gilded quarters, and a heel counter in deep blue suede embellished with embroidered stars and an American flag. *

177

WTAPS X VAULT BY VANS, OG AUTHENTIC LX BONES

COLLECTION OF VANS

The Japanese brand WTAPS was started by Tetsu Nishiyama, a.k.a. TET, in 1996. His clean, edgy designs took inspiration from military attire and the brand quickly became one of Japan's most influential streetwear labels. Over the years, WTAPS (pronounced "double taps")—a military term meaning to shoot a target twice in quick succession—has done a number of collaborations, but one of its most important and long lasting has been with Vans.

Its first collab with Vans was in 2006 and featured WTAPS's crossed-bones motif scattered across the uppers. The pattern was revived in 2016 in honor of Vans's fiftieth anniversary. This release included the famous pattern on the OG SK8-Hi LX, the OG Chukka Boot LX, as well as the Authentic LX. The collaboration with Vans has been one of the most important means of bringing U.S. attention to the brand and for wearers to telegraph their awareness of worldwide sneaker culture. *

2016

SHANTELL MARTIN X PUMA, CLYDE

COLLECTION OF SHANTELL MARTIN

Artist Shantell Martin's work wends its way across mediums, questions boundaries, and draws viewers into larger discussions. Indeed, for Martin, art is a conversation that can sometimes best be expressed through collaboration.

E.S.: You have collaborated with many people, institutions, and brands. Are there both risks and rewards for artists doing collabs?

S.M.: There are definitely risks and rewards to collaborating with a cross-section of brands, people, and institutions. As an artist who creates a lot with physical works, I've run into many issues with collaborations. For example, brands that have taken my work home after the project is over rather than destroying it as agreed; or after we have agreed the work is only to be displayed online, I later find it on billboards across multiple countries. I've had museums let documentaries feature my work without credit or permission, and on one occasion a museum let a pretty right-wing-seeming magazine shoot my work for their publication, even though we had an agreement in place that the museum had to get permission from me for any third-party media use. So, the usage and ownership of collaborative work can be an issue. Even if you have a strong agreement in place and everyone says they have good intentions, some institutions will take the risk of breaking the agreement to keep a work or use it in other ways, knowing that the artist typically doesn't have the means and time to do anything about it. I'm not sure how intentional this is, but it happens a lot. ›

2017

On the reward side, a collaboration is making something that you would never have the ability to make as an individual artist. I've been able to put my work on apparel, sunglasses, buildings, bikes, and sneakers and have these be sold or displayed globally. I've gotten to work with schools and institutions and collaborate with young children learning about my work for the first time. I have been able to be a part of the history and legacy of some of the oldest institutions in the country. All these types of projects connect me more closely to my audience and allow me to spread the message of my work, something I only dreamed of doing at an earlier stage of my career.

E.S.: For years, you customized your own footwear. What did you think when you were approached by Puma? What did you think when you saw someone in a pair of your shoes?

S.M.: I've always been a strong advocate for using what you have access to, and at the same time I've always wanted to have my own lines of sneakers. So at first I would de-brand shoes and make them my own—buying sneakers that I loved the shape of and cutting off all the labels to make the shoe my own.

There are quite a few people out in the world who have a pair of my hand-done custom kicks, but nowhere near the amount of people who have a pair from the Puma collection now.

I've worked with other brands in the past, but this was the first time that I had a clear path to create a meaningful collaboration that I could be, and am, proud of.

It's been pretty incredible to see people on the street wearing my shoes or to be sent photos from fans across the globe from Jakarta to London to South Africa to Singapore to Mexico! My teenage self or even myself ten years ago would never have believed that could be a reality. ∗

"ON THE REWARD SIDE, A COLLABORATION IS MAKING SOMETHING YOU WOULD NEVER HAVE THE ABILITY TO MAKE AS AN INDIVIDUAL ARTIST."

VIRGIL ABLOH X NIKE, "THE TEN"

COLLECTION OF NIKE DNA

In 2017 Nike invited Virgil Abloh, fashion designer, DJ, and founder of the fashion house Off-White, to reimagine ten of the company's most iconic sneakers. Abloh stripped each model down to its most basic parts and created sneakers using translucent materials that seemed both ghostly and futuristic.

 Abloh laid out the conception of the series in the *"10" Textbook*: "I wanted to give people the actual information, allow them to see what year these shoes are from, and how they place in the overall history of the brand. So, I looked at this whole project as like passing the baton and doing right by all that innovation, but adding a lifestyle layer to it, to say that these shoes are icons, they transcended into another space, highlighting what emotional attachment these objects [have]... or how we can now look at them in 2017 and understand how important they were in the past."[50] ✱

2017

187

UNDEFEATED x NIKE, AIR MAX 97

COLLECTION OF UNDEFEATED

Undefeated was founded by James Bond and Eddie Cruz in 2002 in response to the dearth of sneaker stores in Los Angeles at the time. Infusing a West Coast vibe into a New York–style sneaker store, Bond and Cruz sought to create a place where sports, art, music, and fashion comingled. From the beginning, collaborations were central to the ethos of Undefeated. In fact, the very first collab was for the opening of the store, a limited-edition Nike Dunk High created for the company by none other than Mark Parker, now Nike's chairman, president, and CEO.

Over the years, Undefeated has collaborated on myriad sneakers with many brands worldwide, but when asked to pick just one favorite, Bond and Cruz chose the Air Max 97. In 2017 Nike suggested a collab in celebration of the twentieth anniversary of the Air Max 97 and the fifteenth anniversary of Undefeated. For the drop, Undefeated offered three colorways: black, white, and military green. Each model featured patent-leather "mudguards" with red and green piping between the mudguard and upper with the word "UNDEFEATED" in a repeating pattern. *

2017

ALEXANDER WANG X ADIDAS ORIGINALS, SKATE

COLLECTION OF ADIDAS AG

In 2017 Alexander Wang began a collaboration with Adidas Originals to create a collection of footwear and clothing that combined streetwear with high fashion. From the beginning, Wang was interested in delving into the heritage of Adidas so that he could deconstruct and reconfigure aspects of its history, from the simple inversion of the word Adidas in the branding of his line to more complicated reinterpretations of classic shoe silhouettes.

The Skate, which came out in 2017, referenced the traditional skater sneaker with its thick sole, but its buttery-soft suede upper betrayed its intended use as a fashion accessory. The uppers, with their clean, minimalist design and flat, corsetlike laces, suggest cutting-edge style, but the tabs through which the laces run are cut directly into the suede and lend the design an almost medieval quality. *

2017

DANIEL ARSHAM X ADIDAS ORIGINALS, NEW YORK PAST, PRESENT, FUTURE

COLLECTION OF DANIEL ARSHAM

Retros—re-releases of historic, culturally important sneakers—are central to sneaker culture and allow new consumers and collectors access to sneakers from the past. Architect and artist Daniel Arsham's work often focuses on concepts of time and how objects in the present can embody ideas from the past while being transformed by the future. For his Past, Present, Future collaboration with Adidas, Arsham chose to reimagine the Adidas Originals New York sneaker, which was first released by Adidas in 1983, and to explore the narrative potential of sneakers across three separate drops.

The Past, Arsham's first sneaker in the series, features frayed canvas detailing that suggests age and wear. This detail is at odds with the clean, chalk-white colorway of the release, making it appear as though the sneakers have been thrown in the washer or whitewashed in an attempt to erase marks from the past. The words "THE PAST" are rendered on the midsole in glow-in-the-dark material and visible only in ultraviolet light. ›

2017

The Present, in contrast to the Past, features a smooth upper made of neoprene fabric. Like the other sneakers in the series, it is monochromatic. However, the shoe is a practical dark gray rather than an easily sullied white. Despite the sneaker's monochromatic coloring, various details in the design elements create a play of texture across the surface. Like the other sneakers in the series, this shoe came in a specially designed box with a pull-string opening that itself referenced time, as once opened, the box could not be closed again.

The Future sneaker was a Futurecraft 4D model rendered in monochrome aero green. The box for this sneaker had two layers. The first included a pair of socks and a pair of gloves that came with advice about how to handle the artwork in the box, only while wearing gloves, disconcertingly suggesting that the sneakers were artifacts from the past or were destined to become artifacts. Arsham intended the color of the Future sneaker to suggest green-tinted glass, which looks clear when viewed head-on. Although the sneakers appear to be uniform in color, when blue light is shone on the shoe the three Adidas stripes become visible and the word "FUTURE" glows across the toe. *

2017

RICCARDO TISCI X NIKE, RT AIR FORCE 1

COLLECTION OF NIKE DNA

"I've learned more about technology from my collaborations with Nike than I have in twenty years of being a couturier."[51]

—Riccardo Tisci

Italian fashion designer Riccardo Tisci stepped down from his long-held position as creative director of the French couture house Givenchy in 2017 to pursue his own interests—which included returning to Nike to do another collab. Tisci started collaborating with Nike in 2014, and his 2017 collection with the company, which came out only eight months after he left Givenchy, was built around a fantasy NBA team he named the Victorious Minotaurs. This theme was inspired by Tisci's childhood love of basketball and fascination with the mythical Minotaur.

With this collection, Tisci imagined athletes as superheroes, and he wanted each piece to reflect this vision through color and silhouette. For the collection's footwear, he chose to work with the iconic Air Force 1. Ultimately, he designed four versions of the Air Force 1: a low, a mid, a high, and a striking pair of boots that would not seem out of place on Wonder Woman. ✱

2017

TREVOR "TROUBLE" ANDREW X REEBOK, WORKOUT PLUS

COLLECTION OF REEBOK ARCHIVE, REEBOK INTERNATIONAL, LLC.

Trevor "Trouble" Andrew has long been drawn to the power of branding, as well as the convergence of sports, fashion, music, and art. An accomplished skateboarder, Andrew first rose to fame competing as a snowboarder for Canada in the 1998 and 2002 Winter Olympics. Eventually, he moved to New York and became a multidisciplinary artist. His graffiti art under the moniker GucciGhost led to an unexpected collaboration with Gucci in 2016 that propelled him headlong into the world of high fashion.

Andrew's prolific creative portfolio led to an invitation from Reebok in 2017 to collaborate on the classic Workout Plus silhouette as part of Reebok and Foot Locker's 3:AM storytelling project, created by Frank "The Butcher" Rivera. The aim of 3:AM was to explore the creative energy of artists in cities around the world who work whenever they are inspired, be it day or night. A video about New York City featured Andrew working with elements from his artistic vocabulary that would later appear on the sneaker and be put into production.

Translating Andrew's energetic, spontaneous style and his use of spray paint, a highly physical medium, into the design of a sneaker was challenging. However, Andrew's painterly mark was reproduced, and Rivera worked closely with the artist on the precise placement on the sneakers of his symbols. Andrew said those symbols "represent the climb to success, glory, and the obstacles along the way."[52] The first limited-edition sneakers were released at 3:00 a.m. on December 12, 2017, at Foot Locker's event space, NYC33, in New York City and sold out quickly.

The sneaker was rereleased a few months later in February 2018. For Europe, the colorway remained white with predominately black artwork, while in the United States the upper was black with white artwork. ✱

2017

KAWS x JORDAN BRAND, AIR JORDAN IV RETRO

COLLECTION OF BRIAN DONNELLY

Brian Donnelly, known professionally as KAWS, is one of the most prominent visual artists working today. His oeuvre traverses long-established boundaries between fine art and commerce, and it ranges from large-scale paintings to collectable figurines and sneaker collaborations. Donnelly's first Jordan Brand collaboration was the KAWS x Air Jordan IV retros released in 2017. The shoes were made using luxury suede subtly textured with many of KAWS's signature motifs, including his famous XX's. The matte uppers contrast with the icy glow-in-the-dark soles, which feature line-drawn versions of KAWS's iconic gloved hand. *

2017

VETEMENTS X REEBOK, GENETICALLY MODIFIED PUMP

COLLECTION OF REEBOK ARCHIVE, REEBOK INTERNATIONAL, LLC.

Vetements was established in 2014 as a design collective by designer Demna Gvasalia, with his brother. Shrouded in secrecy, the collective has been provocative from the start. Its brazen co-optation and unexpected collaborations have merged skateboard streetwear aesthetic with high fashion and toyed with themes ranging from fashion-as-uniform to the expression of social realism to irony and late-stage capitalism. Collaboration is at the core of the company; its 2017 Spring/Summer collection featured collabs with eighteen long-standing brands.

The Vetements aesthetic is clearly visible in the brand's work with Reebok, which began in 2016. The Genetically Modified Pump was a Frankenstein-esque combination of sixteen archive models that suggested the work of a mad scientist.[53] The sneaker does seem twisted. The pump is shifted off-center to the lateral back quarter, and the complicated and asymmetric lacing gives the upper a feeling of being violently lashed down. Its predistressed scuffs and scrapes suggest some kind of struggle during its manufacture rather than regular post-purchase wear. The shoe's rough, dirty appearance also alludes to the contrast between how sneakers are worn in skateboard culture and how they are worn in urban sneaker culture. The bulky size of the Genetically Modified Pump was in line with the brand's habitually oversized silhouettes, but also presaged the "ugly sneaker" trend that would dominate fashion the following year. *

2017

COMME DES GARÇONS PLAY x CONVERSE, CHUCK TAYLOR ALL STAR '70

COLLECTION OF CONVERSE ARCHIVE

One of the most iconic collaborations in sneaker history began in 2009 when the avant-garde Japanese brand Comme des Garçons began working with Converse. To date, each of their collaborations has featured the heart-with-eyes icon used to express the lighthearted aesthetic embodied by the brand's casual streetwear label, PLAY. The heart was designed by Filip Pągowski in 2002. The simplicity of each Converse collaboration reflects the aesthetic of the brand's founder and creative director, Rei Kawakubo.

The original Comme des Garçons collab was followed by three additional collabs. The 2018 version of the shoe saw the heart icon expanded so that it appears to be rising up the side of the upper to peer over the foxing. *

2018

ALEALI MAY X JORDAN BRAND, AIR JORDAN I RETRO HIGH OG VIOTECH

COLLECTION OF NIKE DNA

Aleali May, a stylist and blogger, became the first woman to collaborate on a pair of Air Jordan Is that were marketed to both men and women. Her second Air Jordan I collab, the Retro High OG Viotech, was released the following year and stood in sharp contrast to her first, the Shadow. Instead of using the muted range of blacks and grays of the Shadow, May paid homage to the brightly colored Nike SB Dunk Low Viotech when creating her own vibrantly hued Air Jordan Is. May wore a bespoke pair of Air Jordan I Viotechs in 2016, but Jordan Brand released this production version only in 2018. ›

2018

E.S.: Can you tell me a little bit about your inspiration? Why did you want to riff on the SB Viotech?

A.M.: The Viotech is a shoe I've loved since first sight. It introduced me to color blocking back when people like Pharrell and Nigo, founder of Bathing Ape, were providing so much inspiration for me and how I wanted to dress—mixing skate culture with hip-hop, fashion in the U.S., and fashion overseas to create the most fire outfits. It touched on travel and the knowledge of worldly fashion affairs.

E.S.: Tell me about the fur at the tongue.

A.M.: The fur tongue provides options. In fashion I've learned so many ways you can add accessories to vamp up your look, or have the option to tone it down. I think providing more options makes it wearable and also more exciting.

E.S.: Did you offer the Viotech in both men's and women's sizes?

A.M.: This sneaker is available for women and the men who can fit women's sizing! This is the first Air Jordan women's pack! ✽

"THIS IS THE FIRST AIR JORDAN WOMEN'S PACK!"

MAYA MOORE x JORDAN BRAND, AIR JORDAN X COURT LUX

COLLECTION OF NIKE DNA

"A little piece of me is on the back pull tab—it's my favorite Bible verse. I leave the Bible verse Colossians 3:23 at the end of my autographs. It's a verse that's a reminder of my motivation—that I'm doing everything ultimately unto the Lord, and it just keeps me grounded, keeps me focused, keeps me motivated, and I love sharing that with people. So how cool to be able to leave a piece of me on the 10s." [54]

—Maya Moore

WNBA superstar Maya Moore joined the Minnesota Lynx as the first pick in the 2011 draft. Among her many awards and accomplishments are Moore's four WNBA championships, the 2014 WNBA Most Valuable Player Award, and gold medals at the 2012 and 2016 Olympic Games. In 2017 *Sports Illustrated* named Moore performer of the year and described her as the "greatest winner" in women's basketball history. [55]

In 2011 Moore was the first female basketball player to sign with the Jordan Brand. In 2018 she and famed stylist Aleali May released a two-pack of Jordans. The two sneakers were sympathetic to each other in color and material, but they also demonstrated diversity in style. Moore's choice of vibrant colors was inspired by the uniforms she has worn during her career, while the "3:23" inscribed on the pull tab references the Bible verse that has become her signature. *

2018

UNION

Union began in 1989 as a New York City store, the brainchild of James Jebbia and Mary Ann Fusco, who later cofounded Supreme. In 1991 a branch was opened in Los Angeles by Eddie Cruz, who later went on to cofound Undefeated. Around this time Chris Gibbs began working at the New York store while he was attending college. When life took Gibbs to the West Coast, he began working at the Union in Los Angeles, and in 2004 he purchased that store. Then in 2009 the New York store closed, leaving Gibbs the sole proprietor of Union, a boutique that he has transformed into a mecca for luxury sportswear, rare sneakers, and exclusive collabs.

X

JORDAN BRAND, AIR JORDAN I NRG, 2018

COLLECTION OF CHRIS GIBBS

In late 2018 Union released one of its most sought-after collaborations to date, a vintage-inspired Air Jordan I. The sneaker was designed to look as though different colorways of the 1985 Air Jordan had been hand-stitched together and featured visible foam at the tongue and midsoles that had "yellowed." The conceit that each sneaker was made from two separate models was reinforced by zigzag stitching to unite the two different parts of the shoe, and the fact that the laces switch color in the spot where the two appear to be connected. The box featured a collage of vintage Jordan ads, and the tissue paper wrapped around the sneakers was designed to offer transparency regarding the collab's process by including snippets of design drawings and a list of the people who had worked on the project. The shoes were first revealed at the Rose Bowl Flea Market, where they were mixed in with other sneakers at a reseller's booth, and were hailed as one of the most important sneaker designs of the year. ›

2018

X

ADIDAS, SPEZIAL GARWEN SPZL, 2018

COLLECTION OF CHRIS GIBBS

Union also collaborated on a capsule collection in 2018 with Adidas Spezial, an Adidas line that captures the terrace-wear fashion of British soccer culture in the late 1970s and 1980s. The capsule included the Garwen SPZL in two colorways, one inspired by the 1994 palette of the Adidas 350 and the other in a natural suede that was reminiscent of a pair of Wallabees.

X

VANS, SLIP-ON, 2018

COLLECTION OF CHRIS GIBBS

Another 2018 collab by Union was the limited-release Vans sneaker created for that year's ComplexCon. Riffing on the traditional Vans black-and-white checkerboard pattern, Union contributed a colored background, in either burnt sienna or seafoam green, covered in black and white dots, with "UN/LA" and "VANS" written inside some of the white dots. ✱

215

SALEHE BEMBURY

Salehe Bembury has created exceptionally innovative footwear and has been part of collaborations with some of the most famous names in fashion. His impressive resumé includes heading the Tom Sachs x Cole Haan collaboration, serving at GREATS as footwear design director, and designing the footwear for seasons three and four of Kanye West's Yeezy collections. Bembury also collaborated with Kerby Jean-Raymond on the footwear for the Pyer Moss Spring/Summer 2017 collection. In 2017 he was appointed senior director of sneakers and men's footwear at Versace and head designer of sneakers for Versus Versace.

E.S.: I love this quote from you: "I'm selfish with my design, where I'm always trying to make the five-year-old kid inside of myself happy." How did you go from being a kid interested in sneakers and sneaker design to actually working in footwear?

S.B.: Sneakers were always something I loved. They have a direct correlation to the nostalgia of growing up (basketball, movies, hip-hop, experiences with my dad). The emotions they evoked made me realize from an early age that I wanted to devote my life to them. I turned my childhood artistic talent into a foundation for design. I then began my journey toward footwear by majoring in industrial design at Syracuse University. There I learned many of the initial tools to identify, analyze, and create successful products. Once I graduated from Syracuse, my first job in the field was at Payless ShoeSource. While not glamorous, the "in-office" experience that Payless gave me was very valuable. ›

2018

E.S.: If you had to pick two collabs that you did before moving to Versace, which two would you pick?

S.B.: Kanye West and Pyer Moss. For Kanye West, I was a member of the Yeezy design team for seasons three and four. Designing for Kanye West taught me the importance of research. A designer is only as good as his or her ability to research. For the Pyer Moss Spring/Summer 2017 show, my good friend creative director Kerby Jean-Raymond asked me to assist with the footwear. The ethos of the show was a dialog about finance. One of the themes involved the feeling of being financially "stuck." Kerby requested that the shoes promote this idea. We initially discussed shoes being stuck in concrete. While it would have hit the mark visually, it wouldn't have functioned. I proposed using silicone to solve for function. I spent my entire educational and professional career executing practical design, and this project forced me to truly think outside of the box.

E.S.: You seem to be very interested in the architecture of shoes and in challenging their traditional structure. How do you reconcile the constraints put on footwear design with the fact that what you make has to be wearable?

S.B.: I think that's where my industrial design degree comes in handy. That major is all about problem solving. I am a "maker" by trade. I think the most exciting yet restrictive aspect of footwear design is that it needs to function. It needs to function and look good. It needs to function, look good, and sell. All of these dynamics make for a stimulating environment in which to create product.

E.S.: Tell me about the shoe you designed for Takashi Murakami's exhibition *Sneakers for Breakfast* at 2018 ComplexCon. I understand that the invitation was to make the ultimate sneaker. What makes a sneaker "ultimate" for you?

S.B.: I met Takashi this summer through my friend Don C. A few months later I ran into him at the Off-White show in Paris. We had a quick exchange, took a few photos, and went our separate ways. Later that day, he DM'd me, asking to meet with me at the Gagosian. When we met he mentioned that I opened up his eyes to a new generation of young footwear designers. He proposed the idea of doing a project with sneakers as the theme. After some discussion, I mentioned that I was so passionate about sneakers that I would daydream about them at the breakfast table. The exhibition name, *Sneakers for Breakfast*, was spawned from this. The basic idea was that each participant would create the ultimate sneaker to be auctioned off for charity. Often in the professional space there are many restrictions for designers. However, this opportunity would allow myself and the other designers to create sneakers with no rules.

About six years ago I was in Amsterdam and saw these beautiful beaded human skulls. I wanted to buy one, but they were $3,000, which I thought was too expensive. Being the able creative that I am, I decided just to make it myself. I purchased a deer skull on eBay, the beads, and a pair of tweezers. Every Saturday during the summer I would sit in a garden and, bead-by-bead, cover the deer skull. Three years later I finished. This project was easily the most difficult and longest I had ever done. Considering the process and feeling of reward that came from this beading project, I decided to continue it with my Takashi Murakami collaboration. However, this time I was lucky enough to have a high-fashion factory execute the beading. In the end the project embodied Takashi's work, my work, and a very intricate beaded upper.

E.S.: Now that you are at Versace, whom would you love to collaborate with on a pair of sneakers?

S.B.: I would say that I already am working with my dream collaborator currently at Versace. I am honored to work under a genius like Donatella and to work with a brand with so much heritage, significance, and rich brand identity. This alone creates so much opportunity in regards to product and marketing potential. In the past, all of the sales potential relied on my design ability. Now it feels like that initiative is split between design, brand, and quality. It is almost as if I have been given the opportunity to collaborate with the past, and that is a responsibility that I do not take lightly. ✶

"I THINK THE MOST EXCITING YET RESTRICTIVE ASPECT OF FOOTWEAR DESIGN IS THAT IT NEEDS TO FUNCTION."

Salehe Bembury with Takashi Murakami, who is wearing sneakers designed by Bembury for the *Sneakers for Breakfast* exhibition at ComplexCon 2018.

JW ANDERSON X CONVERSE, CHUCK TAYLOR '70 TOY

COLLECTION OF CONVERSE ARCHIVE

Northern Irish fashion designer Jonathan Anderson launched his eponymous line in 2008 and quickly garnered attention for his unexpected collections and his interest in blurring gender boundaries. The success of his first collaboration, with Topshop in 2012, led Donatella Versace to select him to do a capsule collection, Versus, in 2013. LVMH purchased a stake in his company that same year, and then Anderson was appointed creative director of LOEWE. He began collaborating with Converse in 2017.

Anderson's Toy collection, his fourth collaboration with Converse, came out in 2018 and featured the classic Converse '70 in candy-colored patent leather. Its high-gloss uppers and translucent soles contrasted with thick, fuzzy laces running through exaggerated eyelets. Although the line was said to have been inspired by glazed ceramic sculptures, its slick design and title "Toy" also hint at the world of fetish—perhaps offering a comment on the role of sneakers in culture today. ∗

2018

221

DR. WOO x CONVERSE, CHUCK TAYLOR '70 SPIDER AND THE FLY

COLLECTION OF CONVERSE ARCHIVE

Sweet creature, said the Spider, you're witty and you're wise;
How handsome are your gaudy wings, how brilliant are your eyes!

—Mary Howitt

Brian Woo, a.k.a. Dr. Woo, is one of the most sought-after tattoo artists in the world. His exceptionally fine line work and black-and-gray designs have garnered him more than 1.5 million Instagram followers and a long list of celebrity clients. In 2017 Converse invited Woo to collaborate, and for his first sneaker he decided to take inspiration from Mary Howitt's famous poem *The Spider and the Fly*. Published in 1828, it offers a warning about the perils of predatory flattery:

Will you walk into my parlor, said a Spider to a Fly;
'Tis the prettiest little parlor that ever you did spy.
The way into my parlor is up a winding stair,
And I have many pretty things to shew when you get there.
Oh, no, no! said the little Fly; to ask me is in vain:
For who goes up that winding stair shall ne'er come down again.[56]

The small graphic fly printed on the toe cap of the left shoe stands before the spider's web that ladders up the tongue. While the ladder is printed in black on white, the embroidered spiders that swarm the uppers are in white on white and therefore harder to pick out. They are revealed only when the play of light and shadow delineates their outlines.

The fine-lined graphics and delicate embroidery on the sneakers add a subtle elegance to the design, but Woo was not interested in keeping these details pristine. Instead, he felt the real story of each sneaker would be revealed through wear. Each wearer, and each wear, create unique stresses on the sneakers, leading to the graphics eventually rubbing off and the embroidery eventually fuzzing, coming undone, and unraveling itself. This poses a question that each pair answers in a unique way over time: which will survive longer, the printed fly or the embroidered spiders? *

2018

NIGEL SYLVESTER X JORDAN BRAND, AIR JORDAN I HI OG NRG

COLLECTION OF NIKE DNA

Nigel Sylvester was the first BMX athlete to do a collaboration with Jordan Brand. He started garnering attention in the early 2000s when he turned pro at eighteen with a Nike 6.0 deal in hand. Since then his GO project, posting GoPro videos of his rides through cities around the world, has earned him millions of followers. Part of the appeal of his videos is that the viewer shares his point of view.

Sylvester's first collab involved the Mavericks and was released only as a Friends and Family pack. His second, the Nike SB x Nigel Sylvester Dunk High S.O.M.P., was designed with Clark Kent in 2014. For his third collaboration, Nigel worked with Frank Cooke at Jordan NRG to create a sneaker that riffs on his POV videos by putting wearers "in his shoes." To achieve this, the two reimagined the Air Jordan I as though it had been broken in by Sylvester himself. The idea came to Cooke after he asked Sylvester to send him one of his worn-in pairs of Shadow Is. According to Cooke, he wanted these collab sneakers to reflect "not only respect for Nigel and his sport but also his daily journey—how he navigates around New York, the relationships he builds. Seeing him practice, seeing what he brings back to the community, is amazing and organic. I definitely wanted to put that into the shoe."[57] ›

2018

The soles and the uppers were distressed to suggest wear, and the overall colorway was designed to create the illusion that the sneakers had once been a crisp white but had yellowed with age and use. To further give the impression that the shoes had been worn by Sylvester, the right shoe was designed to look more distressed than the left to reflect the fact that Nigel rides left foot forward and uses his right to brake. The missing "swooshes" on the lateral sides of the sneakers and pencil-like marks also suggested wear and personalization, as though there had been an attempt to fill in scuffs by penciling back in the "swoosh". The use of reflective material on the medial "swooshes" was a nod to bike culture and riding at night. The additional details, such as a mini "swoosh" at the toe, double-debossed wings, deconstructed logo, and Jordan Biking Co. est. 2017 branding on the inner collar, combine to create a shoe replete with story.[58] ✻

CÉSAR PÉREZ X NIKE, AIR FORCE 1 DE LO MIO

COLLECTION OF CÉSAR PÉREZ

In late 2018 Nike released the Air Force 1 De Lo Mio. Designed by César Pérez, owner of 625 Industries, the shoe was created to honor Dominican culture in New York and in the Dominican Republic. Every stage of the collaboration was about community.

E.S.: How did your collaboration with Nike come about?

C.P.: I own a company called 625 Industries that does creative consulting for Nike across many categories. After seeing me around at a few events, one day, Emily Anadu asked me to stop by the Nike office. When I got there, they asked me, if I could do a shoe, what it would be? I immediately responded, Dominican AF1. Nike was already thinking about doing a sneaker to represent the Dominican community, so it was perfect timing.

E.S.: The shoe is brimming with references to Dominican culture. Can you tell me about these details?

C.P.: The sneakers came in a Nike box that I had the pleasure of designing. I wanted a box that would make it easy to separate from all the other Nike boxes I had, and to show pride in my people at the same time. So we put the Dominican flag on the box—something Nike had never done before—and inside the box came a tissue material with photos from all over New York City that connected to the culture.

The main design influence on the sneaker was dominoes, as they are something that all Dominicans play no matter their socioeconomic status or age. The leather on the shoe has a special water-repellent coating and is dirt-resistant, also an homage to domino pieces that never get dirty no matter how much you play with them. The shoes come with four laces—red/blue intertwined, white, red, and blue—and a full set of domino deubrés.

The "swoosh" is a lenticular material that switches from red to blue and many other colors within that spectrum. This speaks to the many different colors that we Dominicans come in. The "swoosh" is highlighted by a 3M backing that lights up once you hit it with any form of flash. I wanted to speak to NYC and the streets of New York. República Dominicana is also on a tonal 3M patch on the back of the shoes. I wanted it to be loud, but also incognito at the same time.

E.S.: I saw that LeBron James wore a pair of De Lo Mios—what has the response been?

C.P.: The response has been amazing, the shoe sold out in two minutes! People have been so full of pride and excitement that it brings me to tears a lot of the time just thinking about it. This was something I dreamed of doing as a kid, so to be standing here today and see an AF 1 that I designed be sold out and people begging for more is such a surreal feeling. *

2018

MISTER CARTOON X DISNEY X VAULT BY VANS, OG SK8-HI LX

COLLECTION OF VANS ARCHIVE

Los Angeles tattoo artist Mark Machado, a.k.a. Mister Cartoon, is famous for his intricate, fine-line tattoos. He first became prominent when he began working with the hip-hop group Cypress Hill, but his fame reached new heights when Eminem began to flaunt Mister Cartoon tattoos.

In 2018 Vans reached out to Mister Cartoon to collaborate on a pair of OG SK8-Hi LX sneakers that would honor the ninetieth anniversary of Mickey Mouse. Mister Cartoon chose to recall the early black-and-white Mickey Mouse cartoons by Disney. His very So-Cal depiction of Mickey shows him driving a convertible down an L.A. street lined with palm trees. ✱

2018

231

SHOE SURGEON X NIKE, LEBRON JAMES 15

COLLECTION OF LeBRON JAMES

E.S.: It seems to me that you do the most exclusive form of collaboration, just you and your client. You receive so many requests. How do you choose which projects to do?

D.C.: I only take on projects that I feel a strong connection to. Each project I take on has a genuine story and passion behind it. My made-to-order service is a special avenue of my business because it allows me to get to know my clients on a deeper level and explore what their creative ideas are so we can collaborate on something meaningful to both of us. Ultimately, I only take on projects that speak to me.

E.S.: You ask about inspiration in your online request form. Why is the inspiration for a sneaker important to you, and how do you work that into your design?

D.C.: I believe everything is inspired by something. Inspiration can come from a photo or from how someone dresses, or even from a personal experience that represents something significant to my client. Learning about what my clients are inspired by helps me decide which projects I take on and also provides me with a better understanding of their style and vision so I can create the perfect sneaker that they will cherish forever. Without inspiration, I wouldn't be able to create the work that I do. It is what keeps my creativity flowing. The inspiration for the diamond and gold LeBrons was to create something that not only resembled a trophy, but properly celebrated the rare level of achievement he reached with his 30,000-point milestone by incorporating the rarest, most difficult to obtain materials. Having that as inspiration led me to create the ornate work of art that the shoe became. ✱

Dominic Ciambrone, a.k.a. the Shoe Surgeon, rose to fame dissecting and reconstructing sneakers to create one-of-a-kind luxury footwear. His dedication to the art of shoemaking and his use of high-end materials has earned him an A-list clientele, as well as celebrity status in his own right. In 2018 Ciambrone was approached by Nike to create a custom LeBron James 15 that would honor the basketball great's milestone of being the youngest player ever to achieve 30,000 career points.

The sneakers were made using expensive and exclusive materials. The uppers were crafted out of crocodile skin hand-gilded in 24-karat gold. The Nike "swooshes" at the back heel are in gold, and the aglets for the laces were crafted out of gold, stamped with the words "WORLD" and "CHAMPION" and embellished with diamonds.

2018

PYER MOSS x REEBOK, DMX DAYTONA EXPERIMENT 2 AND DMX RUN FUSION EXPERIMENT 1

COLLECTION OF REEBOK ARCHIVE,
REEBOK INTERNATIONAL, LLC.

E.S.: Sneakers have long been a site for storytelling and political expression. What do you think sneakers can say today?

K.J-R.: Sneakers are democratic. Because of their wide acceptance, high/low design, and ubiquitous pricing, they can say "I, too, belong in this space." I personally always feel great going into spaces that were historically prejudiced against casual clothing and wearing sneakers. It's liberating and defies any antiquated class system.

E.S.: How does collaboration assist in the telling of these narratives?

K.J-R.: The big footwear brands are all built on the backs of sport, which limits the perspective and narrative to the voices of athletes. Brand collaborations allow the smaller voices that represent different cultures the ability to be heard on a louder stage and allow the communities they represent a chance to be seen. ∗

In 2017 Reebok and Kerby Jean-Raymond, founder of the fashion house Pyer Moss, took home the *Footwear News* Collaboration of the Year Award. In less than a year, their collaboration resulted in a number of important sneakers. Reebok reached out to Jean-Raymond because of his commitment to revealing untold stories and moving culture toward greater inclusiveness through his clothing designs. Jean-Raymond was drawn to Reebok because the company enabled him to mix politics and design seamlessly through sneakers that push the envelope of design.

2018

235

MACHE X PUMA, RS-X TOYS COMPLEXCON SPECIAL EDITION

COLLECTION OF MACHE

Among the rarest and most exclusive sneakers today are those customized by the artist Daniel Gamache, known professionally as Mache. As a child growing up in Poughkeepsie, New York, Gamache would sketch sneakers and draw portraits based on photos from *SLAM* magazine in his grandmother's art studio. He went on to study fine arts in college and, according to his bio, in 2004, "After slathering different shades of purple on a pair of beat up Air Max 90s in his basement, the first pair of custom kicks were created."[59] Mache quickly established himself at the forefront of the custom sneaker scene. His bold color design and painted gradients that invent entirely new custom colorways, along with his clever use of pop culture iconography, have garnered him an international reputation and a list of celebrity clients that includes Jay-Z, Kanye West, and LeBron James.

Although Mache is best known for his bespoke custom shoes, in 2018 he collaborated on a limited-edition release of the Puma RS-X as part of the Toy series in Puma's display area at ComplexCon. The shoe's bright, primary colors and shaded patterns are reminiscent of the comic book–inspired work of Roy Lichtenstein. According to Mache, "The winners-only section of the Puma RS-X pavilion was centered on trophies and racing. I figured, what colors exemplify speed and victory like red and gold?" Would Mache ever do a wider release of the shoe? "A wider release? Most definitely! Just as long as I don't have to paint them all!"[60] ✶

2018

TRAVIS SCOTT X JORDAN BRAND, AIR JORDAN IV CACTUS JACK

COLLECTION OF NIKE DNA

In 2017 musician Travis Scott announced the creation of his own label, Cactus Jack Records. This was followed by the release of Cactus Jack merchandise, from wearables to collectables. Building on his brand, Scott's 2018 Air Jordan IV collab likewise promoted Cactus Jack. The name is written in a cruciform shape, replacing the Jumpman on the heel tab of the left shoe, and the label stitched to the inside of the left tongue bears the same words.

The striking blue, red, and white colorway of the sneakers is a nod to Scott's hometown, Houston, and was inspired by nostalgia for the original Houston Oilers NFL team's home colors. In 1997 when Scott was only six years old, the Houston Oilers were moved by their owner to Tennessee. The speckled pattern on the mudguard and latchets pays homage to the original Air Jordan IV "cement" details. ✱

2018

RUSS BENGTSON X REEBOK, IVERSON LEGACY

**COLLECTION OF REEBOK ARCHIVE,
REEBOK INTERNATIONAL, LLC.**

For his limited-edition version of the Legacy, Bengtson chose details that he felt expressed Iverson's ethics and aesthetics. The ripstop material in camo for the upper was a nod to Iverson's military-like devotion to his work. The tongue, printed with Iverson's name, was made of Velcro and came with a pack of interchangeable Velcro patches similar to those found on army jackets, continuing the military theme. Each of the patches featured a different Iverson symbol, giving wearers the ability to customize the look of the shoes themselves. Bengtson's choice of a gum sole, like his use of camo for the upper, clearly established that, despite the Legacy's on-court tech, this version was definitely an off-court shoe. Other details included insoles printed with images of the NBA star's tattoo of a skull wearing an army helmet, as well as Bengtson's signature along with Iverson's. One last detail was the phrase "Only the strong survive" running up the heel tab, also inspired by an Iverson tattoo.

At each stage of the project, Bengtson remembers having a "wow" moment. "Getting the first sample, getting the first pair in my size, seeing Allen Iverson hold it and describe it, seeing my name embroidered on his shoe, seeing people buy it and getting Iverson to sign it. Seeing Iverson wear a pair in Philly to ring the bell before the Sixers game, knowing that he could have chosen to wear anything but he decided to wear something I had made. These were all incredible moments."[63] *

In 2018 Frank "The Butcher" Rivera of Reebok, along with Xavier Jones, a former designer with the company, worked with Allen Iverson on his first new silhouette in four years. The resulting sneaker, the Iverson Legacy, was built on the sole of the Answer 1, with an upper designed to pay homage to a number of Iverson sneakers from the past, including the Question, Answer, Answer 2, Answer 3, and Answer 4. The sneaker was set for release in November 2018, but to make its debut even more memorable, Rivera reached out to journalist and editor Russ Bengtson to collaborate on a limited-edition version of the Legacy for that year's ComplexCon.

For Rivera, Bengtson was a natural choice: his deep understanding of sneakers and basketball, combined with his abiding respect for Iverson both on and off the court, lent an authentic voice to the project.[61] For Bengtson, it was an honor that felt like coming full circle.[62] Not only had he chronicled Iverson's storied career, including his sneakers, when he worked first at *SLAM* and later at *Complex*, but also Reebok had been the first brand ever to send Bengtson a sneaker—a pair of gold and black Iverson Questions, in 1996.

2018

DON C X JORDAN BRAND, JORDAN LEGACY 312

COLLECTION OF NIKE DNA

"Don is an amazing collaboration partner with his combination of passion and creativity. He obsesses over shape, feel, and fit, which is showcased in all products he designs."

—Gemo Wong

Luxury streetwear designer Don Crawley, a.k.a. Don C, grew up in Chicago wearing Air Jordans and idolizing Michael Jordan not only for his skills as a basketball player but also for his work ethic. For years Don C was a tour manager and backup DJ for rapper Kanye West, and eventually he became an executive at West's label GOOD Music. After an incident involving paparazzi, Don C decided to leave the music business and turned his attention to luxury fashion; he launched his brand, Just Don, in 2011.[65]

Just Don quickly became known for its luxury take on streetwear, and in 2013 Jordan Brand reached out to Don C to do a limited-edition Air Jordan I commemorating Black History Month. Don C added snapback hats with python bills to the offer and thirty-seven packs were produced for auction, with the proceeds going to the Big Brothers Big Sisters of America organization.[66] Just Don's second collab was based on a luxe redo of the Air Jordan II using quilted leather inspired by Chanel handbags. The first and second iterations of the collab were available only in men's sizes, but the third version, in Arctic orange was released in women's and children's sizes on Mother's Day 2017. The success of these ventures led to Don C's being given the opportunity to create an entirely new Jordan silhouette. The Jordan 312 is a hybrid of three historic sneakers: the Air Jordan II, the Air Jordan III, and the Nike Air Alpha Force Low, which was worn by Michael Jordan in 1988. *

2018

FEAR OF GOD x NIKE, SHOOT AROUND

COLLECTION OF NIKE DNA

For a while Jerry Lorenzo thought he was going to be a sports agent, but as he was managing former Dodger player Matt Kemp, he realized he wanted to make clothes. He had started to style Kemp but could not find the clothing he wanted, so he decided to create it himself.[67] In 2012 Lorenzo established his brand Fear of God, and he quickly began to create clothing for Justin Bieber; he also caught the attention of Kanye West. Nike reached out to Lorenzo in 2018 and offered him the rare opportunity to create an entirely new silhouette.

Working with Nike's Leo Chang, the designer responsible for the Kevin Durant Nike line, Fear of God debuted two models, the Fear of God 1 and the Shoot Around, in 2018. Both were exercises in restrained elegance. The Shoot Around features a seamless one-piece upper with a toggled lacing system that wraps around the ankle; it also has a collar strap and back zipper. The thick sole is a double Zoom Air heel unit in translucent blue. ✱

2018

HARLEM'S FASHION ROW (HFR) X NIKE LEBRON 16

COLLECTION OF NIKE DNA

"One of the ways that women can create opportunities is to join forces—competition is out, collaboration is in."[68]
—Brandice Henderson-Daniel,
founder and CEO of Harlem's Fashion Row

In 2018 Nike and LeBron James joined forces with the fashion collective Harlem's Fashion Row (HFR) to create the first LeBron James sneaker to be reimagined by women designers. HFR is a platform for multicultural designers that helps new designers launch their businesses and encourages greater diversity in the fashion industry. These goals spoke to James, and he embraced the opportunity to work with the collective. He felt that the project not only would honor the strong women in his own life, but also would acknowledge "all the strong women out there who are succeeding despite what might be stacked against them."[69]

The words James used when describing his mother—strength, loyalty, dignity, courage—became the foundation for the shoe and were even written into the sock liner so that wearers would literally stand on them. Three HFR designers—Fe Noel, Undra Celeste, and Kimberly Goldson—along with Meline Khachatourian, a Nike global basketball shoe designer, and Jason Petrie, a longtime Nike designer for James, collaborated to create a sneaker that spoke to these values.

One of the most striking aspects of the design was the reworking of LeBron James's lion motif. In the hands of HFR the detail on the heel became both strikingly sculptural and functional: the laces thread through the lion's teeth. A particularly thoughtful element in the design was a removable ankle strap in natural leather that could also be worn as a piece of jewelry. *

2018

LES BENJAMINS X PUMA, THUNDER DISC

COLLECTION OF PUMA ARCHIVE

Les Benjamins is a Turkish streetwear brand established by Bunyamin Aydin in 2011. Aydin was interested in streetwear beyond New York and Paris; he was inspired by the rich history and new potential evolving in other cities around the world. In 2019 he did his first collabs with Puma, which included the Puma RS-0 high and low, as well as the Puma Thunder. Aydin was born in Germany, raised in Switzerland, and currently lives in Istanbul. He has long been interested in confronting the East-West divide and has sought to address this through fashion.

E.S.: Can you tell me how you created Les Benjamins? What was your motivation?

B.A.: I was actually designing printed graphic T-shirts, combining my passion for photography and fashion. My first-ever tradeshow that I attended ten years ago at the age of nineteen was Bread & Butter, where I showcased thirty tees. I got six accounts, and two of them gave me the excitement to move on. One of them was Sam Ben-Avraham, who used to own Atrium, and the other was Harrods. Another milestone was my first-ever fashion presentation during men's fashion week in Milan, which caught Nike's attention. I was selected as one of twelve designers to reinvent the future of Air Max in 2017. >

2018

E.S.: Can you tell me how the collaboration with Puma came about and what you hoped you would achieve with it? I am interested in your answer at both the design level and the cultural level. What did you hope to achieve in the design of the actual sneaker, and what did you hope to achieve in terms of the cultural impact of this collaboration?

B.A.: From a design perspective, I already knew when Puma approached me what the lower and upper would be. Being a fashion designer who is also a sneaker collector, it was very smooth. I combined the classic Puma Disc upper, which is my favorite, with the sole of the Puma Thunder. My favorite color is black, so I decided to make this Friends and Family edition in Triple Black. It dropped exclusively in Dubai, Istanbul, and Paris. In a way it represents who I am and the youth of Istanbul. We have a deep cultural heritage with a new contemporary vision. The carpet pattern in black and white is a DNA detail of Les Benjamins that you can see in almost every season. I want this sneaker to excite the creative scene and youth of Istanbul, as it's the first collaboration of a Turkish designer and a global sportswear brand. This sneaker is for them to enjoy the moment.

E.S.: Storytelling is often central to collaborations. Is this true for you?

B.A.: The Les Benjamins x Puma campaign revolved around *Journey of Discovery*, a documentary that follows Brooklyn-based photographer/artist 13thwitness [Timothy McGurr] as he sees Turkey for the first time and discovers the cities of Istanbul and Cappadocia. *Journey of Discovery* reflects our DNA, who we are and the stories we tell. In my opinion, brands with no story are only products. It's crucial to have a story and a narrative that brings communities together and creates global movements. *

"WE HAVE A DEEP CULTURAL HERITAGE WITH A NEW CONTEMPORARY VISION."

251

ENDNOTES

A HISTORY OF SNEAKER COLLABORATIONS, PAGES 10–33

1. Examples are held in the Converse Archive.
2. Personal correspondence with Sam Smalldige, Converse Archive.
3. Ibid.
4. Elizabeth Semmelhack, *Shoes: The Meaning of Style* (London: Reaktion Books, 2017), 318.
5. One extant box is marked with a woman's size, suggesting that they were available to women as well.
6. Converse Advertisement in *Ringling Bros and Barnum and Bailey Magazine and Daily Review*, 1934. n.p. https://www.rubylane.com/item/1400693-A-1642/Vintage-1933-Ringling-Bros-Barnum-Bailey The person behind both of these cutting-edge marketing decisions at Converse—the adding of Chuck Taylor's name to the All Stars and collaborating with Walt Disney—was most likely Albert Wechsler. According to Converse archivist Sam Smalldige, Marquis Mills Converse lost control of his company and it was sold to Mitchell Kaufman in early 1929. After Kaufman's death the following year, the company was run by Wechsler, the brother of Kaufman's widow, until the middle of the 1930s, when the company was sold to the Stone family. Whoever made these astute business decisions was remarkably ahead of his or her time, as the potential of celebrity athletic collaborations and brand-to-brand collaborations would not be fully and broadly exploited until decades later. Personal correspondence with Sam Smalldige, Converse Archive.
7. It is interesting to contemplate what might have happened if Jesse Owens had been able to collaborate with Gebrüder Dassler Sportschuhfabrik. In 1936, Adi Dassler managed to get a couple of pairs of Modell Waitzers into the hands of the American superstar athlete Jesse Owens. Before the start of the Olympics, Adi Dassler had asked Waitzer to assist him in getting a pair of Gebrüder Dassler Sportschuhfabrik shoes to Owens. Waitzer was hesitant due to the racially charged Nazi propaganda surrounding the games, but eventually several pairs made their way to Owens and he wore them in practice. Owens did not wear the Modell Waitzers in competition; however, it is interesting to speculate what might have happened if prevailing geopolitics had permitted Owens to accept an endorsement deal, or more significantly, to collaborate with Adi and Rudi Dassler. The start of World War II made any such collaboration impossible.
8. "Rubber in the Military," *The Milwaukee Journal*, February 1, 1942, 1.
9. "Radio: High School Sports Sell Shoes," *The Billboard*, February 26, 1944, 6.
10. "'Self-Expression Shoes' Continue to Catch Teen Eyes," *Women's Wear Daily*, March 1, 1946, 14.
11. "Teen-Age Set: Their Fads for '55 Are Simply Cra-a-zy, and If You Don't Understand Them You Are an Absolute Square," *The Washington Post*, February 20, 1955, AW6.
12. Joseph W. Sullivan, "Leather Feels Pinch as Youths Kick Sales of Sneakers Skywards: High Fashion Design and Low Prices Increase Popularity: Tanners Stir Health Issue," *Wall Street Journal*, October 31, 1961, 1.
13. Ibid.
14. Thomas Turner, *The Sports Shoe: A History from Field to Fashion* (London: Bloomsbury, 2019), 110.
15. "Shoe Sales Lag: Weather, Sneakers Blamed: Total Not Expected to Top $4.5 Billion," *Wall Street Journal*, November 8, 1961, 24.
16. "Acquisition Announced," *The New York Times*, November 3, 1963, F12. For a discussion of the Randy 720, see Turner, 108.
17. Doug Palladini, *Stories of Sole from Vans Originals: Updated and Expanded Edition* (New York: Abrams, 2016), 16.
18. Stan Smith, *Some People Think I Am a Shoe* (New York: Rizzoli, 2018), 22.
19. Ibid., 65–68.
20. Personal correspondence with Puma Archive.
21. Turner, 152.
22. Joseph Durso, "For Star Athletes, New York Is at the End of the Rainbow," *The New York Times*, August 29, 1975, 29.
23. Richard Flaste, "For Eighth-Graders, the Sneaker is More Than Sum of Its Parts, *The New York Times*, May 12, 1973, 38.
24. Bobbito Garcia, *Where'd You Get Those? New York City's Sneaker Culture, 1960–1987* (New York: Testify Books, 2003), 12.
25. Palladini, 27
26. Julie Hatfield, "Not Your Average Sneakers," *Boston Globe*, April 4, 1989, 25.
27. Andrew Pollack, "Case Study: A Onetime Highflier; Nike Struggles to Hit Its Stride Again," *The New York Times*, May 19, 1985F17.
28. Ibid.
29. Personal correspondence with Kristi Keffer Nike DNA, E
30. *Sneaker Shopping*, S4: E12, April 10, 2017, https://www.youtube.com/watch?v=KcwDLiCV8U4.
31. Larkin Starling, "It Looks Like Gucci Knocked Off Dapper Dan's Designs in Their Latest Collection," Fader, May 30, 2017, https://www.thefader.com/2017/05/30/gucci-knock-off-dapper-dan-jacket
32. Personal correspondence with Jelani Day.
33. As quoted in Turner, 28.
34. Brendan Dunne, "How Spike Lee Became Michael Jordan's Hypeman: Jim Riswold of Wieden+Kennedy Speaks," *Sole Collector*, March 20, 2015, https://solecollector.com/news/2015/03/jim-riswold-nike-air-jordan-wieden-kennedy.
35. As quoted in Patricia McLaughlin, "The Sneaker as Cultural Icon," *St. Petersburg Times*, June 19 1989, 2D.
36. Glenn Rifkin, "All About Basketball Shoes: High Tops, High Style, High Tech, High Cost," *The New York Times*, January 5, 1992, A10.
37. Terry Lefton, "Falling Stars," *Brandweek*, February 2, 1998, 22–27.
38. Ibid.
39. J. C. Conklin, "Don't Throw Out Old Sneakers; They're Actually a Gold Mine," *Wall Street Journal*, September 21, 1998, https://www.wsj.com/articles/SB906332982138892500.
40. Bob Ryan, "Reputation Is Established," *Boston Globe*, May 9, 2002, E8.
41. Lefton, 22–27.
42. For an in-depth discussion on the importance of boots on urban fashion see Semmelhack, *Shoes*, 152–156.
43. "NIKEiD(TM) Puts the Power of Design in the People's Hands," *PR Newswire*, November 22, 1999, 1.
44. It should be acknowledged that past generations, such as beatniks, hippies, and punks, had shaped countercultural identities through dress, often by mixing historic references or vintage items into their wardrobes. But the generation coming of age at the turn of the twenty-first century had greater access to information, which added additional layers of complexity to their statements.
45. Personal correspondence with Stephanie Schaff, senior archive specialist at Reebok, whose research on the Chanel x Reebok collaboration has confirmed the date.
46. As quoted in Jonathan Sawyer, "Yohji Yamamoto Explains How He Began Working with Adidas and How Y-3 Started," *Highsnobiety*, August 30, 2016, https://www.highsnobiety.com/2016/08/30/yohji-yamamoto-Adidas-master-of-the-shadows/.
47. Alex Rakestraw, Highsnobiety, February 1, 2018, https://www.highsnobiety.com/p/sneaker-collaborations-how-to.
48. Cam Wolf, "'The Vibe of the Times': How Nike Became the Biggest Fashion Brand in the World," *GQ*, September 24, 2018, https://www.gq.com/story/how-nike-became-the-biggest-fashion-brand-in-the-world.

SNEAKER ENTRIES, PAGES 42–250

1. Sam Smalldige, personal communication, March 20, 2019.
2. Lewis F. Atchison, "'Basket Ball Clinic' Seen Need Here: Coach, Players and Fans Could Diagnose Ills of Court Game," *The Washington Post*, January 7, 1935, 17.
3. Doug Tribou, "Meet Chuck Taylor: The Man Behind The All Star", November 2, 2013. http://www.wbur.org/onlyagame/2013/11/02/chuck-taylor-biography-converse
4. Converse Mickey Mouse Skoots adverstiement, 1934.
5. Ibid.
6. "The Mark of Max Is Everywhere," *Life*, September 5, 1969, 35.
7. Ibid.
8. David Blevins, *The Sports Hall of Fame Encyclopedia: Baseball, Basketball, Football, Hockey, Soccer, Volume 1* (Lanham, MD: Scarecrow Press, 2009), 1067.
9. Kareem Abdul-Jabbar, *Coach Wooden and Me: Our 50-Year Friendship On and Off the Court* (New York: Grand Central Publishing, 2018). https://books.google.ca/books?id=FewZDQAAQBAJ&pg=PP1&dq=Coach+Wooden+and+Me:+Our+50Year+Friendship+On+and+Off+the+Court&hl=en&sa=X&ved=0ahUKEwiZoajJ1sjiAhUrZN8KHRR4A7wQ6AEINDAC#v=onepage&q=socks&f=false.

10. Julie Hatfield, "Not Your Average Sneakers," *Boston Globe*, April 4, 1989, 25.
11. Ibid.
12. Steven Smith, personal communication, December 19, 2018.
13. Jonathan Sawyer, "Yohji Yamamoto Explains How He Began Working with Adidas and How Y-3 Started," *Highsnobiety*, August 30, 2016. https://www.highsnobiety.com/2016/08/30/yohji-yamamoto-Adidas-master-of-the-shadows/
14. There is some discrepancy as to when Stella McCartney officially began collaborating with Adidas, but Adidas provides 2005 as a firm date, as corroborated by a late 2004 press release titled "Adidas by Stella McCartney—Introducing the First True Sport Performance Design Collection for Women." https://www.Adidas-group.com/en/media/news-archive/press-releases/2004/Adidas-stella-mccartney-introducing-first-true-sport-performance/
15. Marc Richardson, "Atmos and the Art of Collaboration, *Grailed*, June 21, 2018. https://www.grailed.com/drycleanonly/atmos-collaboration-history
16. Todd Krinsky, personal communication, November 9, 2018.
17. Todd Krinsky, personal communication, November 9, 2018.
18. "Reebok and Jay-Z Create an Unprecedented Demand with The S. Carter Collection by Rbk," PR *Newswire*, April 22, 2003.
19. Todd Krinsky, personal communication, November 9, 2018.
20. "Phat News: Rappers Choose Reebok Shoe, Joseph Pereira, and Stephanie Kang," *Wall Street Journal*, November 14, 2003, B1.
21. "Reebok and Jay-Z Create an Unprecedented Demand."
22. "Dave Oritiz in a 'Beyond the Box,'" *Sneaker News*, May 26, 2018. https://sneakernews.com/2018/03/26/dave-ortiz-dqm-nike-air-max-90-bacon/
23. "Dave Ortiz—Beyond the Box." *The Berrics*. https://theberrics.com/dave-ortiz-sneaker-news-interview
24. https://stockx.com/jordan-4-retro-eminem-encore
25. Kathy Van Mullekom, "No Respect for Missy?" *Daily Press*, November 15, 2004, D1.
26. Rob Marfell, "Nic Galway Speaks on How Kanye Stretched His Comfort Zone," *Sneaker Freaker*, April 3, 2018. https://www.sneakerfreaker.com/articles/nic-galway-speaks-on-how-kanye-stretched-his-comfort-zone/
27. Rodrigo Corral, Alex French, and Howie Kahn, *Sneakers* (New York: Razorbill, 2017), 64–65.
28. Ibid.
29. Frank Rivera, personal communication, November 15, 2018.
30. Hussein Chalayan, "Manifesto," *Reading Design*. https://www.readingdesign.org/manifestos-hussein-chalayan
31. Dave White, personal communication, January 9, 2019.
32. Tom Sachs, *NikeCraft Mars Yard Shoe*, 2012. https://www.tomsachs.org/item/nikecraft-mars-yard-shoe
33. Steff Yotka, "5 Things You Didn't Know About Missoni," *Vogue*, April 25, 2016. https://www.vogue.com/article/missoni-history-5-unknown-facts
34. Melody Ehsani interview with Jeff Staple, *Business of Hype*. https://hypebeast.com/2018/3/the-business-of-hype-with-jeffstaple-episode-6-melody-ehsani
35. Ash Taylor, personal communication, December 14, 2014.
36. Rebecca Knott, "Converse Maison Martin Margiela: A fresh lick of paint literally," *Elle*, April 9, 2013. https://www.elle.com/uk/fashion/news/a2522/converse-maison-martin-margiela-collaboration-designs-revealed/
37. https://rafsimons.com/about
38. Amirah Mercer, "How Rihanna's Puma Creeper Became the Year's Must-Have Shoe," *Vanity Fair*, May 25, 2016. https://www.vanityfair.com/style/2016/05/rihanna-puma-creeper-shoe
39. Rachael Allen, "How Rihanna and Puma Dreamed Up the Most Desirable Shoe of 2016," *Footwear News*, November 26, 2016. https://footwearnews.com/2016/influencers/collaborations/rihanna-puma-fenty-creeper-footwear-news-achievement-awards-fnaa-shoe-of-the-year-280124/
40. Mercer, "How Rihanna's Puma Creeper."
41. *Apollo Operations Handbook Extravehicular Mobility Unit*, March 1971. https://www.lpi.usra.edu/lunar/documents/NASA%20TM-X-69516.pdf
42. Buzz Aldrin with Ken Abraham, *Magnificent Desolation: The Long Journey Home from the Moon* (London: Bloomsbury, 2009), 39.
43. Tomas Kellner, "What's the Buzz? Moonwalking in the Space Sneaker," *GE Reports*, July 19, 2014. https://www.ge.com/reports/post/91874310550/whats-the-buzz-moonwalking-in-the-space-sneaker/
44. Chris Danforth, "Sneakersnstuff and Social Status Discuss the Adidas Consortium Sneaker Exchange," *Highsnobiety*, February 2, 2017. https://www.highsnobiety.com/2017/02/02/Adidas-consortium-sneaker-exchange-interview/
45. https://www.parley.tv/fortheoceans
46. Ibid.
47. "Adidas Test to Sell Shoes Made of Ocean Plastic Was So Successful, They're Going Even Further," Good News Network, March 23, 2019. https://www.goodnewsnetwork.org/Adidas-shoes-from-ocean-plastic-going-even-further/
48. Miles Socha, "Pharrell Williams, Adidas Set 'Human' Project," *Women's Wear Daily*, September 26, 2016. https://wwd.com/fashion-news/intimates/pharrell-williams-Adidas-nmd-human-project-10565164/
49. A Ma Maniéere x Diadora N9000 Georgia Peach press release, 2016.
50. Virgil Abloh, "10," Nike, INC., 12. https://content.nike.com/content/dam/one-nike/en_us/season-2018-su/NikeLab/TEN/TEXTBOOK.pdf
51. Jake Woolf, "Riccardo Tisci Talks Nike and His Return to the Fashion World," *GQ*, October 12, 2017. https://www.gq.com/story/riccardo-tisci-talks-nike-and-his-return-to-the-fashion-world
52. Trevor Andrew, personal correspondence, December 12, 2018.
53. Jake Woolf, "Why These Dirty Reebok Sneakers Will Cost You $1,000," GQ, October 12, 2017. https://www.gq.com/story/reebok-vetements-genetically-modified-black-sneaker-of-the-week
54. Noah Lehava, "Exclusive: Aleali May & Maya Moore Drop 2 New Jordans," *Coveteur*, December 6, 2018. https://coveteur.com/2018/12/06/aleali-may-maya-moore-jordan-collaboration/
55. Richard Deitsch, "Maya Moore Is the Greatest Winner in History of Women's Basketball—and Best May Be Yet to Come," *Sports Illustrated*, December 5, 2017. https://www.si.com/sportsperson/2017/12/05/maya-moore-sports-illustrated-performer-of-the-year
56. Mary Howitt, "The Spider and the Fly" in Child, Lydia Maria, *The Mother's Story Book or Western Coronal*, (London: T.T. and J. Tegg, 1833), 214.
57. Frank Cooke, personal communication, December 20, 2018.
58. Austin Boykins, "Nigel Sylvester Talks Turning a Childhood Dream to a Reality with His Air Jordan I Collab," *Hypebeast*, August 30, 2018. https://hypebeast.com/2018/8/nigel-sylvester-air-jordan-1-interview-closer-look
59. "About Mache." Mache Custom Kicks. http://machecustoms.com/about-mache/
60. Dan Gamache, personal communication, January 8, 2019.
61. Frank Rivera, personal communication, November 15, 2018.
62. Russ Bengtson, personal communication, November 19, 2018.
63. Ibid.
64. Gemo Wong, personal communication, November 30, 2018.
65. Evan Glazman, "Who Is Don C, And Why Is His Air Jordan Collab So Insanely Hyped?" *Konbini*, 2017. http://www.konbini.com/ng/lifestyle/don-c-air-jordan-collab-insanely-hyped/
66. Brendan Dunne, "Just Don x Air Jordan 1 'Black History Month' – Available on eBay," *Sneaker News*, April 17, 2013. https://sneakernews.com/2013/04/17/just-don-x-air-jordan-1-black-history-month-available-on-ebay/
67. Complex, "God's Plan: How Jerry Lorenzo Went From Sports to Nightlife to Fashion's Cult Favorite," *Complex*, March 17, 2017. https://www.complex.com/style/2017/03/how-jerry-lorenzo-of-fear-of-god-became-fashions-cult-favorite
68. Nike, "Nike–HFR x LeBron 16: Women of Harlem's Fashion Row," September 4, 2018. https://www.youtube.com/watch?v=eC3_ctzCZzU
69. "Cav Empt Connects London's Past with Tokyo's Present to Create Its Own Future," *Nike News*, January 11, 2019. https://news.nike.com/news/cav-empt-air-max-95

PHOTO CREDITS

adidas AG/studio waldeck photographers, courtesy of adidas AG: 43, 67, 69, 91, 101, 117, 173, 191
again & again: 8, 34, 37, 41, 83, 85, 89, 93, 107, 123, 125, 141, 153, 181, 207, 213, 215, 225, 249
A Ma Maniére: 177
Daniel Arsham Studio: 193–95
© Bata Shoe Museum: 105, 113, 157 by Suzanne Peterson; 55, 63, 115, 119, 133, 159 by Ron Wood
© Salehe Bembury: 219
Bethel Woods, courtesy of The Museum at Bethel Woods: 50–51
Concepts: 129, 131
Converse Archive: 45, 47, 49, 139, 147, 205, 221, 223
Adrien Dirand/OWENSCORP, courtesy of Rick Owens: 151
© Bernard Freeman, courtesy of Bun B: 149
© Bobbito Garcia: 109, 111
Eric Haze: 75
Huf: 153
Courtesy of KAWS: 201
Madison McGaw/bfa.com: 96
Nike DNA: Courtesy of the Department of Nike Archives: 65, 71, 79, 87, 89, 131, 185–87, 197, 209, 201, 227, 239, 243, 245, 247
OVO: 165
Farzad Owrang, courtesy of KAWS: 4
Copyright 2018 Phillips Auctioneers LLC. All rights reserved: 56, 57, 121, 169, 171, 183
David X Prutting/bfa.com: 217
Puma Archive: 103, 237, 251, 183
Reebok Archive: 39, 59, 61, 73, 77, 92, 93–94, 127, 142–43, 145, 199, 203, 241, 235
Geraldo Rodriguez, courtesy of César Pérez: 229
Tom Sachs: 137
The Shoe Surgeon: 232
Raf Simons: 155
© Steven Smith: 117
Sneakersnstuff: 163
Social Status: 161, 175, 177
Giovanni Solis/theleagueofus.com, courtesy of Jacques Slade: 6
© StockX: 81
© Alexander Taylor: 167
Undefeated: 189
Union: 213, 215
Vans: 53, 179, 231
Dave White: 135

ACKNOWLEDGMENTS

I want to sincerely thank all the people who contributed to this book.

Firstly, I would like to thank Mayan Rajendran. Mayan encouraged me to take on the serious study of sneakers from day one. His incredible generosity and unwavering kindness have meant so much to me over the years. The many portraits Mayan took of the featured designers add so much depth and beauty to this book.

I thank Charles Miers for seeing the potential of this idea and agreeing to publish this book, and I thank Margaret Chace, who has been a champion of my projects at Rizzoli. I owe great thanks to Andrea Danese, my editor at Rizzoli, whose commitment to this book was immediate and whose work ethic and good humor have made creating it a pleasure. I also want to thank Ferdinando Verderi and Sylvia Gruber at Johannes Leonardo for the book's striking and innovative design.

I offer special thanks to Jacques Slade for his wonderful Foreword, I cannot imagine a better way to kick off the book. I want to thank all of the inspiring and creative people who have so generously given me their time and who have allowed me to interview them at length. I especially thank Chris Hill, who took me step-by-step through the collaboration process, and Nic Galway, who gave me new insight into how each collaboration is unique. I am profoundly grateful to Jeff Staple, Kenzo Minami, Shantell Martin, Melody Ehsani, Bobbito Garcia, Salehe Bembury, Deon Point, Frank "the Butcher" Rivera, Todd Krinsky, Bunyamin Aydin, Gemo Wong, Nigel Sylvester, Tom Sachs, Steven Smith, Vashtie Kola, Trevor Andrew, Aleali May, Chris Gibbs, César Pérez, Eric Haze, Dave White, Bun B, Rick Owens, Kerby Jean-Raymond, Dan Gamache, Dominic Ciambrone, Russ Bengtson, Cey Adams, and Buynamin Aydin, all of whom so graciously and thoughtfully answered every question I asked. I also thank Keith Hufnagel, Peter Jansson and Mubi Ali, Mr. Cartoon, Alexander Taylor, Leonard Hilton McGurr, Brian Donnelly, Daniel Arsham, Oliver El-Khatib, and James Whitner for their generosity and willingness to be a part of this project.

I want to thank the archivists, brand publicists, and others who have been beyond helpful. I am grateful to Erin Narloch and Stephanie Schaff at the Reebok Archive, as well as Chris Strachan, Philippe Bun, Lisa Guo, Ash Taylor, and Jennifer Hall at Reebok; Sam Smallidge, archivist at Converse, as well as Monique Krasniqi and Matt Maestrallis at Converse; Bertrand Bordenave and Demetria White at Nike; Samantha Baker at Jordan Brand and the team at Nike DNA; Marta Rodiguez Sainz and Teresa Tayzon at Puma; Sandra Trapp, Susen Friedrich, Lauren Devlin, and RaEsa Benjamin-Wardle at Adidas; Dazman Primus, Rian Pozzebon, Taylor Norman, and Laura Doherty at Vans; Joanna Barrios and Eugenia Hermo at Rick Owens; Yoshimi Sanada at Kaikai Kiki; Arnold Lehman, Ana Ivy, and Elizabeth Wallace at Phillips; Michael Stern and his Pop Culture Collection; Wade Lawrence at Bethel Woods Center for the Arts; Josh Luber, Boru O'Brien O'Connell, and Katy Cockrel at StockX; Fresco Wilson at Stadium Goods; Kim Caban at Staple Design; Michelle Bonomo with KAWS; Zaïre Prosper with Vashite Kola; Zhaniya Bektay with Hussein Chalayan; Meghan Clohessy and Tori Geddes at Daniel Arsham Studio; Clare Ngai with Aleali May; Justin Velasquez at Union LA; Alex Bruzzi and Ilias Panayiotou at Undefeated; Daniela Vega and Anna Sork with the Shoe Surgeon; Jay Bil with Eric Haze; Nicholas Wojciechowsk and Scott Howe at Concepts; Sedef Sunay and Zohaer Majhadi at Les Benjamins; Elizabeth Hess and Camilla Scales at Johannes Leonardo; Ed Barrón at BFA; Thomas Bui at OVO; Nate Hinton and Jaton Brady at Hinton Group; Minna Axford at Alexander Taylor; Sarah Helmig at PR Consulting; Katherine Emrick and Chase Warner at Huf; Erum Shah and Serena Smith with Tom Sachs; Michael Seegars Jr. and Nate Shuler at Whitaker Group. I also thank Chad Jones, Nick Avery, Geraldo Rodriguez, Jordan Bratman, Brittney Escovedo, David X Prutting, Rudah Riberio, Greg Street, and Frank Cooke. I thank the Bata Shoe Museum, especially Suzanne Peterson, who is the museum's collection manager and who also manages the museum's image rights and takes many photographs of the artifacts for the collection. I also wish to thank Ron Wood for his beautiful photography.

I thank my dear friend Emily Anadu, who has cheered me on throughout this project while always offering invaluable suggestions and introductions. I thank my husband for reading all my writing and for his endless willingness to engage in long conversations about my work. Finally, I want to thank my children Benjamin and Isabelle whose keen and distinctive intellects have suggested many new perspectives for me to consider as I have worked on this book.

Front cover: Union x Jordan Brand, Air Jordan I NRG, 2018. Collection of Chris Gibbs

First published in the United States of America in 2019 by
Rizzoli International Publications, Inc.
300 Park Avenue South
New York, NY 10010
www.rizzoliusa.com

Copyright © 2019 by Elizabeth Semmelhack

For photography credits, see page 254

Publisher: Charles Miers
Associate Publisher: Margaret Rennolds Chace
Editor: Andrea Danese
Production Manager: Kaija Markoe
Managing Editor: Lynn Scrabis

Design
Creative Director: Ferdinando Verderi @ Johannes Leonardo
Art Director: Sylvia Gruber @ Johannes Leonardo
Project Manager: Camilla Scales @ Johannes Leonardo

All rights reserved. No part of this publication may be reproduced, stored in a retrieval system, or transmitted in any form or by any means, electronic, mechanical, photocopying, recording, or otherwise, without prior consent of the publishers.

Printed in China

2021 2022 2023 / 10 9 8 7 6 5 4

ISBN: 978-0-8478-6578-9
Library of Congress Control Number: 2019943797

Visit us online:
Facebook.com/RizzoliNewYork
Twitter: @Rizzoli_Books
Instagram.com/RizzoliBooks
Pinterest.com/RizzoliBooks
Youtube.com/user/RizzoliNY
Issuu.com/Rizzoli